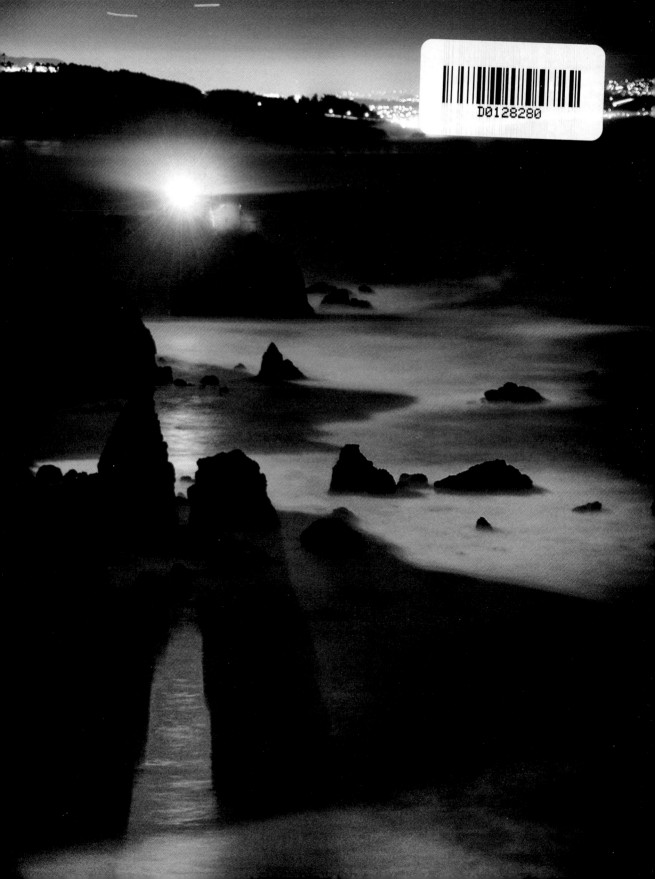

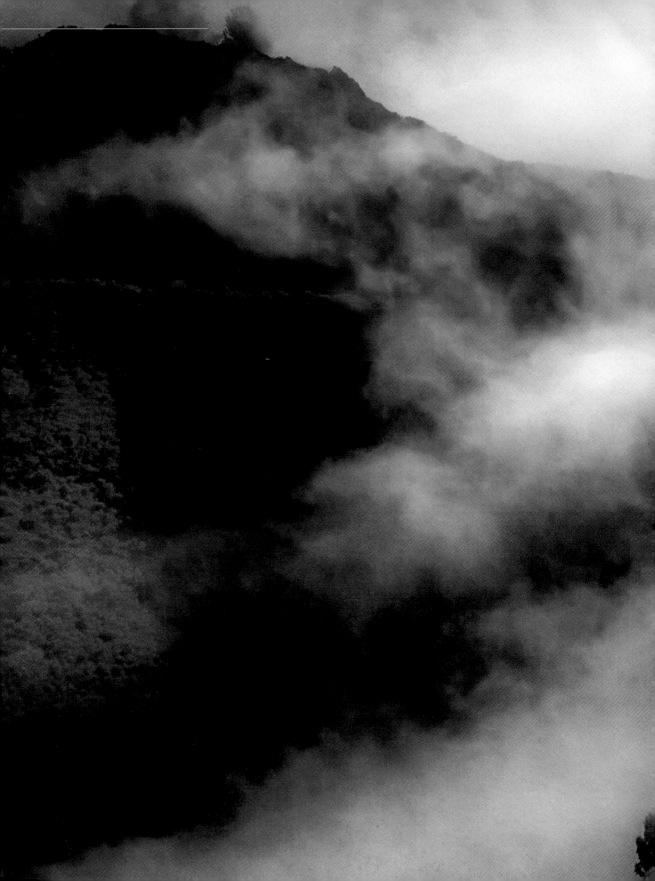

Creative Black & White

Digital Photography Tips & Techniques

Harold Davis

WILEY

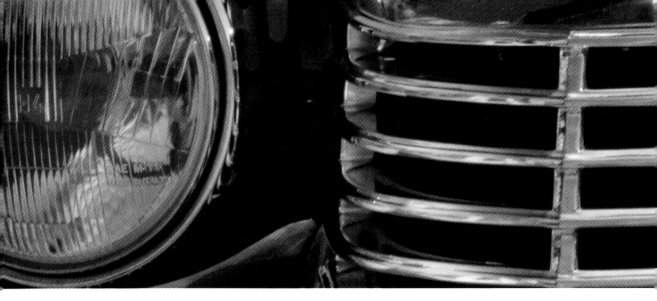

Creative Black & White: Digital Photography Tips & Techniques
by Harold Davis

Published by
Wiley Publishing, Inc.
10475 Crosspoint Boulevard
Indianapolis, IN 46256
www.wiley.com

Published simultaneously in Canada

ISBN: 978-0-470-59775-0

Manufactured in the United States of America

10 9 8 7 6 5 4 3 2 1

For general information on our other products and services or to obtain technical support, please contact our Customer Care Department within the U.S. at (800) 762-2974, outside the U.S. at (317) 572-3993 or fax (317) 572-4002.

Wiley also publishes its books in a variety of electronic formats. Some content that appears in print may not be available in electronic books.

Library of Congress Control Number: 2010922558

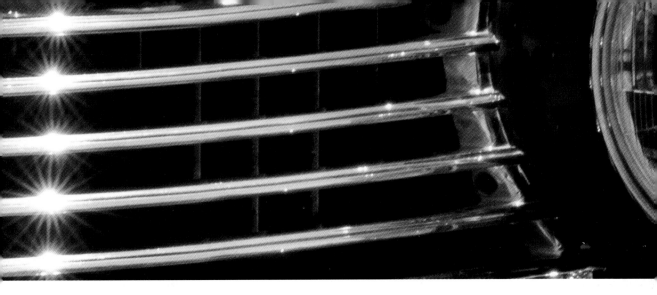

Acknowledgements

Special thanks to Courtney Allen, Christianna Aronstam, Bill Bachmann, Mark Brokering, Steven Christenson, Gary Cornell, Katie Gordon, Kimi, Denise Judson, Barry Pruett, Alice Raffael, Joseph Siroker, Sandy Smith, and Matt Wagner.

Credits

Acquisitions Editor: Courtney Allen

Project Editor: Matthew Buchanan

Technical Editor: Chris Bucher

Copy Editor: Matthew Buchanan

Editorial Manager: Robyn Siesky

Business Manager: Amy Knies

Senior Marketing Manager: Sandy Smith

Vice President and Executive Group Publisher: Richard Swadley

Vice President and Publisher: Barry Pruett

Book Designer: Phyllis Davis

Media Development Project Manager: Laura Moss

Media Development Assistant Project Manager: Jenny Swisher

▲ Front piece: In this photo of Point Bonita and the Golden Gate near San Francisco, California moonlight supplied ambient background light, with the Point Bonita lighthouse as an important focus of the composition.
52mm, 2 minutes at f/5.6 and ISO 200, tripod mounted

▲ Title page: With this composition of fog and sunlight I intentionally underexposed to bring out the graphic patterns revealed by the composition.
75mm, 1/640 of a second at f/8 and ISO 100, tripod mounted

▲ Above: I used the bright sunlight and grill reflections to make this semi-abstraction of a 1930s Cadillac.
200mm macro, 1/15 of a second at f/32 and ISO 100, tripod mounted

▼ Page 6: This night time view of traffic lights on the Golden Gate Bridge uses the absence of color to suggest the colors that are presumably present in the scene.
380mm macro, 10 seconds at f/11 and ISO 100, tripod mounted

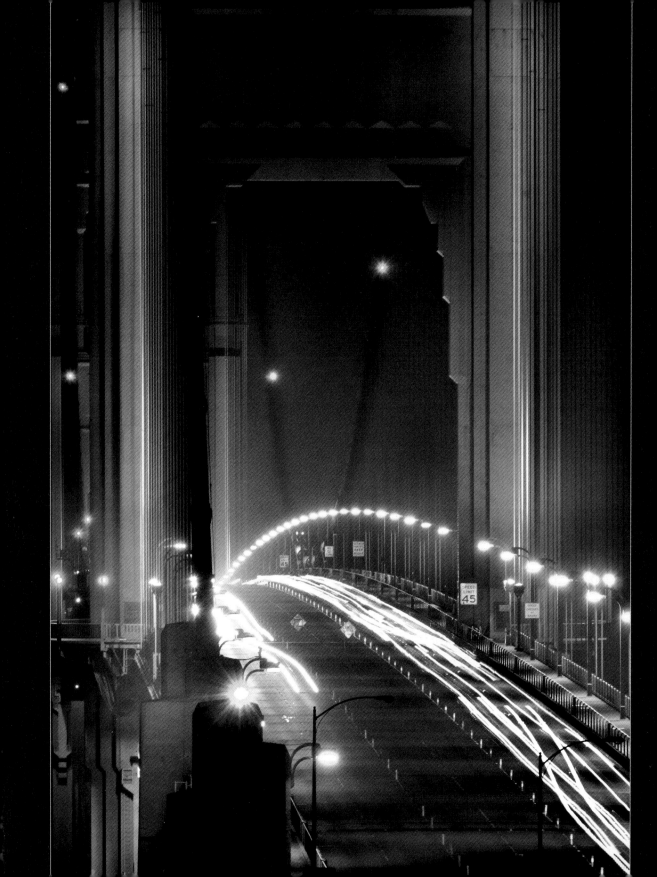

Contents

Introduction

As photographers, we are confronted each and every day with a wide array of choices. Most of us have the experience of being paralyzed with indecision when confronted with all the choices about what can be photographed.

Besides your choice of subject, you can worry about how your photograph is going to be lit (if you are using artificial light), or what time of day the lighting is best (if you are relying on natural light). Then there's the choice of lens, focal length, f-stop, shutter speed, ISO, and so on—not to mention the choices about how you will process and present your photo after it has been shot.

Bewilderment in the face of so many artistic choices can lead to creative blocks, and is sometimes called *horror vacui*—or fear of "empty spaces" on the canvas of life that presents itself to every photographer. One response is to intentionally limit one's artistic palette so there are not so many choices. A natural self-limitation in photography is to leave out the color and present the world in black and white.

Limiting photography to black and white is an obvious strategy because of the history of photography. For a substantial part of

the history of photography, the only choice was monochrome—and people thought of photography as being black and white. Color was only introduced to photography in the mid-twentieth century, and people have had a hard time accepting color work as part of the accepted canon of photographic art.

As I'll show you in *Creative Black & White: Digital Photography Tips & Techniques*, many things are different with the rise of digital technology. Presenting a photo in black and white is not a consequence of the materials used; rather, it is an intentional aesthetic choice. Furthermore, from a technical perspective it almost always makes sense to shoot and initially process a digital photo in color—even if you plan from the very beginning to present it in black and white.

Black and white photography is redolent with echoes from the history of photography, and it is wise to keep this in mind as you make your own black and white images. The absence of color in a black and white print or online image can strongly imply the color that isn't present—but only imagined. Black and white photography must play strongly to the imagination

▶ The idea for this photo was to isolate the typewriter key used to type French accents, because it looks like a little funny face. To achieve this goal I kept the circumflex (^) key sharp, while letting everything else in the image go out of focus.

I wanted to present the photo with an antique look, so once I'd processed the black and white version I added a sepia tone layer with reduced opacity (see page 166 for more information about this technique).

200mm macro, 1.3 seconds at f/4.5 and ISO 100, tripod mounted

of the viewer. This often means taking advantage of the power of the graphic design that can occur when an image is composed only in monochrome.

My goal in *Creative Black & White* is to be your companion and guide as you create your own black and white imagery. Together we'll experience what it means to think in black and white. I'll show you many of the visual ideas that can work well with black and white, and share my expertise about the technical approaches that can be used to create high quality digital black and white photos.

I have a great passion for black and white photography, and I look forward to sharing my joy in the art and craft of digital monochromatic image creation with you!

Harold Davis

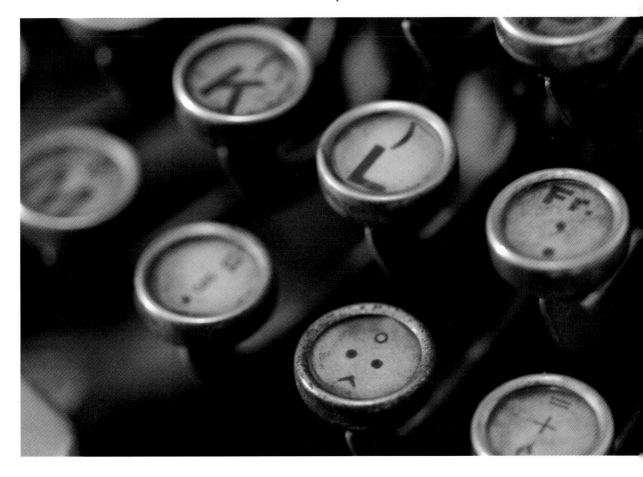

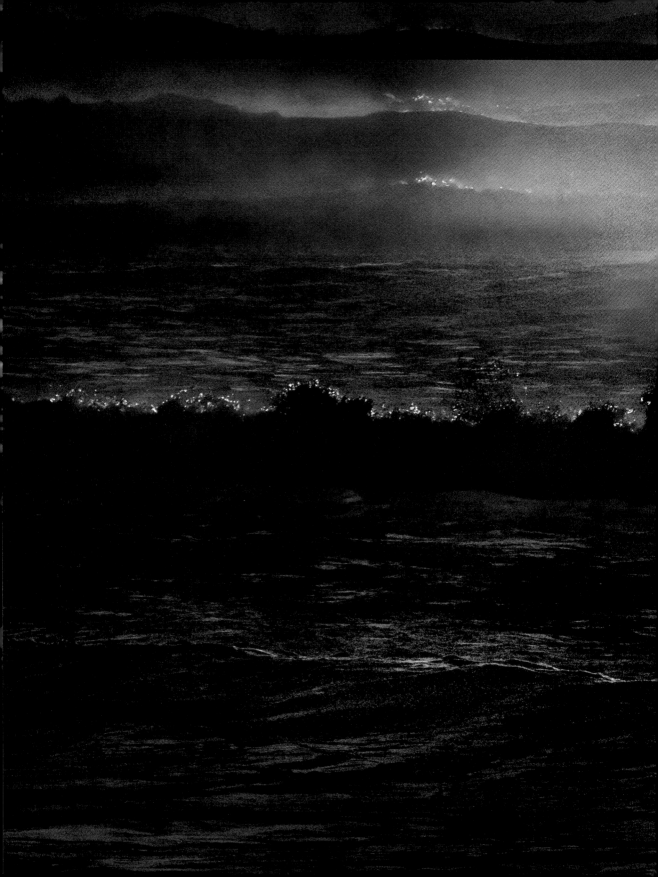

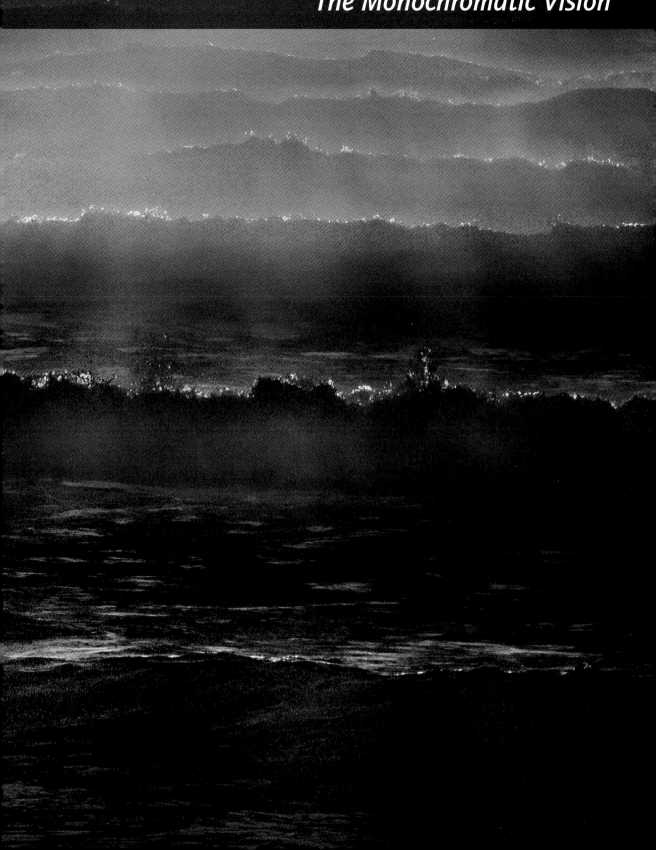

Past, Present, and Future

In large part, when we think of great photography prior to the digital era, we think of black and white imagery.

Gritty stills of the Second World War. Magnificent Ansel Adams landscapes of the American West. Classical compositions of nudes, peppers and shells by Edward Weston. All these and more are part of the shared black and white collective consciousness.

Sure, once color film came along we started filling up those yellow boxes with slides. But until fairly recently color photos have not been recognized as art.

Back in the days of film, you could shoot in color *or* in black and white. A vast gulf separated the two. Amateurs, and some advertising photographers, shot color. Art photographers worked in monochrome.

An oversimplification, of course. But the fact remains that if you had a 35mm camera, you had to decide what kind of film cassette to load, and whether it should be color or not.

With the domination of digital technology in photography, the choice of color versus black and white no longer belongs to the physical domain. The best bet is to shoot full color whether you intend to present your final image in color—or to make an outstanding black and white image. I'll tell you more about the best practices in creating *Black and White in the Digital Era*, starting on page 66.

The implication is that the choice to create black and white imagery is virtual. In other words, it is an aesthetic choice, similar in nature to presenting work that is only blue in tint, that uses a specific focal length or lens, or is limited to a certain kind of subject matter. The choice of black and white does not have to be made until "after the fact"—because the photo has already been taken—although the best black and white imagery is intentionally created with monochrome in mind.

In other words, your photos of a given scene can be presented in both color and black and white. Or you can decide to present your work in monochrome after you see how your shoot has turned out. There's nothing wrong with these approaches. But since black and white is now an affirmative choice—amounting to the intentional abnegation of color—it works best to make this choice with intentionality.

Whichever way you choose to work, learning to think in black and white is part of the job.

▲ Pages 10-11: Just before an early winter sunset I stood on a bluff above a beach to the south of San Francisco, California and photographed the incoming long rollers. My idea was to exploit the contrast between the extremely bright highlights created by the setting sun and the darkness in the valleys between the waves. Knowing I was going to transfer the color scene in front of me into a black and white vision, I intentionally shot the image to be dark (by underexposing) at a very fast shutter speed (1/8000 of a second), which also served to stop the motion of the waves.

190mm, 1/8000 of a second at f/7.1 and ISO 400, tripod mounted

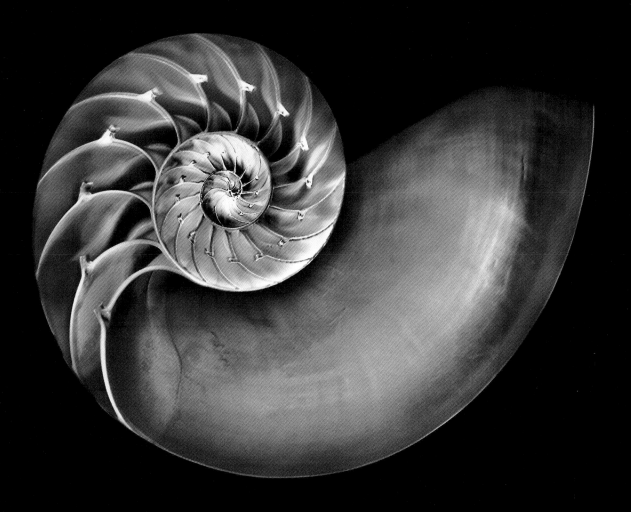

▲ When photographing the wonderful spirals of a Chambered Nautilus shell, it's hard not to think of the classical black and white imagery of Edward Weston. With this fairly straightforward macro photograph of the shell, I was able to use the color information I captured to create a really rich monochromatic image with great tonal range.

50mm macro, 8 seconds at f/32 and ISO 100, tripod mounted

Thinking in Black and White

The absence of color does not mean the obliteration of color. Black and white is a choice—and surprisingly, this choice can call attention to implied color in the image even more than if the image were actually presented in color.

If you want to think in black and white you must learn to view the world as seen through your camera in terms of implied color, and through gradations of gray.

A black and white image potentially shows a range from pure white to absolute black (leaving aside issues of tinting and toning, explained starting on page 166).

These extremes are not often seen to any great extent in a color photo because pure white represents highlight blowout, and absolute black is approximated in impenetrable shadow. Except in unusual circumstances, color photos don't usually feature as wide a range of grayscale tonal values as monochromatic imagery.

Contrast

Thinking in black and white means thinking in contrasts. The building blocks of composition are shape, design, and form. In the case of black and white, this formalism is consistent, and unleavened or softened by color. As I've noted, taking this to its limits, the contrast is between white and black.

Black and white photographers know that one of the primary tools of their compositional trade is the edge—the line between white and black. A hard edge between light and dark becomes a black shape on a white background—or a white shape on a black background.

In either case, the interrelationship between black and white allows for complexity in the handling of positive and negative spaces in the composition. Experienced black and white photographers know that creating, or emphasizing, the edge adds an element to a photo that is often not present in a color image.

Life doesn't usually present us with obvious hard edges between black and white to photograph. Finding these edges requires developing a special kind of vision. Look for:

- Strong, interesting shadows: the shadows themselves may create a hard line between darkness and light.

- Compositions that are monotonic: if color is already mostly absent, then it is likely you can add light, expose, or add post-processing effects to create high contrast imagery.

- Extremes between areas of brightness and shadow in a subject: if there are extremes between light and dark, then a composition may lend itself to a high

▶ The sun was streaming through a great arch carved by the Pacific Ocean, creating highlights on the surf coming through the gap. Everything else in the scene was in deep shadow. I pre-visualized a black and white image exposed for the bright surf framed by the surrounding cliffs, shown in silhouette as a black negative-space shape.

95mm, 1/320 of a second at f/9 and ISO 200, tripod mounted

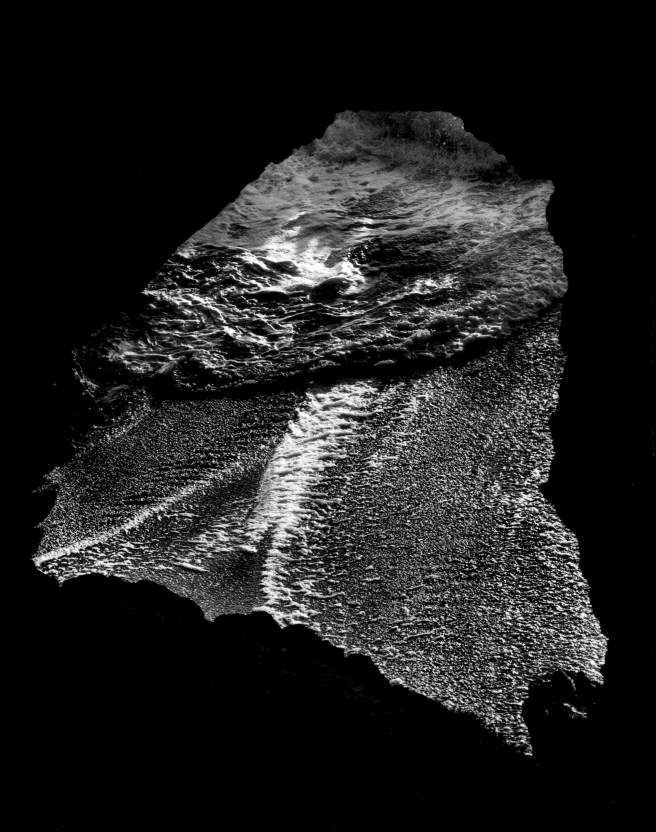

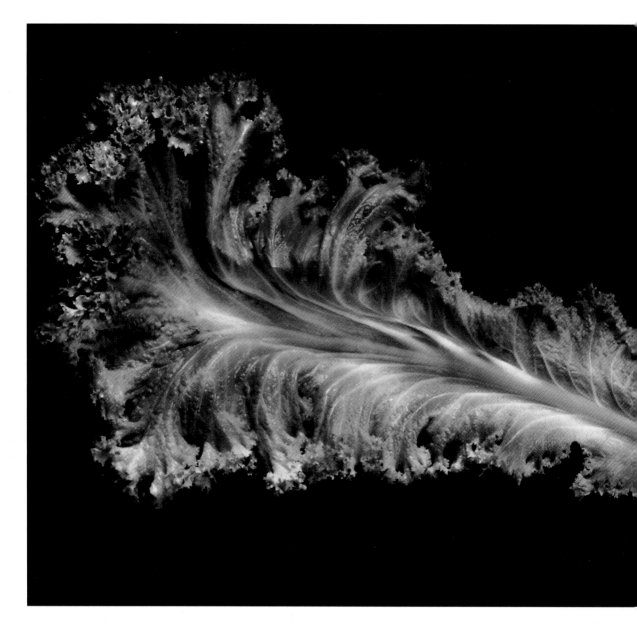

▲ In color, this lettuce-like leaf looked like some green and luminous sea creature, complete with curling tentacles. Converting the image to black and white added elegance. Oddly enough, the black and white version presents a more natural representation of the actual leaf than its color counterpart—because the actual color appears unnatural. Converting to black and white, we can substitute natural colors of our own imagining to come up with something like a Platonic ideal of a mustard leaf.

85mm macro, 5 seconds at f/51 and ISO 100, tripod mounted

contrast black and white treatment.

Even when you recognize a high-contrast photographic subject, there may be additional work to do. You'll want to consider:

- Positioning the camera to emphasize the edge, or the delineation between dark and white areas.

- Use lighting to maximize the contrast.

- Underexpose dark areas to make them blacker in the final image or overexpose bright areas to make them whiter in the image. To compensate, you'll need to adjust processing in areas that you don't want to go fully black (or white).

- Consider various post-processing effects to increase tonal range, or to emphasize light or dark areas important to the composition.

Color Implied

Our expectation is that scenes and objects in our world are colored. For example, lettuce is green, a tomato is red, and an orange is, well, orange.

The fact that one is viewing an object in black and white doesn't negate the fact that we know the object has color. We tend to visually impute color to the subjects of photos unless these subjects seem so ancient or far away as to be beyond the reach of realism.

The imputation of color means that a photographer who is presenting work in black and white can assume that the subject will be seen as colored, at least to some degree.

Therefore, the photographer can take advantage of what monochrome does best, namely present the underlying forms and contrasts. In the universe of black and white, color can take care of itself, but it doesn't mean it isn't present. Color is the elephant in the room—not talked about but with a vast presence.

Black and white photographers who want to take advantage of the imputation of color should:

- Look for subjects whose color is readily known (think apples, oranges, and lettuce).

- Consider photographs where the natural colors don't work well for some reason, but where imputed colors would be an improvement.

- Try to create a composition where formal aspects of design outweigh the allocation of color to the objects within the photo.

The Tonal Landscape

From the earliest origins of photography, black and white has been specially associated with landscape photography. The best landscape photographs have a purity of expression that meshes well with the sparseness of black and white. In addition, the simplicity and tonal range of black and white allows details to be brought out that would otherwise be camouflaged by the complexities of color.

To create interesting black and white landscape compositions, you should:

- Look for landscapes with varied textures and forms in the earth and sky.

- Avoid landscapes where the interest is primarily in saturated colors.

- Try to create compositions that take advantage of the bold shapes possible in black and white.

- Seek drama in the interplay between light and dark areas in your photo.

▶ Unusual snowfall in the coastal range mountains of California made this scene dramatic. However, overcast skies kept compelling colors out of the landscape. I realized that to make an interesting landscape image I would need to process the image file to bring out the extensive contrast and color range that I saw in the scene in front of me (see *Black and White in the Digital Era* starting on page 66 for more information about post-processing black and white).

200mm, 1/620 of a second at f/13 and ISO 200, hand held

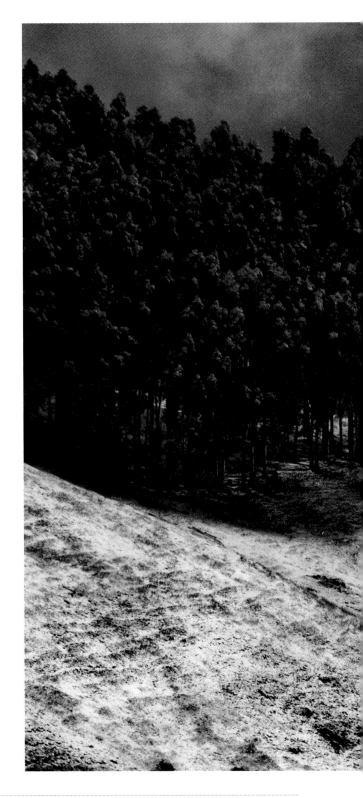

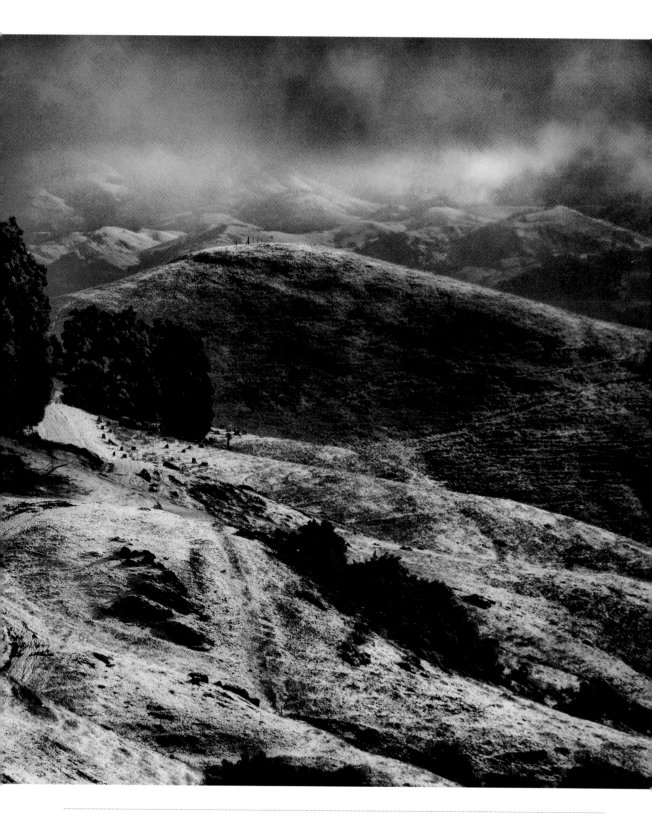

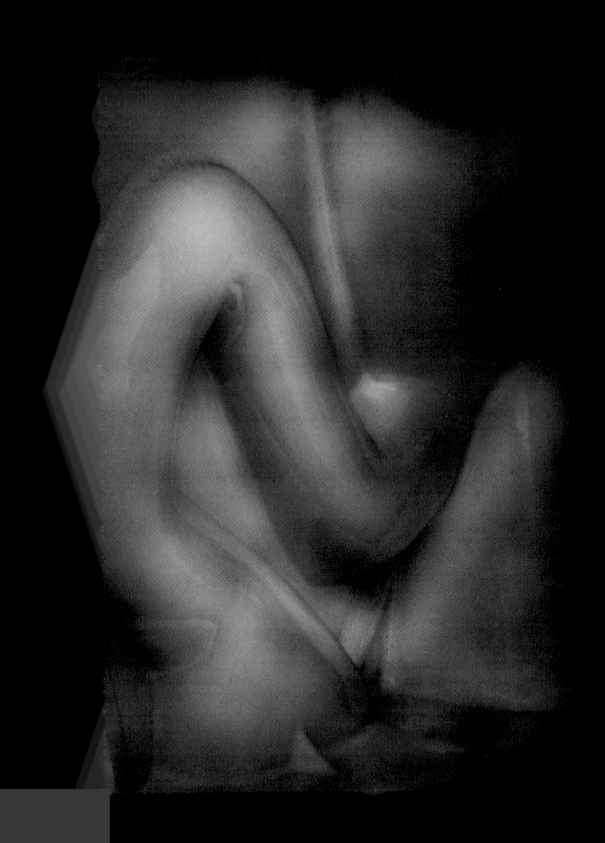

Visual Implication

A black and white photograph shows the full spectrum world of color monotonically. By stripping the color from a scene, the photograph adds mystery. When black and white is done correctly, we don't always know what we are looking at. There's a sense of ambiguity and—hopefully—profound mystery.

Ambiguity causes a double-take, engages the viewer, and makes the viewer spend time with the image. This is a good initial goal for any work of art because when time is spent deciphering the image, the viewer may progress to a deeper relationship with the work.

When the image is studied carefully and pursued to its logical extreme, certain visual implications can be drawn.

Ideally, visual ambiguity should be set up so that looking at the photo long enough does make the real subject matter—as opposed to the superficial first apparent subject—apparent.

Black and white photography that uses visual implication works on a kind of pun. The viewer gets a frisson of delight and a sense of collaboration with the photographer, when the real subject is uncovered.

To create images that take advantage of ambiguity and visual implication, you should:

- Look for subject matter that can be interpreted visually in more than one way.

- Use positioning, framing, focus, and exposure to exploit the visual ambiguity by highlighting secondary visual meanings.

- Be aware that camera angle and choice of lens can be particularly important in creating visually ambiguous imagery.

- Post-process images to keep the sense of mystery alive.

- Work to create photos whose visual meaning can only be decoded a bit at a time.

◄ My idea when I photographed this close-up of a toilet was to abstract the shapes so the subject matter of the image wasn't clear at first glance. When this kind of image works, the viewer does a double-take. At first look, this might be a human nude—of course, it is not. The implied domain of the image (a nude abstraction) is not the actual subject matter of the photo (plumbing).

85mm macro, 1/15 of a second at f/64 and ISO 100, tripod mounted

Seeing in Black and White

From thought (learning the characteristics that are important to a black and white photo) to action (the act of making a monochromatic image) can be a long journey. Fortunately, there's an intermediate step: learning to see in black and white. Pre-visualization techniques, explained on pages 26–29 and 68–73, can help you see your photos as they will appear in monotone before you take them, but it is also important to think about the more general issues of seeing.

I consider far more photos in my mind's eye than I ever end up actually taking. The whole approach to photography should be an inverted pyramid looking something like what is shown below,

starting with thought and conception and ending with presenting the work. At each stage in the photographic journey, there are less and less images.

Here's the explanation for the reduction in quantity of photos. At the top stages of the pyramid, the world is one's oyster. Everything is grist for the visual mill, and the possibilities have not been limited.

A few of the possibilities out there actually become digital photos, either as planned photos or because something in the world captures the attention of a diligent photographer.

Of these few, an even smaller number will actually be fully processed in Lightroom, Photoshop or some other

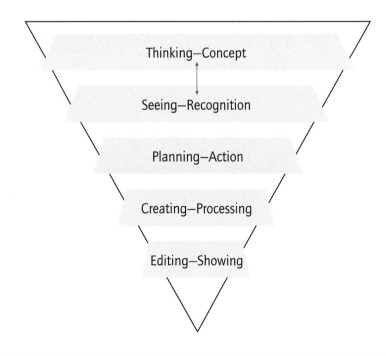

Thinking—Concept

Seeing—Recognition

Planning—Action

Creating—Processing

Editing—Showing

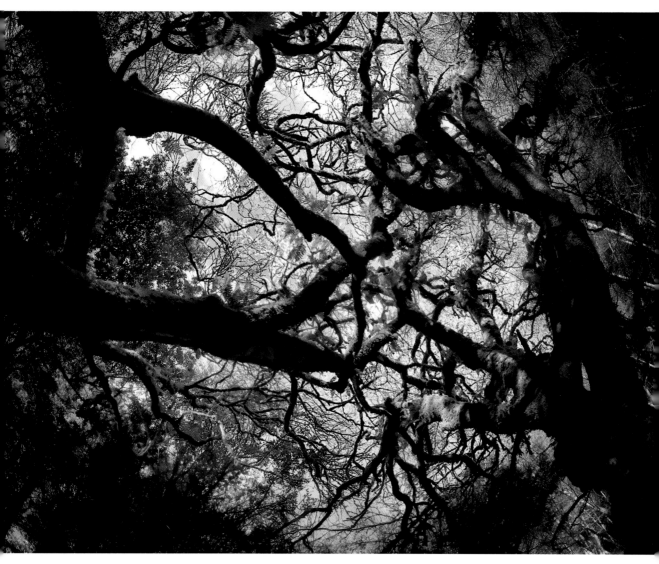

▲ Lying back in a dense forest, I looked up at the sky. Suddenly I saw the sky as a circular shape in the center of my field of view, apparently held up by the tangled and gnarled trees. I knew that in black and white I could isolate the white, round shape of the sky from the dark background of the forest and trees—transforming the image into one "round globe" (actually the sky) held up in "space" by the trees.

If you look at the composition carefully, you'll see perfectly well that it is an image of the sky seen through branches of trees. But at a quick glance, the circular shape makes it appear to be something else (the globe in the sky). Visual ambiguity of this sort greatly appeals to me in my black and white imagery.

10.5mm digital fisheye, 1/60 of a second at f/8 and ISO 100, hand held

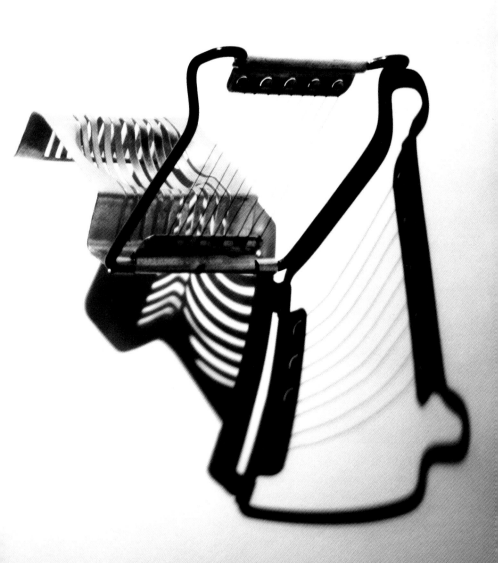

software. And fewer still of those processed will actually see the "light of day"—get shown to others.

Online communities of photographers such as Flickr or Photo.net have changed this equation somewhat—because it is easy to post images where they may be widely seen. But I'd keep in mind the wisdom a famous art director shared with me when I was beginning my career as a photographer. He told me that if I needed to show more than six images then I didn't really understand what was important about my work.

Black and white photography limits the choice of subject matter further than it would otherwise be limited—to those images that actually work, or are improved, without color. Therefore, the universe of possibilities is far smaller at each stage of the inverted pyramid than for digital imagery overall.

There's nothing wrong with limiting one's photography to specific techniques. In fact, it can be a valuable approach for enhancing creativity. But the fact remains that not all photos should be shown in black and white.

In my drawing you'll note that I've shown *Thinking* and *Seeing* connected with a double-headed arrow. This is because, like chickens and eggs, it is a little hard to know which comes first. The two activities are interrelated. I prefer to conceptualize first, and then "see" my photos without feeling too bound by ideas about what "should" be in the photo.

My ideas about creative black and white photography are to look for:

- Positive and negative spaces, because sometimes these will create the composition.

- Level of contrast within the image, because high contrast often works well for black and white. (There are some exceptions, such as high-key imagery, explained on pages 40–43).

- Formalism in composition, since design becomes extremely important to the success or failure of a monochromatic image.

Finally, I use the pre-visualization techniques and exercises explained on pages 26–29 to try very hard to see the world without color. Seeing without color is not the same thing as seeing black and white; but it is a first step. From a world that has no color, one can start to abstract and pre-visualize what a piece of the world captured in a photo might look like as a black and white work of art.

◀ I placed this egg slicer on a white seamless background, and lit it to emphasize the shadow. There was an absence of color in the composition, and I saw that the contrast between the strong shadow and the rather mundane kitchen utensil could create a striking black and white composition.

85mm macro, 6 seconds at f/64 and ISO 100, tripod mounted

Pre-Visualization Techniques

Pre-visualization refers to the ability to see in the "mind's eye" how a final image will come out based simply on the scene in front of one. Ansel Adams maintained that pre-visualization was a crucial skill in his work and for all photographers; in the era before digital he was often able to accurately "know" what his final print would look like, taking into account the vagaries of exposure and development, as well as the craft of fine print making.

Without pre-visualization, photography can be largely random, and lacks conceptual clarity. You'll also waste a great deal of time by making captures that don't come out the way you'd expect or like.

Some people think that digital technology has made pre-visualization greatly easier. With a digital capture, you can "see" what you've got right after the exposure—or

▶ I photographed this small, white Hellebore flower in a room with the curtains drawn so that there was only a single shaft of sunlight on the blossom.

Looking at the essentially monochromatic flower, I saw that if I made darks darker and whites whiter I might have an interesting black and white image with deep shadows in the "valleys" between the petals and highlights creating interesting shapes around the petal rims. But what I saw in my viewfinder didn't correspond to my pre-visualization.

I adjusted the light focused on the flower, and moved its position, to create deeper shadows with highlights playing on the petal edges. Post-processing yielded the black and white image I had pre-visualized.

200mm macro, 24mm extension tube, 1/6 of a second at f/35 and ISO 100, tripod mounted

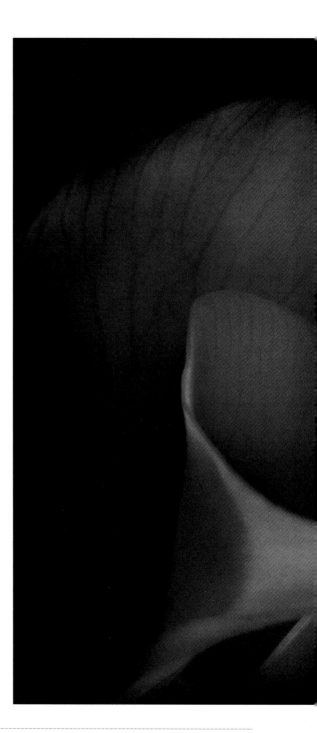

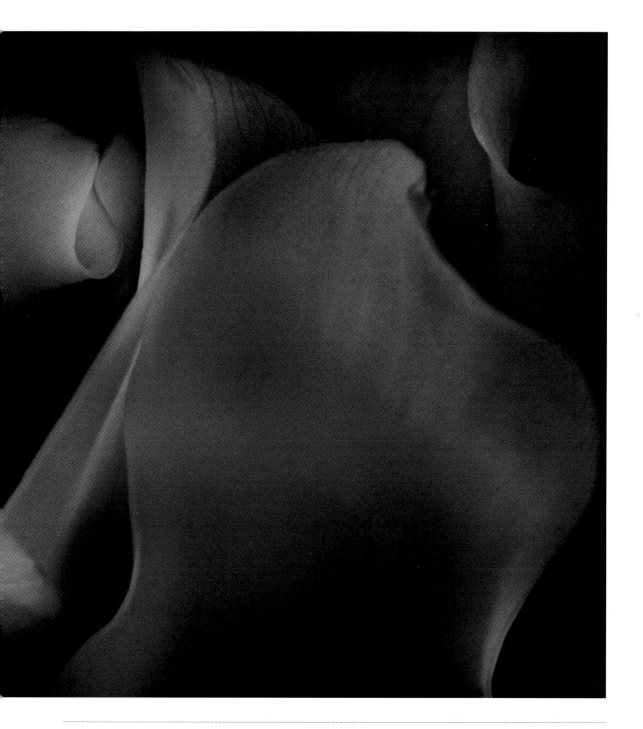

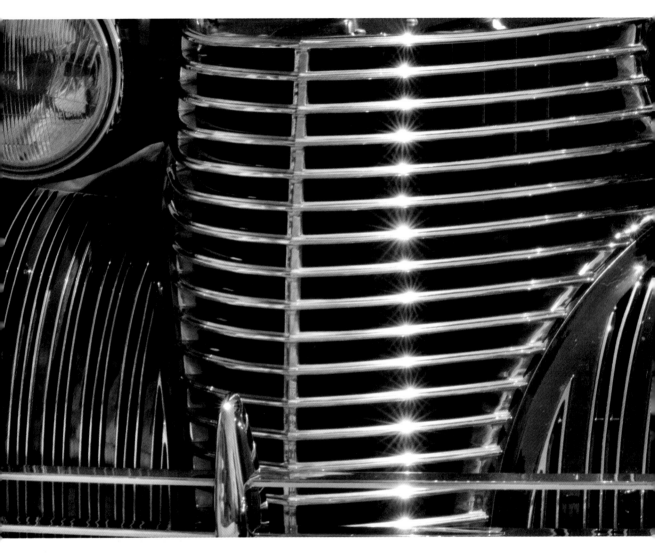

▲ Wandering at an outdoor classic car show, I kept my eye out for interesting compositions. When I saw the sunlight reflecting on the grill of this 1930s Cadillac, I was able to pre-visualize an interesting monochromatic image. One reason that I was able to see this composition in advance is that the car itself wasn't highly colored. Perhaps taking a leaf from Henry Ford—his customers could have any color they wanted so long as it was black—this classic car was black with chrome detailing.

The contrast between the chrome, brightly lit by the sun, and the deep black car body, helped to create the kind of pattern that can be very interesting in black and white imagery.

200mm macro, 1/15 of a second at f/32 and ISO 100, tripod mounted

using Live View even before you make the exposure. For more information about using these aspects of digital technology to help you pre-visualize black and white imagery, see pages 70–73.

Reviewing a photo on your LCD screen can be a great way to check the accuracy of your exposure and the basics of your composition, but there are a couple of reasons why pre-visualization in the digital era is still as great a challenge as it ever was.

Assuming you've set your camera to create RAW captures, the image you see on your LCD is a JPEG rendition of the RAW file—and as such gives you only one data point regarding the potentialities available within the complete capture. See pages 74–75 for a comparison of JPEG and RAW captures in the context of black and white digital photography. It's as if Ansel Adams were pre-visualizing his negatives developed only one way instead of considering how his negatives might come out depending on the complex chemical mixtures he used determined by shooting and exposure conditions.

There's also close to an infinite universe of possible approaches to digital post-processing. You can take the file representing a photo and process it in numerous different ways—with tremendous variations in the final black and white image. From this viewpoint, the ability to pre-visualize digital black and white takes knowledge of the vast array of post-processing techniques as well as the ability to see with subtlety and clarity how the color world translates to monochrome. (This is the subject of *Black and White in the Digital Era* starting on page 66 and *Creative Black and White Opportunities* starting on page 142.)

Here are some techniques I use to help develop my pre-visualization skills, and to try and see how particular photos will "come out" in their final black and white versions:

- I consider a generally monochromatic subject—this could be anything ranging from a bush to a door—and pay special attention to how it is lit. I think about whether I can make a black and white photo from the contrast between highlights and shadows. If not, I consider how I need to change the lighting to create an interesting photo.

- I sometimes bring a small sketchbook and a pencil with me on my shoots. Before making any exposures, I try to draw the key shapes I see in the image. I'm not in the least worried about the quality of my drawing. Often, this work helps me clarify the important aspects of the composition I am trying to make.

- Looking at a potential photo in my viewfinder, I try to see the image in black and white. In my mind's eye I try to take both black and white areas to the limit. What happens when the darker areas go completely black? What happens when the lighter areas go completely white? What are the results if both "moves" are attempted at the same time?

By the way, pre-visualization is not a be-all and end-all by itself. It's a tool and technique to help you create more powerful images with greater control. But don't get caught in the trap of excluding alternative possibilities when you come to process your imagery. Often, the most interesting photos come from surprise detours along the way rather than following the straight and narrow path of your original roadmap.

Black and White Composition

In the classic film *Casablanca*, Captain Renault describes the intriguing nightclub owner Rick in these words: "Oh, he's just like any other man, only more so."

You could also say that black and white composition is like composition in color—only more so. Since color is not present to entertain, beguile, and misdirect the eye, formal composition becomes more important.

The elements of formal composition that are most important to black and white photos include:

- Framing and the relationship of an image to its "frame"
- Patterns and symmetry
- Use of lines and shapes

To learn more about issues discussed in this section, you might want to check out my book *Creative Composition: Digital Photography Tips & Techniques*.

Framing

By definition, a photograph appears within a *frame*—which is to say that the image is bounded and has a boundary. It's important to design your framing to present an interesting view of the world.

The way your image is framed should complement—rather than compete with—the rest of your composition. Essentially, your framing puts the world within a rectangle. You should consider why the particular rectangle you've chosen is interesting, whether your choice of rectangle

is as compelling as possible and how the framing rectangle relates to the elements within your composition.

When you are thinking about the black and white composition of a photo, you cannot ignore the frame and create a successful image. I'm not talking about picture frames here, but rather the edges of the photo.

Black and white composition requires a particularly forceful approach to framing—because there are fewer compositional elements to play with than in a color composition. In addition to featuring an interesting view of the world, strong framing often divides the frame, or presents a frame within a frame. The two effects can be combined for more compositional power.

Here's how it works: frame division focuses compositional elements into different discrete areas—for example, shadow and light. Dark areas that are in shadow contrast with bright areas that are well lit and combine to create the formal composition.

Often the elements used to divide frames are exclusively horizontal, or vertical—

▶ On snowshoes in a storm, I climbed to Vernal Falls in Yosemite Valley. As I approached the waterfall, the storm lifted. Everywhere I looked, the scene was magnificent. While the scene was one to savor, I knew that to create a striking photo I needed to frame an interesting "slice" of the view in front of me. I decided to use the relatively dark pine trees dusted with snow as a "frame" to show the white waterfall behind the trees as a contrasting compositional element. This both divides the frame of the photo vertically and creates the effect of a frame within the frame.

200mm, 1/800 of a second at f/5.6 and ISO 200, hand held

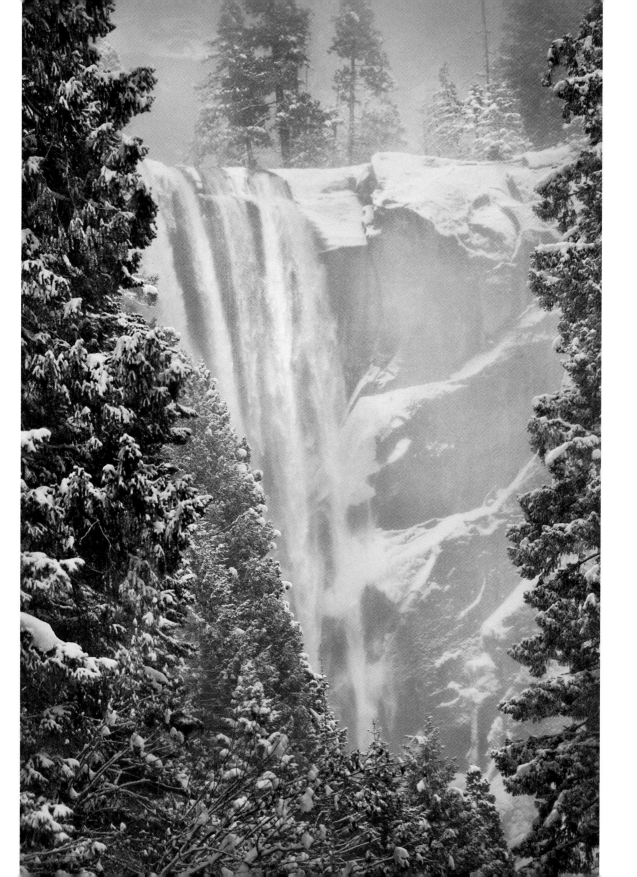

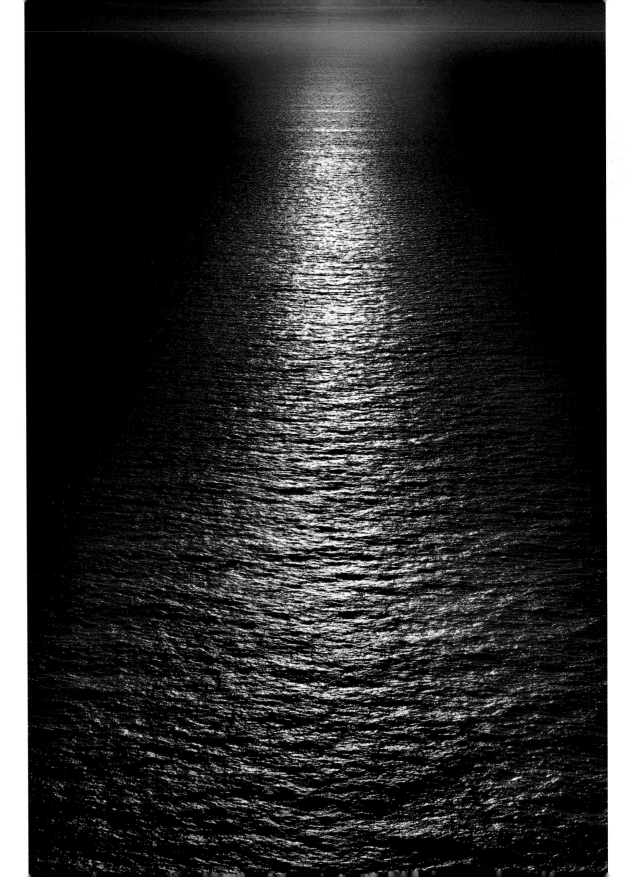

although diagonals can also be involved.

A frame within a frame uses elements within a photo to construct a virtual frame within a composition. The virtual frame can be literally created by causing the viewer to "look" through a window of some sort. Alternatively, the inner frame can seem to be a natural consequence of the shapes of the composition.

When frame dividers also serve as an inner frame then you get the power of frame division and of having a frame within a frame. For example, in the photo on page 63, the window inside the image acts as a frame within the frame.

When you are pre-visualizing your black and white compositions, you should also think about the role framing will play. It pays to make the most use of framing possible, and to see if you can maximize the power that good framing brings to any composition.

Patterns

In photographic composition, a visual pattern is a repetition of similar, or essentially similar, shapes that combine to create a pleasing whole. Patterns are an important part of how we perceive the world and can add to the power of black and white compositions.

◀ Sunsets are usually seen, pre-visualized, and presented photographically in color. With this image, I decided to take up the challenge of creating a visually interesting sunset image in black and white, using only the simplest visual elements: the sunset's reflection on the ocean and the shadows framing that reflection.

The delicate lines of the horizontal waves play against the predominant dark diagonal lines of the shadows in this composition. The demarcation between shadow and light works as an effective frame divider.

50mm, 1/640 of a second at f/11 and ISO 100, hand held

Patterns are made up of lines and shapes, and can occur at many different scales. In black and white, the most important aspect of a pattern is the repetition of a specific variation in contrast.

It's interesting to consider the end of a pattern. A pattern that goes on forever is not all that interesting. On the other hand, many patterns don't continue infinitely. Therefore, there must be an end to the pattern, either present in the photograph or visually implied. Some of the most interesting black and white compositions that rely on patterns use the pattern boundaries to combine the impact of the pattern and the way the pattern interrelates with the frame.

Lines

Black and white photographs are made up almost exclusively of lines and shapes. Lines connect points and enclose areas to create shapes. The edge of a shape is a line. So lines and shapes are related, but for a moment consider the simplicity and occasional complexity of a line itself.

A line moves across a composition in one of several ways: it is horizontal, vertical or diagonal. Lines themselves can be curved or straight. Curvilinear lines are different from straight lines. Lines have width. They have brightness: you can have a dark line on a white background, or a light line on a black background. A simple line can be a most expressive thing!

Lines are particularly compelling in monochromatic compositions. When you are shooting for black and white, look to see how the lines in your compositions interrelate; and look to see what you can do to strengthen the way those lines express emotion.

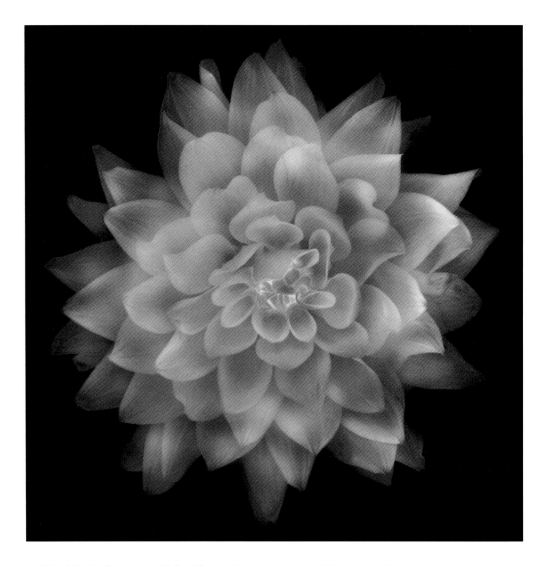

▲ This white Dahlia was essentially without color, so it was natural that a monochromatic image should occur to me. In considering the composition, I realized that the flower was symmetric, creating a strong natural pattern with whiter inner petals contrasting with the grayer petals nearer the perimeter of the flower.

In addition, the shape of the flower resembled a kind of starburst. This shape could be effectively contrasted with a square, black photo frame.

85mm macro, 20 seconds at f/64 and ISO 100, tripod mounted

▶ The rough quality of the broad lines formed by the shadows of the seeds contrasts with the delicate lines of the seeds themselves, making for an interesting black and white composition.

85mm macro, 1 second at f/51 and ISO 100, tripod mounted

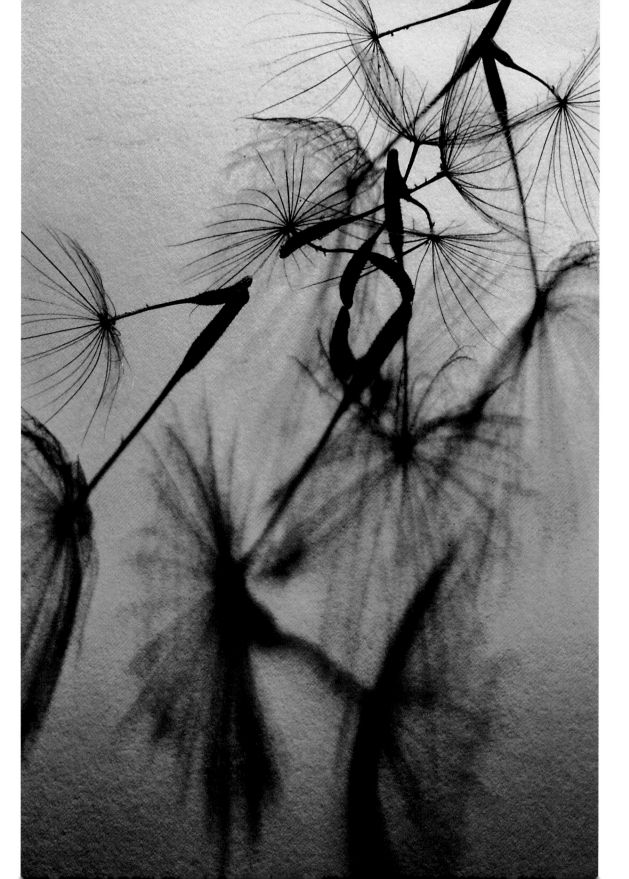

Shape and Form

How do you know when the shapes and forms in your black and white composition will be effective?

The best way to pre-visualize the impact of shapes on your photos is to practice separating form and function. In other words, try to forget about the subject matter of your photo as you abstract a composition from the shapes in front of you.

True, in an ideal world, form should follow function, and the two should be inextricably partnered in a dance that will last as long as we have material things. But as a practical matter, if you keep what something *is* too much in mind, then that very "is-ness"—the function of the object—will intrude into your vision and overlay issues of pure form.

In fact, some of the most startling black and white compositions occur when the form portrayed in the image appears very different from the function of the object in the photo—or at least unusual, in the sense that the form isn't usually associated with the object.

When I'm pre-visualizing an image, one part of my work is to ignore the meaning and function of the actual object or scene in front of me. I look for formal components such as framing, lines, and shapes.

Sometimes I have a hard time looking at things in such an abstract way. When this happens, I find that I can amuse myself by inventing alternative scenarios. I picture the image in front of me as belonging to an alien, possibly absurd universe. I try to invent humorous stories about the objects.

If I can succeed in inventing plausible alternatives, then it is very likely that I can sit back and "cancel out" both this everyday world and my invented alternative. With no points of reference to connect the objects or scene in my photo to "thingness"—the physical reality and function of the actual world—I am able to create visual constructs that use shapes as compositional building blocks and create forms that are fluid and graceful.

▶ Split chambered Nautilus shells have been the subject of classical black and white photography for many years (see page 13 for another example of Nautilus shell photography). Up close, as this macro image of a Nautilus resolved in my viewfinder, I no longer saw a shell; but rather the curved deco lines of an elegant sapling tree.

200mm macro, 6 seconds at f/36 and ISO 100, tripod mounted

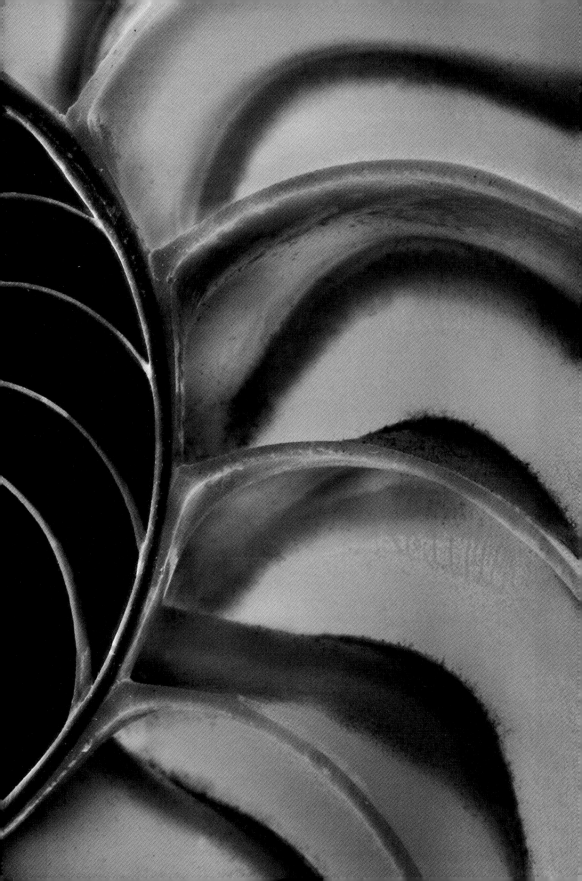

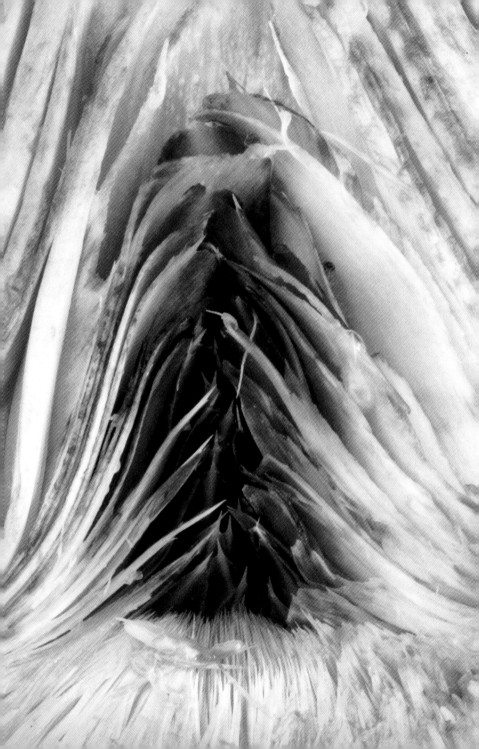

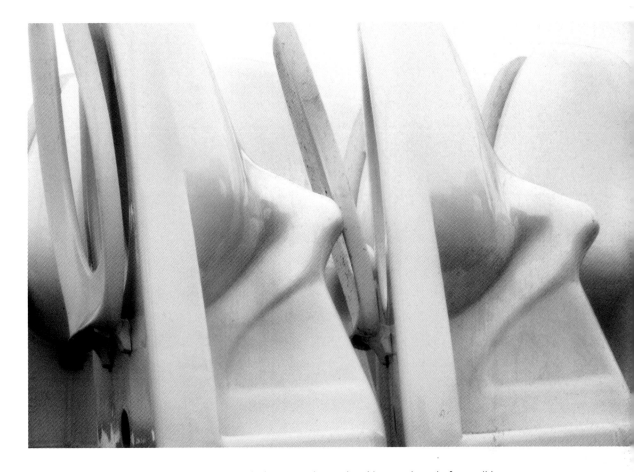

▲ Near where I live there's a special recycling yard where many interesting things are brought for possible reuse. The bulk of the stuff you'll find there comes from home renovations. When I saw these toilets in a row, I made my mind blank. Without preconceptions, I didn't see plumbing fixtures and toilets, but rather a chorus line kicking up their heels! I blinked my eyes and visions of shapely legs vanished. But having seen an alternative reality I was better able to concentrate on combining the shapes that were in front of me in a pleasing way.

85mm macro, 0.1 seconds at f/64 and ISO 100, tripod mounted

◄ Artichokes are good to eat, and they are also an occasional subject of classical black and white photography by Edward Weston and others. In my studio, artichokes proved to be a surprisingly difficult subject because they turn brown quickly after they are cut open. But I was enchanted by the interplay of lines and forms when the center of the artichoke was examined closely. I had to persevere through a number of "models" to get this image.

85mm macro, 30 seconds at f/45 and ISO 100, tripod mounted

High Key

I've already noted that black and white photography from a formal perspective is largely about the contrast between lights and darks (see pages 30–39). Powerful black and white compositions often require very dark blacks and very light whites—both in the same image.

It's interesting that the opposite approach can also work well.

High-key photos are predominantly white, bright, and can be characterized as overexposed. Low-key photos are largely black, or dark—and can easily be considered underexposed (see pages 44–47). In these images, the single key predominates. Particularly with high-key imagery, there is seldom very much contrast at all.

To create a high-key image, look for a subject that is well lit and quite bright in tonal values. You may think this goes without saying, but if you look around, you may be surprised at how few compositions actually meet this requirement.

A high-key composition as a whole may work best if it operates by intrigue, mystery, and indirection. In some ways it may not matter that much what your actual subject is since high-key compositions can be built around many different kinds of subject matter. You should look for simple, evocative, subtle lines and shapes that evoke a sense of wonder in the viewer.

High-key effects can be created in post-processing, although these after-the-fact techniques will not be appropriate for all photos (see pages 142–147).

It's best to shoot with high-key in mind. This means overexposing. It's okay to bracket by shooting many frames at different exposures. That way you can pick the exposure that works best. I bet you'll be surprised by how far to the overexposure side a high-key image needs to be. So don't be timid about your overexposures when you are going for a high-key effect.

With a properly lit high-key image that is already creatively overexposed, exotic and attractive, you can proceed to use the post-processing techniques explained later in this book to amplify the impact of the effect.

▷ The actual subject of this photo is the shapes underneath a somewhat dirty toilet bowl in a salvage yard. A high-key exposure reduces this subject to a single, curvilinear line that meets soot on the upper right. I overexposed to eliminate the extraneous detail in the white areas of the photo.

The photo becomes about its composition, and the associations that a simple line can evoke—with the subject matter forgotten and irrelevant.

85mm macro, 0.1 seconds at f/64 and ISO 100, tripod mounted

▶ I set this vase and flower up on a white seamless background and lit the flower using a single light source to create an interesting shadow. Then I intentionally overexposed it to create a high-key, evocative, and dreamy effect.

55mm, 1/2 second at f/32 and ISO 200, tripod mounted

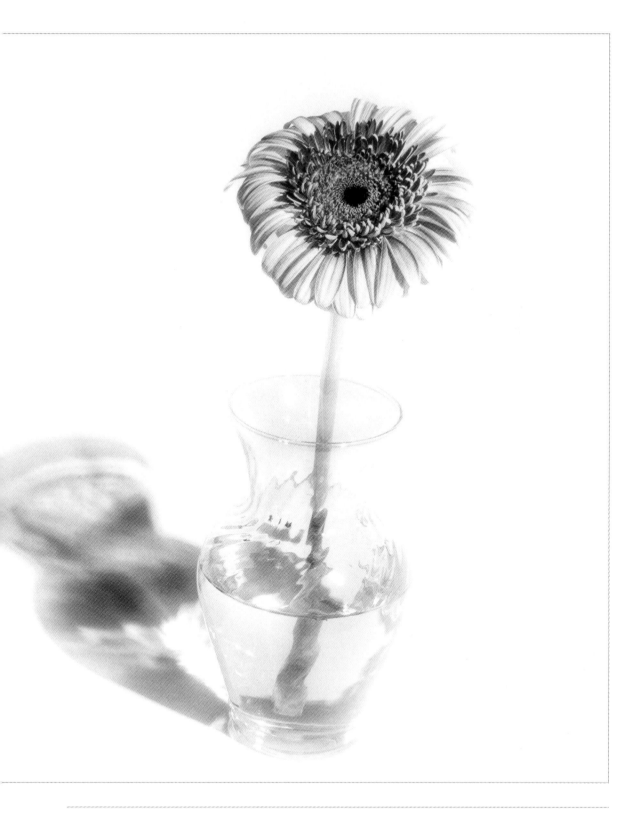

Low Key

While a high-key photo is predominantly presented in white and light tones, low-key images are mostly very dark or black. When this kind of image works, it is because the darkness that encompasses most of the photo focuses attention on the areas that are not dark, providing a sense of mystery.

Low-key imagery tends to work because it is human nature to replace the mystery of darkness with imaginary scenes or objects.

To make this kind of image, you should look for an overall dark scene. In addition to a pervading sense of darkness, the scene needs to be lit with intermittent light. In an effective low-key image, one area of interest can specifically be lit; for example, the eyes in a portrait on a black velvet background, or a shaft of moonlight.

Alternatively, there can be lighting more spread out across a generally dark scene. In this case, it's often effective to look for *chiaroscuro*—moody lighting that shows contrasts between shadows and brightness.

Post-processing techniques can help you create a low-key image after the fact (see pages 148–153). However, it is very desirable to start with a photographic subject that is appropriate for low-key treatment.

You should look for subjects that are largely dark with intermittent illumination of significant features, or specific areas lit either by direct light or using chiaroscuro.

As with high-key imagery, it's desirable to bracket exposures, because a good creative low-key exposure may register in your camera's light meter as surprisingly under-exposed. Essentially, you want to expose for the lit part of your composition—and let the rest of the image go completely black.

Be careful to avoid an average light meter reading as the way to judge the brightness of a low-key scene. Since you really don't care how dark the black background gets in these images, it's best to take a spot meter reading of the lit areas of your subject.

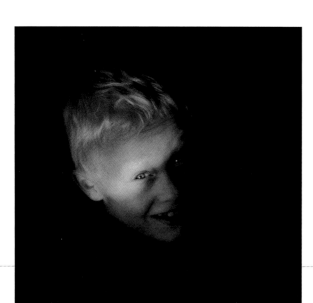

◀ A shaft of light illuminates this boy's face in an otherwise dark background, creating an interesting portrait.

200mm, 1/200 of a second at f/5.6 and ISO 100, hand held

▶ I shot this hand-held night shot at a high ISO (3,200), and planned a low-key exposure based on the brightness of the moon. This exposure would capture the moon and moonlight reflected on the water crisply while letting the surrounding ocean and sky go black.

65mm, 1/30 of a second at f/5.0 and ISO 3200, hand held

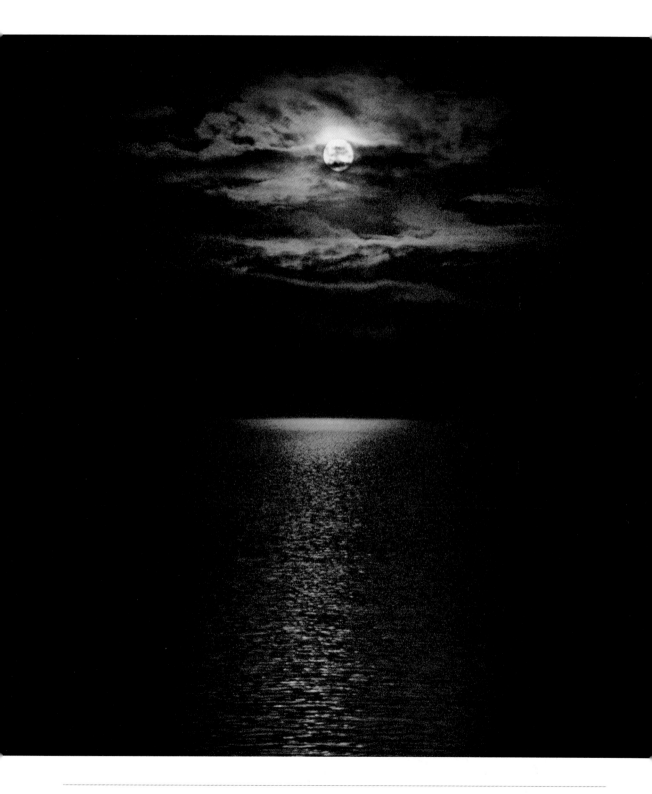

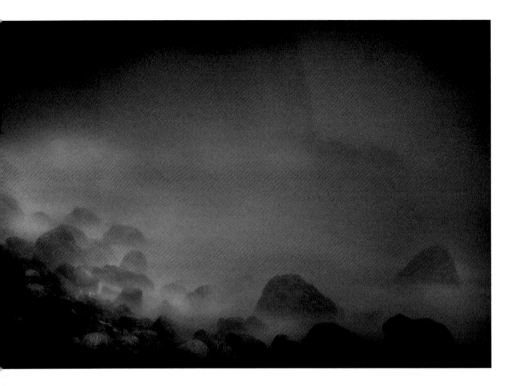

▲ I intentionally underexposed this near-night scene of waves pounding at the surf to create a low-key, mysterious image.

48mm, 30 seconds at f/22 and ISO 100, tripod mounted

▶ The intermittent lighting and significant underexposure relative to an average light meter reading contributes to the moodiness of this low-key tidal scene.

18mm, 1 second at f/5.6 and ISO 100, tripod mounted

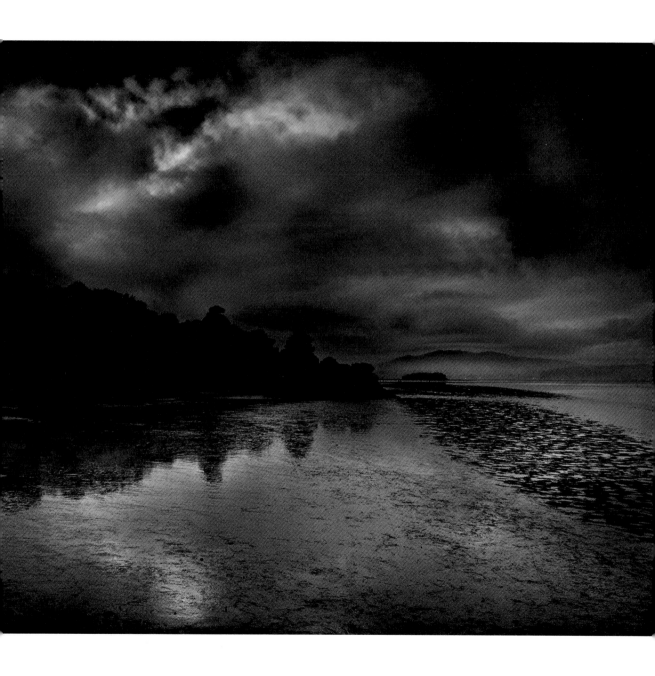

Shades of Gray

By definition, every black and white image consists of a range of grays. I've noted that the majority of black and white photos work by contrasting dark against light (pages 30–39). These darks and lights are shades of gray, of course.

High-key images, consisting of a subtler shade of gray, work with the tones towards the lighter end of the scale (pages 40–43). Low-key images primarily use the dark tones on the grayscale (pages 44–47).

Yet another effective black and white strategy is to employ midtones as the predominant compositional element. These compositions use midtone gray values to work together in an endless compositional dance. The nearness of tonal values means that there are relatively few sharp breaks in a predominantly midtone gray composition—you won't find many hard black forms or white areas that are highlights.

When a midtone gray composition works, it is because the eye looks to the subtlety of the relationship between the tonal grada-

tions. So when you are considering this kind of composition, be careful to present tonal values that work well together.

You should look for subjects that present intricate patterns of grays working off one another. Do not expect the drama of a dark shape against a light background, the Zen simplicity of lines in a high-key setup, or the unrelenting angst of a low-key photo. The virtue of the grayscale is a virtue of subtlety.

As opposed to high-key and low-key imagery, midtone photos should be captured so they are neither underexposed nor overexposed. To achieve this kind of "just right" Goldilocks exposure, consider using your light meter set to average the scene.

If what you see in front of you tends to be a little dark, you may have to lighten things a bit with your exposure. Conversely, if things seem too bright you may have to underexpose slightly to damp things down.

▶ My goal in creating this image was to emphasize the interplay between the feathery lines of surf and the hard edge of the shore. While the left side of this image is quite dark, the real visual interest in the photo is how the surf works in midtone grayscale with grays overlapping and competing against each other.

170mm, circular polarizer, 1.6 seconds at f/32 and ISO 100, tripod mounted

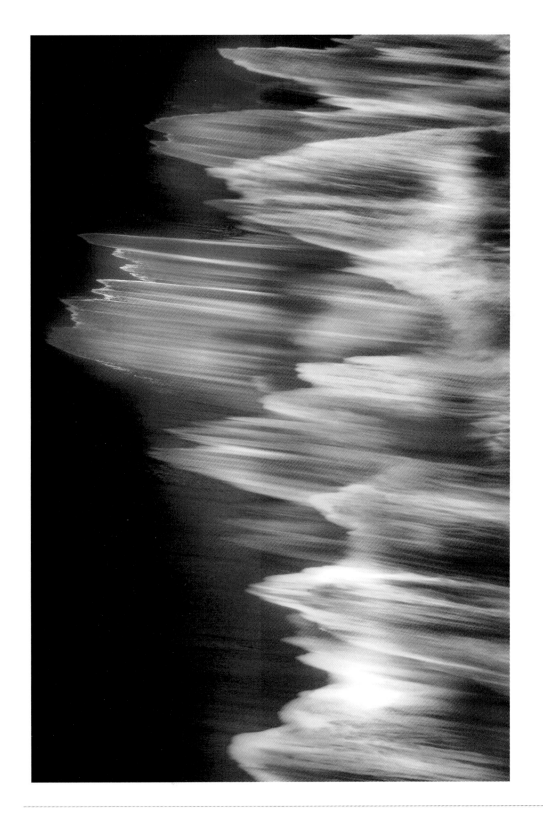

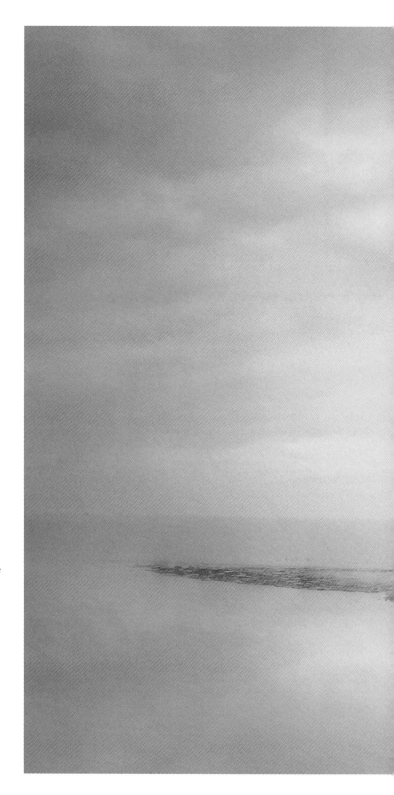

▶ In this photo, a lonely islet in San Francisco Bay appears to be much darker than the surrounding water and sky. But this is to some extent an illusion. In fact, none of the grays in the image are very dark—and the entire photo has a low tonal range, almost biased towards the high-key except for the great tonal range of grays.

A viewer who spends some time with this photo will be intrigued to pick out details such as the reflection of the tree on the island and the lit boat in the background—which at first glance appears to be a fairly featureless gray.

18mm, 2 seconds at f/8 and ISO 100, tripod mounted

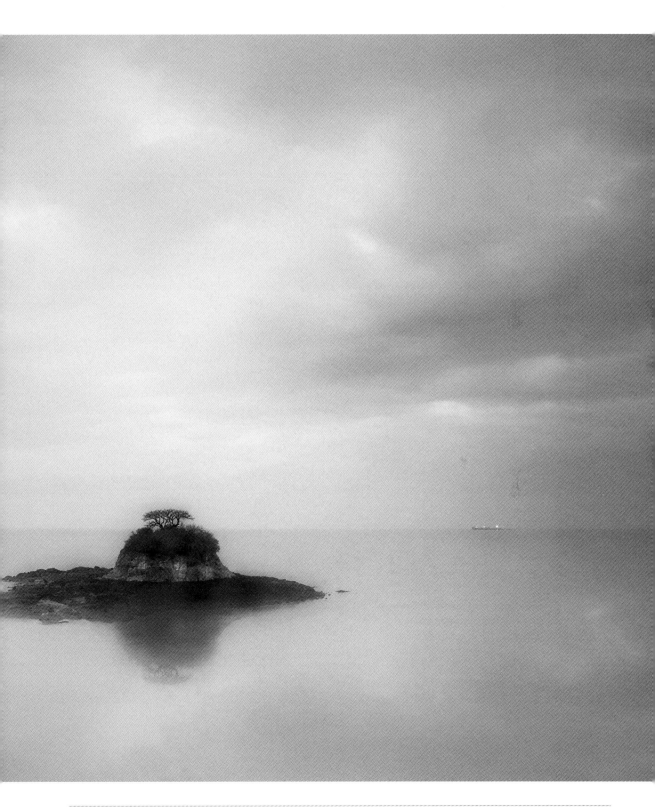

Finding Monochromatic Subjects

There are as many different things to photograph as there are photographers. A good photograph uses the world around us and the human way of visual perception, and filters these elements through the consciousness of the photographer and camera and lens to create a new way of presenting the subject matter photographed.

People, places, and things are all grist for the photographer's mill—whether presented in an overall environment or isolated in a different context.

Either way, the range of black and white photographic subjects isn't that different from what you might take photos of in color. But there are two additional factors you need to consider:

- The tonal contrast on the grayscale

- The artifice of presenting the world without color

There are many different degrees of tonal contrast. Some monochromatic images rely on extremes of tonal contrast (pages 30–39): high-key black and white photos make their point solely using the tones on the lighter end of the grayscale (pages 40–43); low-key photos are at the darker end of the grayscale (pages 44–47).

However, some images primarily rely on the interplay between midtone grays for their appeal. You should consider your strategy in relation to these options to create successful monochromatic photos, since the grayscale is so important to black and white imagery.

Make a choice, then expose and process your image to back it up. If one of these choices is not feasible, then it is possible that your image is not the best choice for black and white.

Photography was once entirely monochrome, but of course this has not been true for a long time (see pages 12–13). One consequence is that digital black and white images can look artificial. If you're not careful, instead of enjoying your image the viewer will be asking the question, "Why is this photo being presenting in black and white?"

The image should itself present a compelling visual reason why it is monochrome. Here are some possibilities:

- The graphic content of the image is clearer without the distraction of color.

- A great contrast is being presented between darks and lights.

- Shadows play a big role in the image.

- The subject matter of the image is in some way old-fashioned or anachronistic.

Perhaps you can come up with other reasons why presenting your photos in black and white is a good idea (but please understand, "I just love black and white!" may not count).

If you have a general idea of the kind of subjects that work well with black and white, you will be able to find monochromatic images in many places.

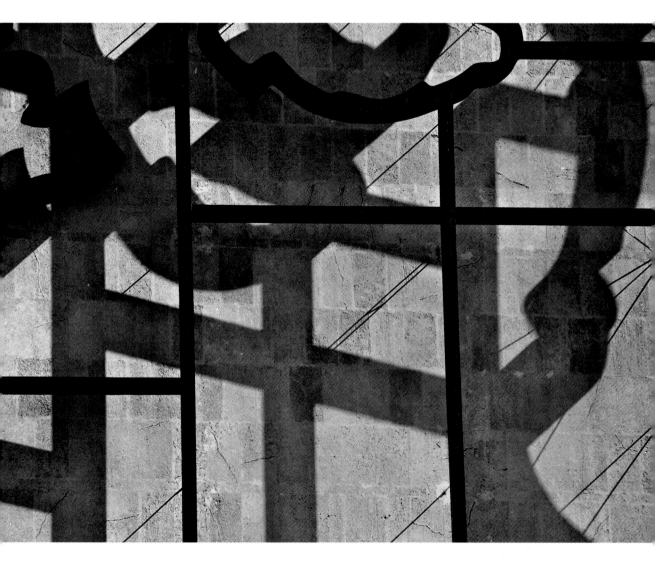

▲ In Revolutionary Square in Havana, Cuba many photographers concentrate on the big picture—in this case the huge wire sculptures showing the heads of Fidel Castro, Che Guevara, and other revolutionary leaders. But looking at the wire sculpture of Che, I was struck by the way the strong tropical light created a pattern of shadows and lines formed by three elements: the wire sculpture itself, built several feet out from a building façade; its shadow; and the supports holding the wire sculpture in place.

I used a telephoto lens to photograph a detail of the Che wire sculpture. A polarizer helped to adjust the contrasting light in the image so the difference between the various elements was stronger.

130mm, circular polarizer, 1/320 of a second at f/9 and ISO 100, handheld

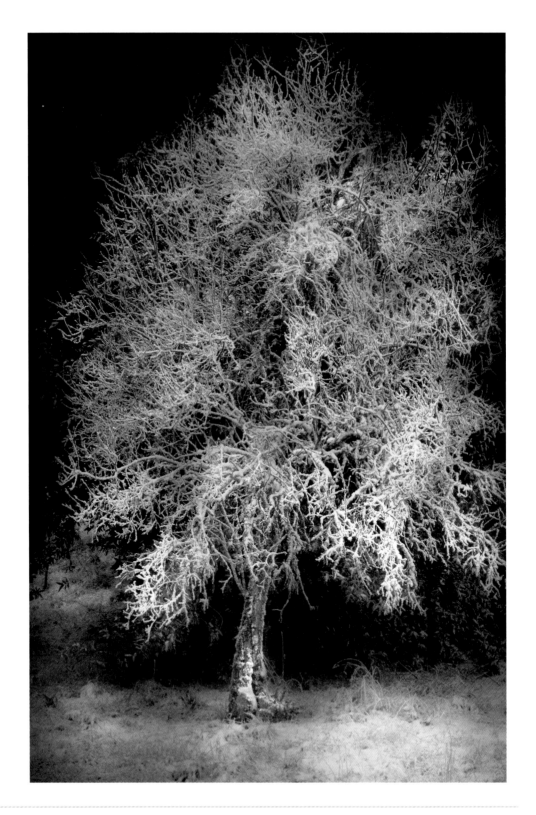

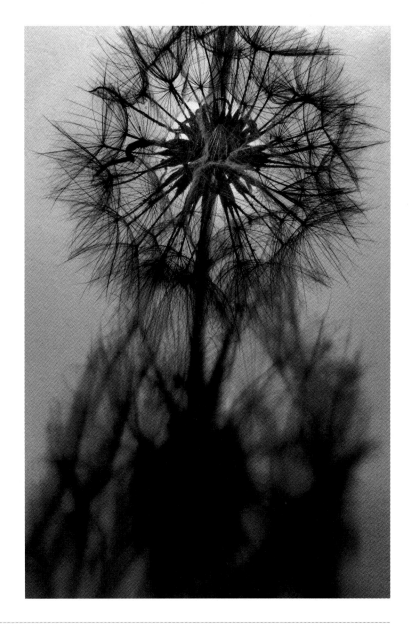

◀ I made this photo during a freak snowstorm in the California coastal range hills. This tree was lit with subdued sunlight in a nook with towering dark fir trees behind. I intentionally underexposed to let the background go dark, and to bring out the contrast between the white branches and the dark background.

62mm, 1/250 of a second at f/14 and ISO 200, hand held

▶ The point of this photo is the relationship between the flower gone to seed and its shadow. I used a direct, harsh light behind the flower to create the strong shadow, and positioned my camera below and to the left, taking care to avoid pointing it directly at the light.

85mm macro, 8 seconds at f/51 and ISO 100, tripod mounted

Black and White at Night

It's often not recognized that photography at night can produce wonderful results in black and white. As is generally true with black and white, if color is important to an image, it will work no better at night than in the day. In other words, spectacularly colored star trails do not work in the absence of color. At night, black and white requires strong composition with considerable contrast between light and dark areas.

When I consider photographing at night in black and white, I'm looking for scenes that have a strong compositional appeal. In addition, the absence of color should add to the viewer's appreciation of the scene. Someone looking at a black and white photo should think they know or feel some-thing unusual about the scene presented. Perhaps there's a sense that colors are more vivid than they would actually be if

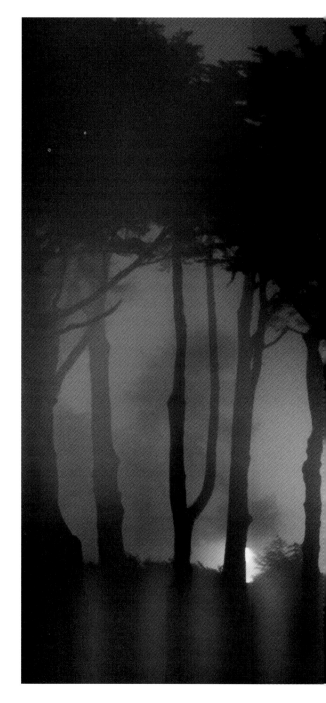

▶ I came to photograph the view facing the ocean, but it was totally obscured by the fog. Turning in the other direction, I saw intense, orange street lighting coming through the trees on the other side of the parking lot.

I knew this image would not work in color, because the quality of the street lights was very orange and made the scene look muddy. However, the shadows created by these lights towards the bottom of the row of trees were extremely visually intriguing. Here was a perfect situation for black and white at night!

56mm, 52 seconds at f/4.8 and ISO 100, tripod mounted

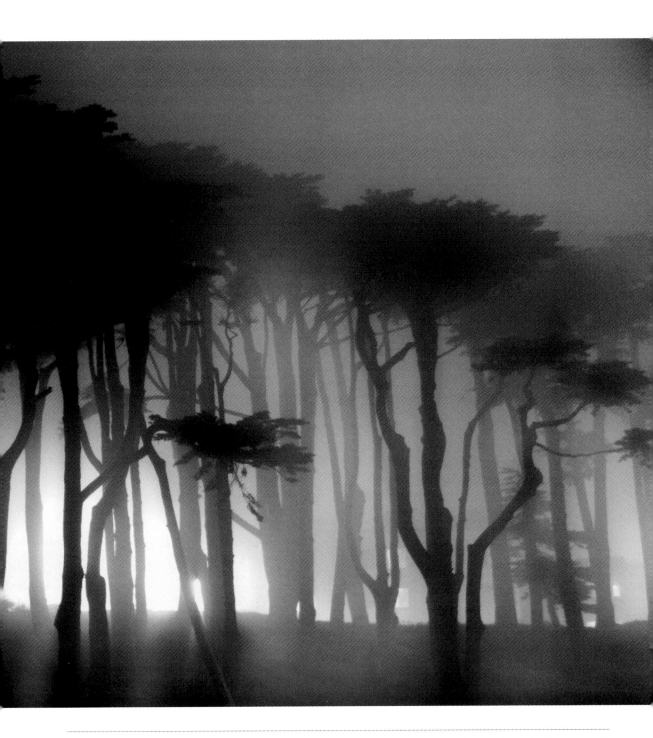

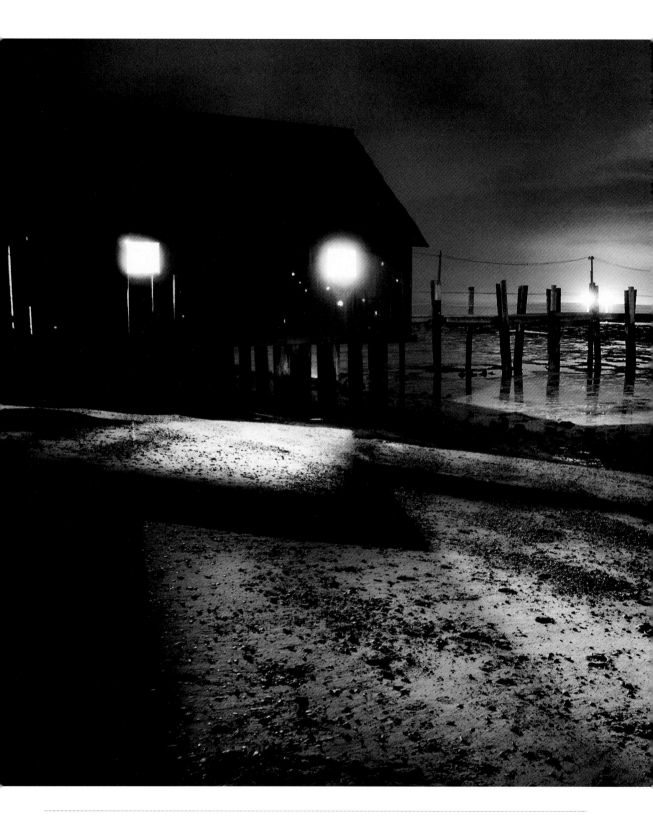

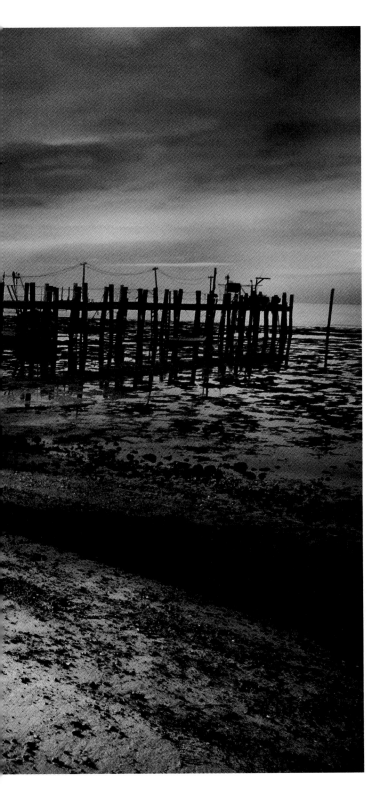

the photo were seen in color. Or maybe there's an edge to the image that makes the viewer wonder about what they are seeing.

Wandering in the night, we are without the sense of clear sight that we usually rely upon. This causes many people to feel that they are adrift in a strange environment.

Small noises can cause anxiety. Wind whistling through trees can sound like a howling gale. Phosphorescent eyes staring from a forest's edge can be creepy. Black and white photos can pick up on this perceived anxiety, and produce images that are thought provoking and keep viewers on their toes.

◀ In color, the clouds and ocean at low tide were quite attractive in this early night scene. But the whole scene looked much too friendly. Converting to black and white brought out the sinister aspects of this composition, and also amplified the difference between the light coming from the windows in the beach shack and the textured shadows cast by this light on the beach.

18mm, 30 seconds at f/4 and ISO 200, tripod mounted

Portraits in Black and White

"Character is destiny," wrote Greek philosopher Heraclitus back in the fifth century BC. And what better way to see character than to observe the lines of someone's face?

As I've previously noted, in the absence of color you have shapes—and lines. Therefore, black and white emphasizes lines and portraits created using black and white can show character at a deeper level than those in which the structural issues are masked by color.

For these reasons, black and white portraits can stick in our memory and stay with us as powerful statements of character. Color photographs of celebrities and movie stars are often glamorous. Black and white can be glamorous too—think of movie star portraits of the 1930s—but more often black and white seems to tell the truth, and to present the underlying character of its subject.

When I take a portrait, my goal is to attempt to reveal the character of the subject. Just as with a landscape, I am doing my job right when I marry the craft and technique of photography with the subject.

Like landscapes and other subject matter, black and white portraits can predominantly involve contrast, or make their compositional point by being high-key, low-key, or by featuring the interplay of gray midtones—all formal concerns.

No matter what the subject, your choice of black and white treatment impacts the emotional response to the subject matter. In the case of portraiture, a decision about rendering will "color" the viewers response to the person shown.

High-key portraits usually show happy people in fun situations. Dark, low-key and high contrast portraits show characters who have led interesting or dramatic lives, or who may be involved in emotionally charged situations.

◄ This essentially high-key portrait shows the affectionate nature of the portrait subject.

200mm, 1/160 of a second at f/6.3 and ISO 400, hand held

► The low-key interpretation of this portrait of mother and child works well with the chiaroscuro lighting and evokes classical paintings with similar subject matter.

32mm, 1/80 of a second at f/5.6, hand held

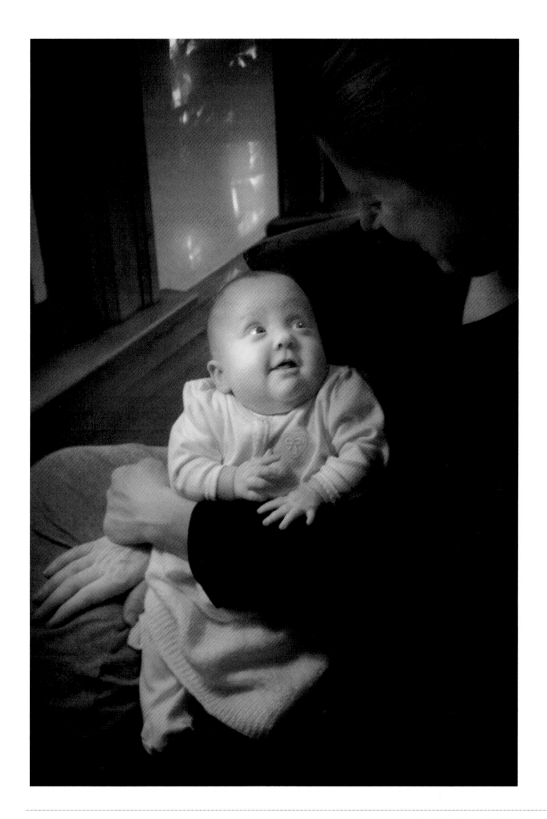

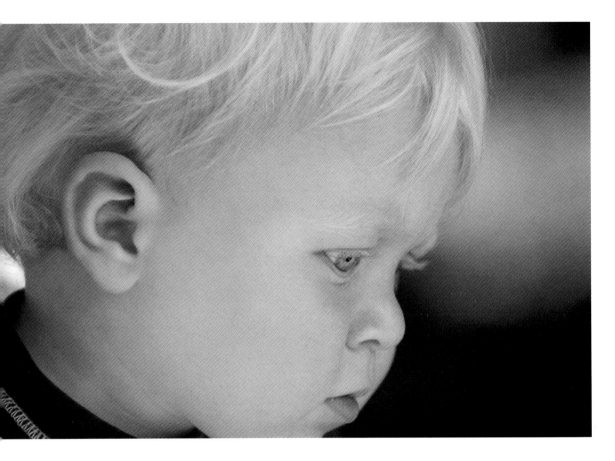

By the way, as adults we grow into the faces we deserve. But even kids with unlined cheeks, untouched as yet by life, have characters. All right, maybe they are characters, too! Black and white photography can help to reveal the inner being of a child just as surely as with those who are more mature.

One can go too far in imputing emotional affect to portraits via the compositional and technical choices made. A child shown in high-key lighting is not necessarily an angel! However, your visual choices regarding monochromatic treatment play a big role in how your portrait subjects will be perceived—and as a photographer it is important not to lose sight of this impact.

▲ You can practically see the neurons firing in this portrait of a contemplative child. I made sure that the midtone grays in the child's face were harmonious with each other so as not to distract from the point of the portrait—the intense look of his gaze.

200mm, 1/320 of a second at f/4.5 and ISO 200, hand held

▶ The contrast between the boy and the play structure he's in helps to make this an interesting portrait. The window opening acts as a frame within the frame of the photo.

18mm, 1/160 of a second at f/6.3 and ISO 100, hand held

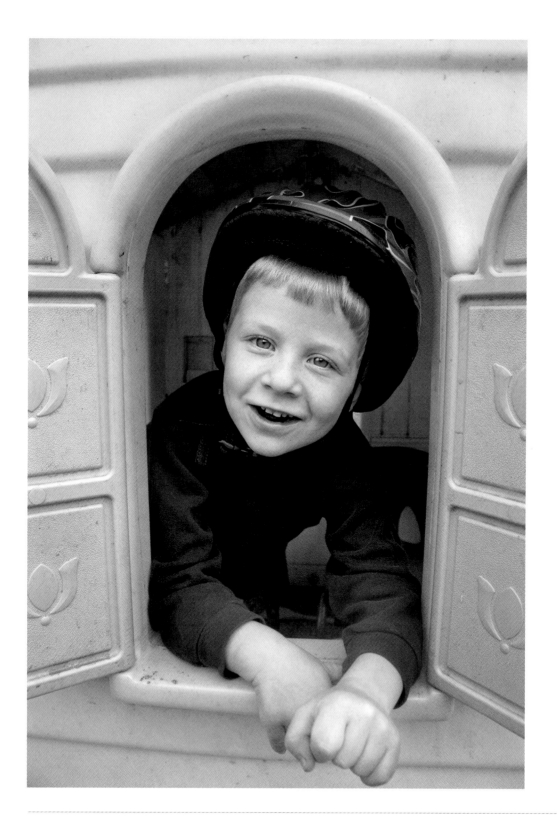

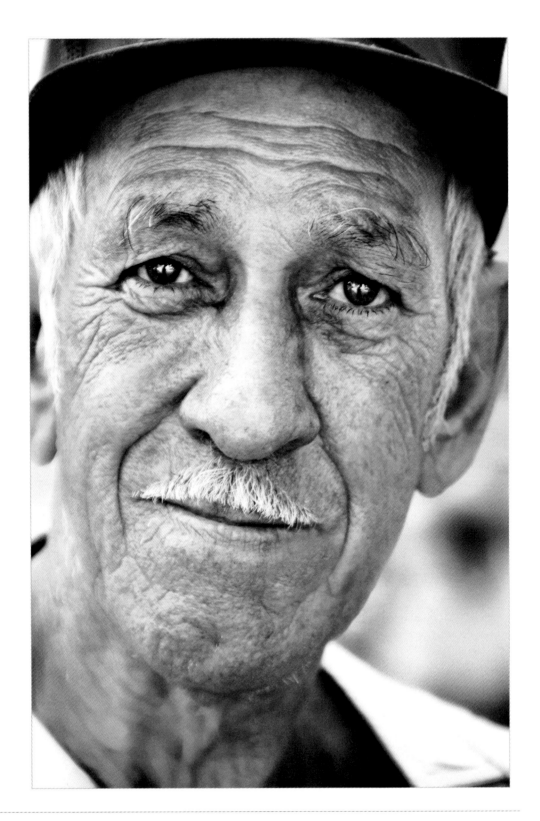

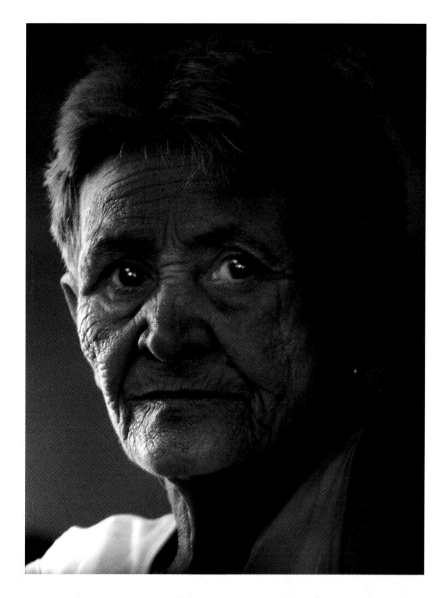

▲ This woman helped to run a coffee shop for tourists in a Cuban ecology reserve. I felt that the lines on her face showed a life that had seen much sorrow, so I photographed her using high contrast, low-key lighting to emphasize this feeling.

170mm, 1/40 of a second at f/5.6 and ISO 200, hand held

◄ I photographed this man on the streets of a Cuban provincial capital. To me, he looks like he's seen a great deal of life, not all of it pleasant—but he retains warmth and a happy outlook on life. The contrast between the relatively dark tones of his eyes and the lighter area of the rest of the portrait help make this image subtly dramatic.

200mm, 1/160 of a second at f/6.3 and ISO 200, hand held

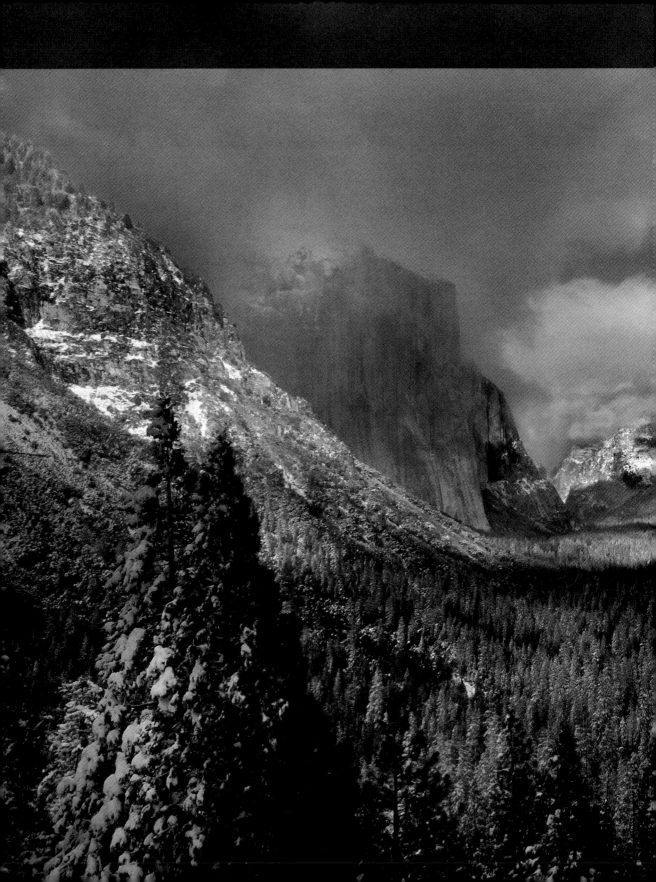

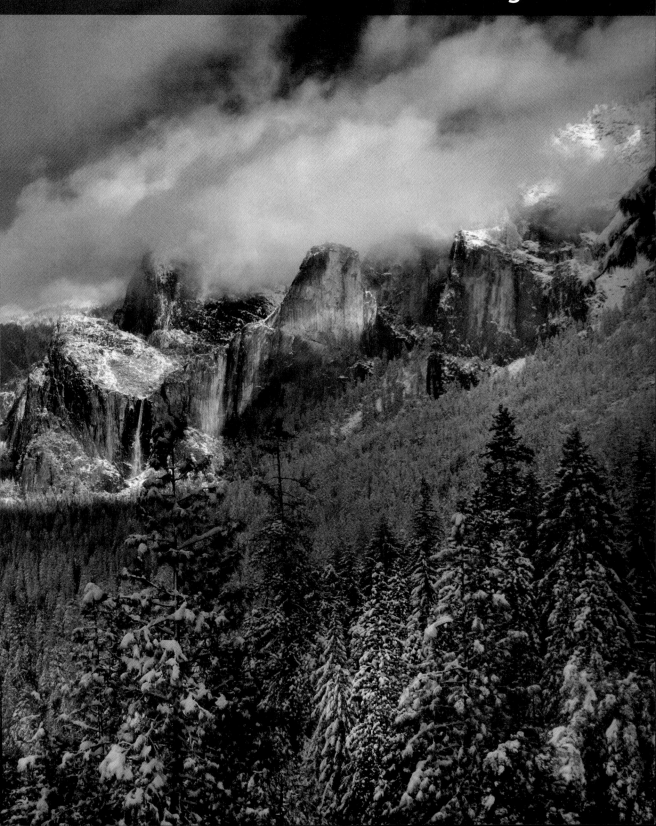

Digital Black and White Roadmap

Creating a digital black and white photograph is an odd act of resistance, anachronism, and artistic passion considering that digital captures are inherently in color. One way or the other, starting with digital and ending up with black and white means discarding the color information in favor of gradations of gray.

It's important to understand that the color information itself can profitably be used as the basis for this transformation to black and white.

There are many paths towards achieving black and white imagery starting with a digital capture. As you might expect, approaches that take more effort in conversion tend to yield better results—this reminds me of the slogan "no pain, no gain." For very simple black and white images, converting JPEGs in programs like iPhoto and Picassa may work fine. But if you want a more artistic approach, you'll have to work harder and get your digital hands dirty.

It's also the case that the vast array of possible techniques for converting a digital capture to black and white can lead to confusion and paralysis. The chart shown below should help you clarify your options so you can get started creating spectacular black and white photos.

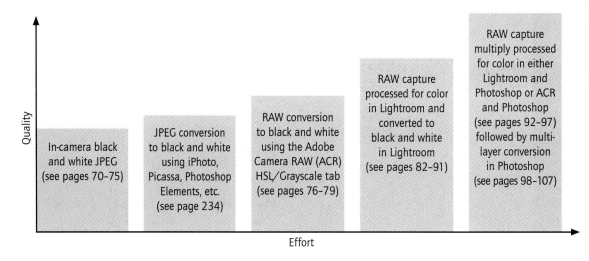

Quality / Effort chart:

In-camera black and white JPEG (see pages 70–75)

JPEG conversion to black and white using iPhoto, Picassa, Photoshop Elements, etc. (see page 234)

RAW conversion to black and white using the Adobe Camera RAW (ACR) HSL/Grayscale tab (see pages 76–79)

RAW capture processed for color in Lightroom and converted to black and white in Lightroom (see pages 82–91)

RAW capture multiply processed for color in either Lightroom and Photoshop or ACR and Photoshop (see pages 92–97) followed by multi-layer conversion in Photoshop (see pages 98–107)

▶ During the years since the revolution, an elegant palace in a provincial capital in Cuba had gone to ruin. I stood at the bottom of a stair in the old palace, and used the contrast between lights and darks to frame an image that I knew I would process to eventually become a black and white image.

In converting the image to black and white, I cropped it to square to emphasize both the darkness of the shadow areas and the comparative brightness of the stair.

10.5mm digital fisheye, 1/10 of a second at f/22 and ISO 100, tripod mounted

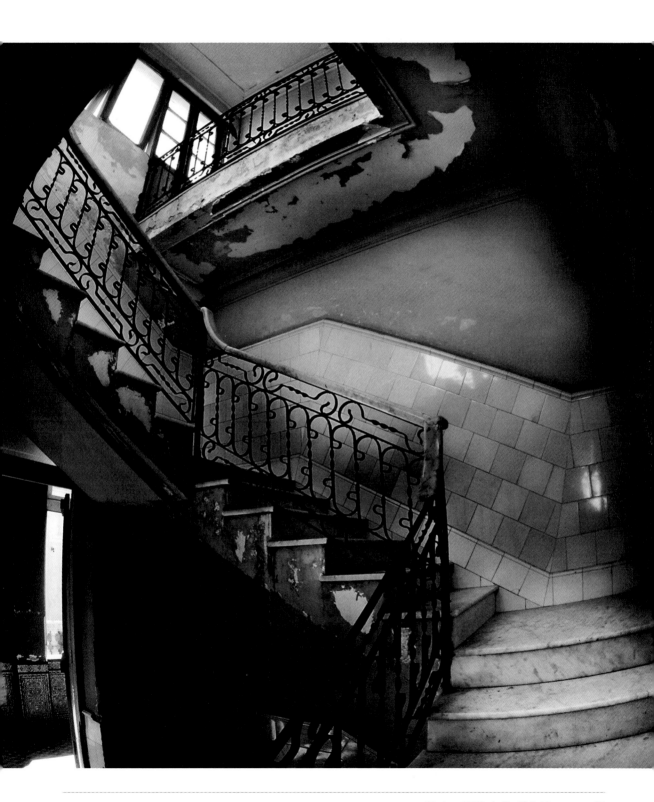

It was a blustery, bright winter day along the outer Marin Headlands, California with big waves rolling in.

I used a fast shutter speed to "freeze" the motion of the waves in place, and a polarizer to boost the contrast between the surf, clouds, and cliffs. I made the capture using my camera's native RAW format, converted the image to color using Adobe Camera RAW (ACR) and Photoshop, and proceeded to use multiple Black & White adjustment layers in Photoshop (see pages 122–127) to create the final version shown on the facing page.

All versions: 32mm, circular polarizer, 1/400 of a second at f/8 and ISO 200, hand held

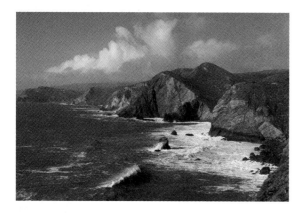

▲ Here's the RAW capture I made, shown using default "As Shot" settings.

▲ For comparison purposes, the in-camera black and white JPEG is shown. It's not bad, but there are not tonal gradations. Depending on your purpose, it may be good enough.

▲ Converting to grayscale in ACR sometimes leads to middle-of-the-road black and white that is fairly flat and does not have great tonal variations.

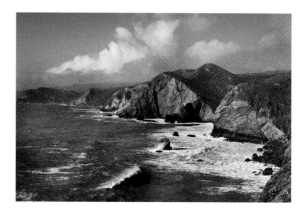

▲ The version I processed into color is bright and shows quite a bit of contrast between light and dark areas.

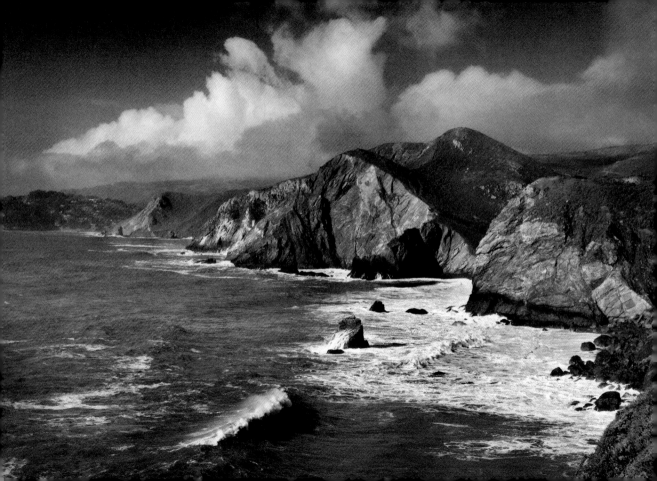

My idea in photographing this exploding wave was to capture the action of the fast-moving surf using a high shutter speed to reveal what it looked like beyond the ability of the human eye to stop the motion of the water. I purposely underexposed so that the details of the water in the sunlight would be crisp, creating contrast between the wave and the shore.

▲ In-camera, I duplicated my capture in black and white to get an idea of what it might look like, but it was too dark.

▼ I also tried the sepia (left) and cyanotype (right) in-camera options as well, but they were also too dark.

▼ None of the in-camera options were satisfactory. Processing the RAW image multiple times through Adobe Camera RAW (pages 108–113) and converting to black and white in Photoshop using a stack of Black & White adjustment layers (pages 122–127) yielded the more interesting black and white work shown below.

130mm, 1/1250 of a second at f/10 and ISO 200, hand held

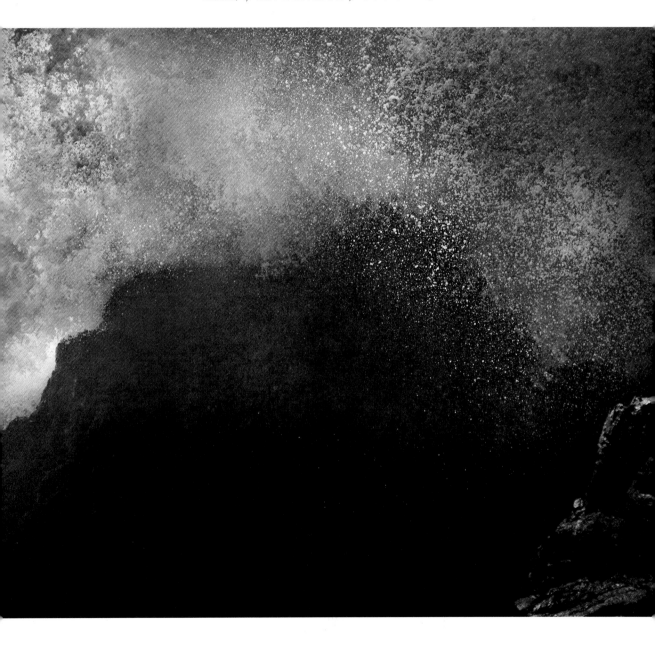

The RAW Advantage

A RAW file is a complete record of the data captured by a digital sensor. The detailed implementation of RAW files varies from camera manufacturer to camera manufacturer, but it is important to understand that a RAW file represents a large number of potential images rather than a specific rendering of the digital bits captured.

Most reasonably sophisticated digital cameras can save their captures as RAW files, although you may have to change the default settings to make this happen. Cameras can also capture images as JPEG files. A JPEG file is a single version of a RAW capture, as interpreted by the camera that can be used without any further work. You can usually set your camera to save both JPEG and RAW versions of a capture at the same time.

The advantages of the JPEG format are that JPEG files are compact and don't take up much space, and that you don't have to do any further work

on these files before they are usable on most computers.

However, if you are interested in creative photography, RAW files give you many advantages. You can use your own ideas of how the image data should be interpreted—for example, how the image should be exposed. Furthermore, if you've chosen to make RAW captures you can process different portions of your photo differently. The exposure and color values do not have to be the same across an entire image. Last, but not least, you are not throwing away much of the data collected by the sensor, as a JPEG capture inherently does.

Fundamentally, the creative advantage to a RAW capture as opposed to a JPEG capture is that you get to implement your creative idea of what your photo should look like—and not be forced to rely on the camera's "brain" to make your final image.

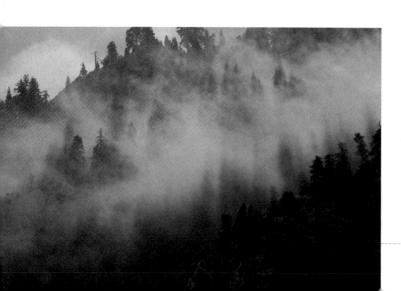

◀ The in-camera JPEG version of this essentially monochromatic shot is nothing special, with the detail on the lower right completely lost.

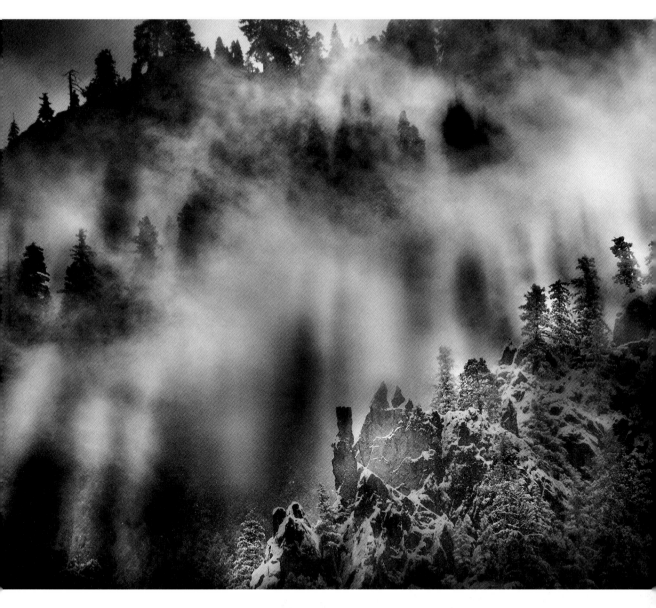

▲ Starting with the RAW file, I multi-RAW processed the image using its color information (pages 108–113), then used a layer stack to convert the photo to black and white (pages 114–133). The result is a black and white image of the mist in the mountains above Yosemite Valley that shows a great tonal range and is far more interesting than the in-camera JPEG version. (See pages 156–163 for more information about extending tonal range.)

Both: 200mm, 1/750 of a second at f/14 and ISO 100, tripod mounted

Black and White in Adobe Camera RAW

One of the easiest ways to gain much of the power of RAW without having to go to a great deal of trouble is to use the Adobe Camera RAW (ACR) grayscale conversion feature. This works best on images that don't have a huge range of color, and are a fairly easy target for black and white conversion.

By way of comparison, I sometimes set my camera to shoot both JPEG and RAW, then drop the color information from the JPEG file (see the examples on this page). This shows me what I *don't* want my final black and white image to look like. You can get far better results from ACR with a few simple manipulations.

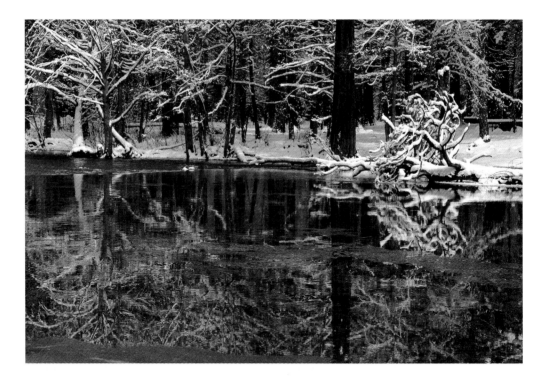

▲ The in-camera JPEG version of this photo isn't bad, but it doesn't have as much brightness and tonal range as it might. Depending upon what you are going to do with the image, the in-camera JPEG might be satisfactory. It certainly takes no effort at all. However, using a JPEG generated by your camera means that you have no control over the aesthetic choices involved.

The point here is that there are many ways to formulate black and shades of gray. Using the sliders in ACR, you can determine how the colors in your photo are combined to create these blacks and grays.

In many situations, this will give you the control you need to create interesting black and white images—particularly if you are not looking for an extended tonal range. In situations where you do need a dramatic range of tones in your photo, it does take a little more work. You'll need to use the tools available in Lightroom and Photoshop to extend the dynamic range in color before you begin the black and white conversion process.

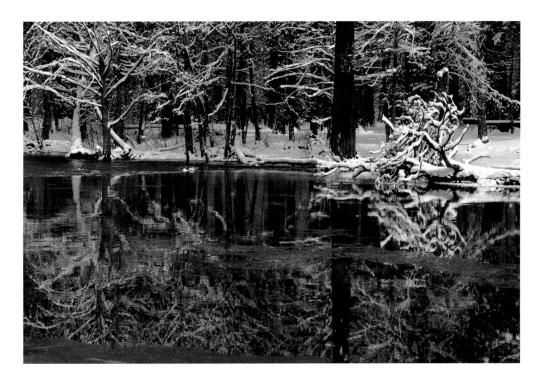

▲ For comparison purposes, this shows the in-camera JPEG version with the color information simply dropped. Yes, it is a black and white image, but it certainly doesn't have a great tonal range nor is it very exciting.

▶ Step 1: To convert a capture to black and white in ACR, start by double-clicking on your RAW file to open it in the Photoshop Adobe Camera RAW (ACR) plug-in.

▶ Step 2: On the Basic tab in the ACR window, use the Temperature, Tint, Exposure, Contrast, and Saturation sliders to enhance the color and contrast in the image. If you compare the first in-camera JPEG version of the image shown on page 77 with the color version shown here in ACR, you'll already see improvement.

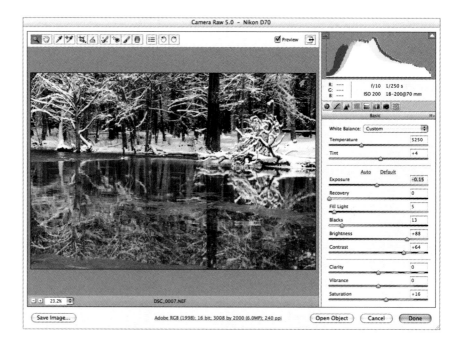

▶ Step 3: Open the HSL/Grayscale tab by clicking the fourth tab from the left in the ACR window.

Put a check in the Convert to Grayscale check box. The default settings on the tab shown here simply drop the color information when the image is converted to grayscale.

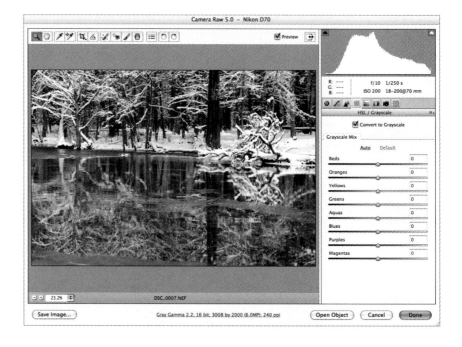

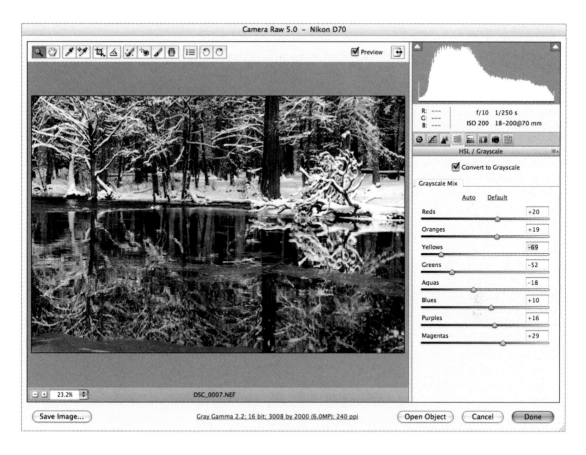

▲ Step 4: Instead of dropping all the color information, you can tweak how the color data in the RAW file is applied during the grayscale conversion. Here I increased the tonal range in the image primarily by pushing the Yellow slider to the left. This decreased the impact of the yellow during the image conversion.

When you are pleased with your settings, click Done. The converted grayscale image will open in Photoshop. You can then further enhance your black and white photo, although you may have to convert from Grayscale to RGB by choosing Image ► Mode ► RGB to access all the functionality of Photoshop.

▼ Pages 80–81: Crunching on my snow shoes across fresh snow in Yosemite Valley, California I came across a pond with still winter reflections. I used a polarizer to maximize the reflections, and a tripod to compose this image, which is essentially monochromatic except for the tree trunks.

I used ACR to brighten the image and increase the contrast, then worked with the ACR grayscale conversion feature to improve the rendition of the image in monochrome. After I converted the image to grayscale using ACR, I worked on the image in Photoshop to increase its drama and tonal range, with the results shown here.

All: 70mm, circular polarizer, 1/250 of a second at f/10 and ISO 200, tripod mounted

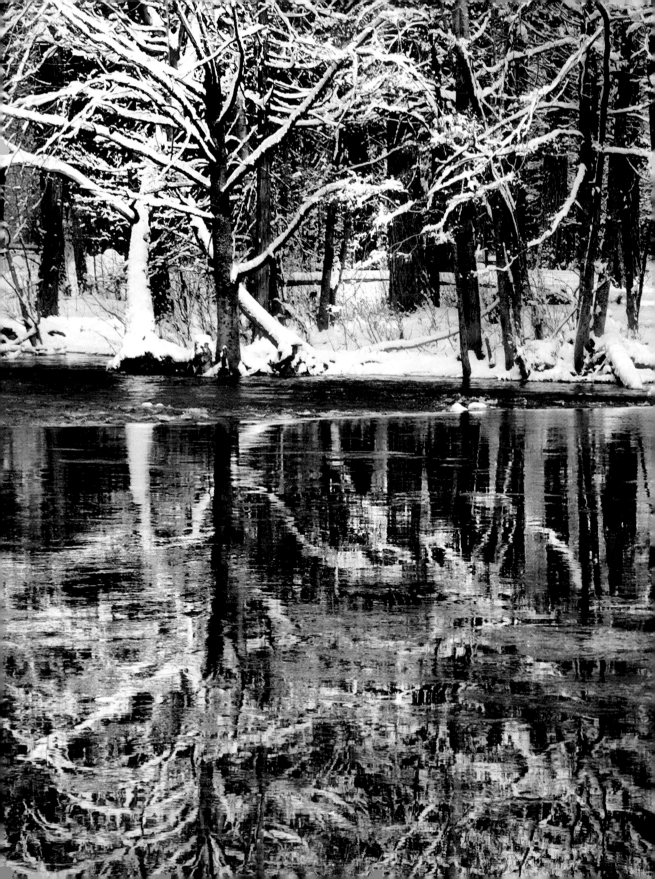

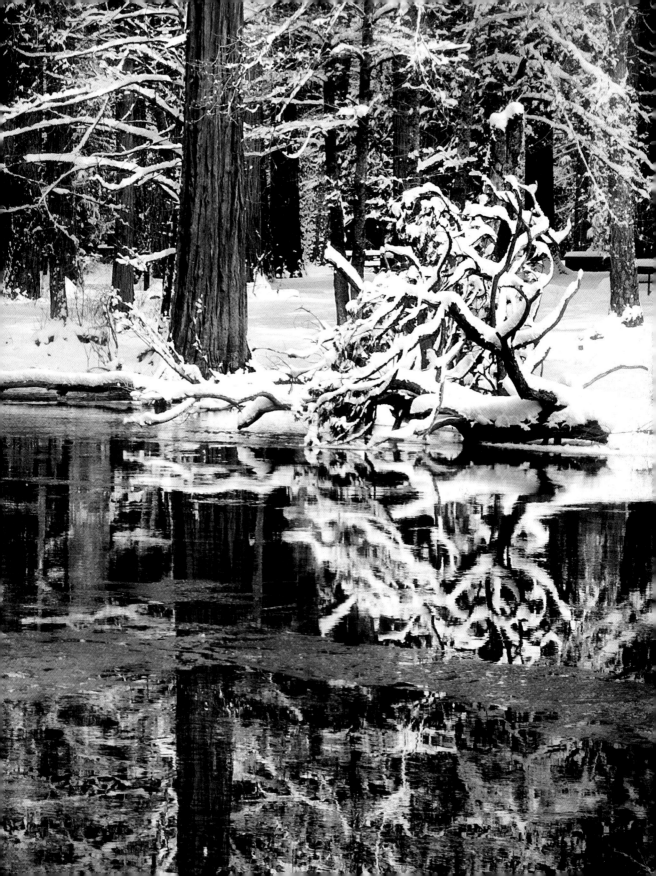

Black and White in Lightroom

Many photographers enjoy using Adobe Lightroom for post-processing their photos because Lightroom provides a simplified workflow and environment specifically designed for digital photography—the program can also produce great black and white images from RAW originals with relatively minimal effort.

Lightroom combines the power the ACR RAW converter, additional developing tools and a great image cataloging system into a very friendly user interface.

The trade-off is that Lightroom doesn't provide the complete pixel-level control of Photoshop. However, there's plenty of ability to process RAW captures into black and white. If necessary, you can edit the results in Photoshop for further work.

For the most part, unless I am processing a great many photos at one time, I use Photoshop to keep complete control of my black and white creative process. However, there are times where the convenient workflow features (Lightroom makes it very easy to keep track of different versions of an image) and the simplicity of obtaining good black and white results makes me sigh with relief when I use Lightroom.

If Lightroom is already part of your digital workflow, as it is for many photographers, then by all means you should incorporate it into your process of black and white conversion. If you are new to black and white image rendition from RAW originals, then Lightroom may be a great place for you to start with your creative monochromatic digital photography.

Grayscale Conversion Using Presets

The easiest way to convert an image to black and white using Lightroom is to simply use the Lightroom grayscale conversion features. This can be done using the Develop module (see HSL Conversion starting on page 86) or when in the process of importing a RAW image, as shown on page 83.

By way of comparison, the RAW image processed at default "As Shot" values is shown to the left.

◀ When I inspected this image before importing it, I felt it would be a good candidate for preset conversion because of the overall acceptable exposure without great ranges.

▼ Step 1: When you import a RAW file into Lightroom you can apply a preset using the Develop Settings drop-down list.

I converted the image to black and white using the Creative-BW High Contrast Lightroom preset.

▶ Step 2: You can also apply more than one preset to an image. Select Sharpen-Portraits from the Develop Settings drop-down list following the Creative-BW High Contrast conversion.

Lightroom ships with a number of effective presets; in addition, you can create your own custom presets or download them from the web.

However, you don't have to use the import process to apply presets. Once an image has been imported into Lightroom, you can apply presets and further tweak the image in the Develop module shown on pages 84–91.

Default Settings
Creative - Aged Photo
Creative - Antique Grayscale
Creative - Antique Light
Creative - BW High Contrast
Creative - BW Low Contrast
Creative - Cold Tone
Creative - Cyanotype
Creative - Direct Positive
Creative - Selenium Tone
Creative - Sepia
General - Auto Tone
General - Grayscale
General - Punch
General - Zeroed
Sharpen - Landscapes
✓ Sharpen - Portraits
Tone Curve - Flat
Tone Curve - Strong Contrast

Silver Efex Pro and Lightroom

Silver Efex Pro, from Nik Software, can be configured to work in conjunction with Lightroom. This elegant black and white filter set is explained in the context of Photoshop on pages 128–135, and works pretty much the same way with Lightroom. You don't need to buy two versions of Silver Efex Pro; the same software works with both Lightroom and Photoshop.

Please refer to the Silver Efex documentation for information about configuring Silver Efex Pro to work with Lightroom, and working with Silver Efex from within Lightroom.

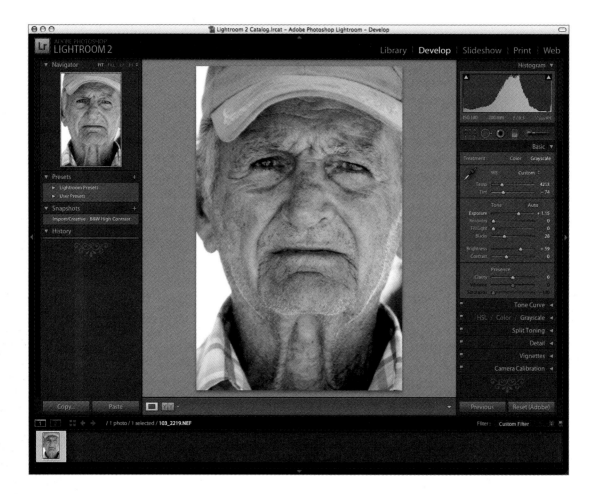

You can use the Develop module shown above to fine tune an image that has been imported in black and white.

There are many other approaches to creating black and white images besides the simple two-or-three click approach I've shown you here; some other ways to go about monochromatic interpretation are shown in the next few pages.

▷ In an impoverished village in the Cuban countryside, beside the ruins of an old sugar mill, I photographed this farmer. Back at my computer, using Lightroom, it took only a few mouse clicks to convert this image to black and white using the Lightroom Creative–BW High Contrast and Sharpen–Portrait presets.

200mm, 1/160 of a second at f/6.3 and ISO 100, hand held

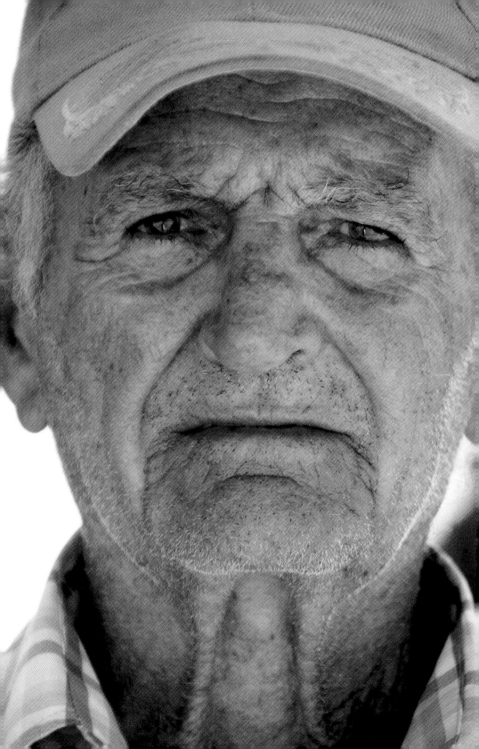

HSL Conversion

You can get a bit more control over your black and white interpretation if you import your RAW file into Lightroom without applying a preset.

Once you've imported your image, in the Develop module you'll find controls on the Basic panel that can be used to set White Balance, Tint, Exposure, and so on. If this reminds you of the comparable controls in ACR, it should come as no shock—they are the same.

As with the HSL/Grayscale tab in the ACR window, you can use the HSL/Color/

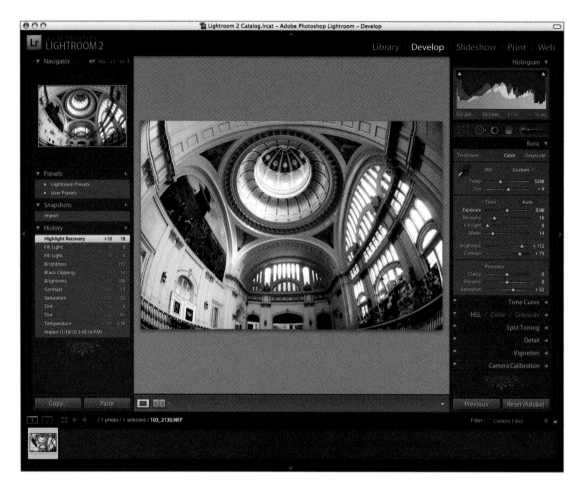

▲ You can use the controls in the Develop module to adjust your image.

▶ The HSL/Color/Grayscale panel lets you set how the different colors in your photo are used to create a grayscale image.

Grayscale panel in the Develop module to determine the way in which the colors in your image are used to blend to grayscale.

Some images require different kinds of work in different areas. Provided this is not the case, you can get very satisfactory black and white results quite quickly by importing your RAW photo into Lightroom, then tweaking the settings on the Basic panel and the HSL/Color/Grayscale panel.

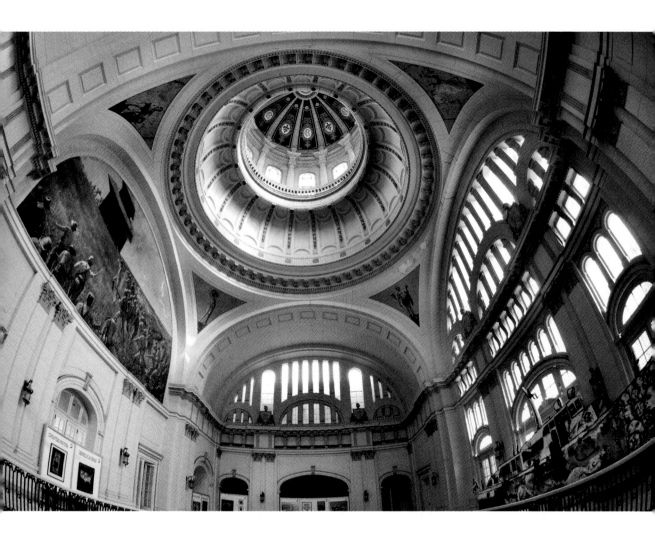

▲ In Havana, Cuba, the Presidential Palace with its dome decorated by Tiffany became the Revolutionary Museum when Castro took over. I used a fisheye lens to take in the whole scene, with the thought that the patterns of lights and darks shown in the central space under the dome would make an interesting monochromatic image.

105mm digital fisheye, 1/8 of a second at f/11 and ISO 200, tripod mounted

Exposure Gradients and Adjustments

Photographers are often confronted with exposure challenges in which part of a scene is considerably brighter than the other part. In the days before digital photography, such situations could be met by using a graduated neutral density filter—for example, darker on the upper part for the bright sky and lighter beneath for the dark earth.

If portions of the photo were still too dark or too light, they could be "burned" or "dodged" in the darkroom. Burning made a print darker by exposing selected areas longer; dodging made the print lighter in selected places by withholding exposure of the enlarger from specific areas.

RAW photos in Lightroom can be adjusted for the kinds of exposure problems that were treated with graduated neutral density filters or burning and dodging quite easily.

For example, I opened the image shown below in the Lightroom Develop module using the Creative-BW High Contrast preset. You can see that the upper part of the photo is too light, and that detail has been lost in the dark shadow areas at the bottom.

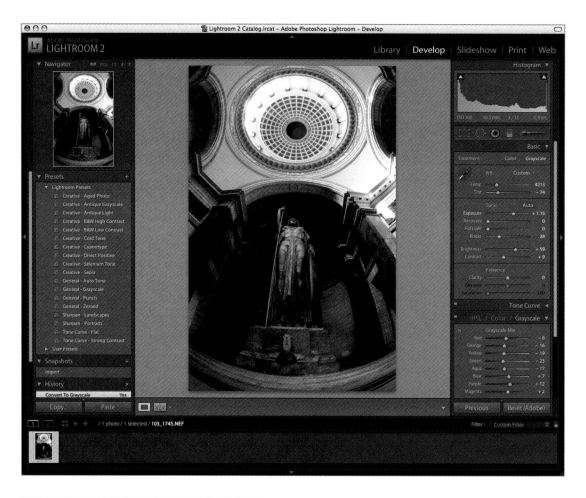

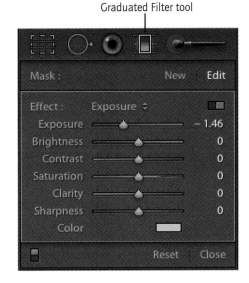

▶ Step 1: To adjust the exposure of the top part of the image using a gradient, choose the Graduated Filter tool, found fourth from the left, right under the Histogram. The Graduated Filter allows you to apply changes in exposure using a gradient.

▶ Step 2: Choose the exposure adjustment you want. For example, to make the top part of the photo darker, choose a negative value for the Exposure slider.

▶ Step 3: Click and drag the mouse down from the top of the image to draw the gradient. Notice that as you drag the mouse, lines appear representing the gradient. A circle on the center line shows where the middle of the gradient is. The gradient controls how the exposure is applied—from most at the top to the least where you release the mouse. Note that you can view the impact of your changes in the main photo window of the Develop module, and adjust as necessary.

▶ Step 4: When your exposure adjustment is just right, click Close.

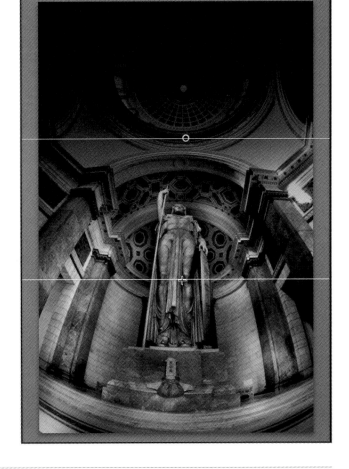

◀ If you look at this image, the upper part appears much too bright, while a great deal of the detail has been lost in the shadow areas at the bottom.

Step 5: To darken or lighten specific areas in your photo as if you were burning or dodging, choose the Adjustment Brush tool (fifth from the left, right under the Histogram).

The Adjustment Brush tool lets you "paint" in areas with different exposure values so that they become lighter or darker.

Step 6: In the Effect area use the Exposure slider to set how light or dark the painting will be. Moving the Exposure slider to the left towards the negative side will result in darker areas just like burning. Moving the Exposure slider to the right towards positive values will make the areas painted lighter, like dodging.

Step 7: Use the Size slider in the Brush area to choose a brush size that lets you paint in the areas you want to adjust.

Step 8: Paint in the adjustments. You can adjust the brush size as you paint, if you need more or less coverage on a particular area.

Step 9: Click Close when you are finished.

With very little effort, the finished photo shown on page 91 is a great deal more satisfactory than where it started. The overly bright areas are toned down and the details cloaked by dark shadow are revealed.

Adjustment Brush tool

The entrance foyer to the Capitolio Nacional in Havana, Cuba is dominated by a giant statue of the Greek Goddess of wisdom, Athena. Unfortunately, the building has only rarely been used for the purpose it was intended.

Standing beneath the statue with my camera on a tripod using a fisheye lens, I visualized this photo as showing an extreme tonal range—in other words, an example of black and white HDR photography (see pages 156–165 for more about extending dynamic range in black and white). Lightroom allowed me to easily adjust the dynamic range in the photo using a Graduated Filter and the Adjustment Brush.

10.5mm digital fisheye, 0.8 seconds at f/13 and ISO 100, tripod mounted

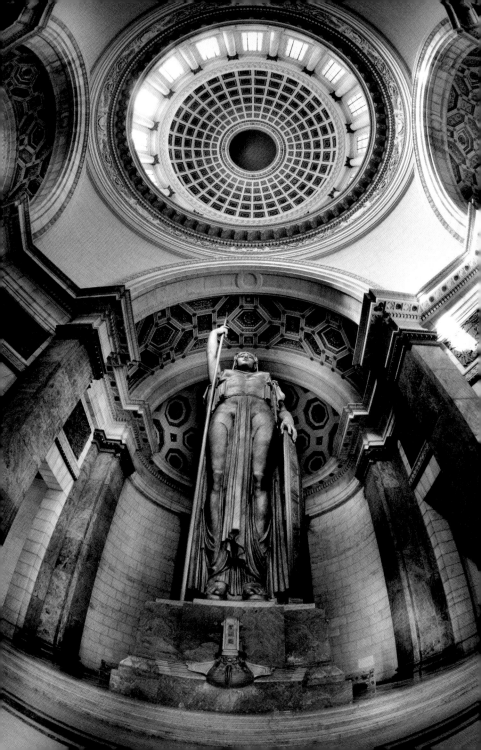

Exporting Virtual Copies into Photoshop as Layers

Lightroom Graduated Filters and the Adjustment Brush function a great deal like Photoshop layers—more precisely, like Photoshop adjustment layers. But if you really want to take advantage of the full power and precision of Photoshop layers and masking, you'll need to bring your photo into Photoshop itself.

Fortunately, it's easy to integrate Lightroom with Photoshop. You can use the stream-lined workflow interface provided by Lightroom and then pull your work into Photoshop for the finishing touches.

For example, I imported a photograph of the The Wave rock formation into Lightroom using the Creative-BW High Contrast preset. Looking at the image as an abstraction, I decided I needed to increase the contrast, and make the left side a bit brighter and the right side a bit darker.

Using the Lightroom tools shown in *Exposure Gradients and Adjustments* (pages 88–91), it would be perfectly possible to accomplish these tasks. But I decided the easiest way to get exactly the creative effect I wanted was to export three versions into Photoshop. The first version would be the default black and white conversion using the preset which would work as my background; the second version would be lighter; and the third version would be darker.

Lightroom makes it easy to create these different versions using the Photo ► Create Virtual Copy command. Once the virtual copies have been edited, all three versions can be easily exported as Photoshop layers.

► The photo of The Wave converted with the Creative-BW High Contrast preset.

▶ Step 1: From the Lightroom Photo menu, choose Create Virtual Copy to create a copy of the image. This copy appears selected next to the original image in the Filmstrip at the bottom of the window.

Virtual copy

Filmstrip —

▼ Step 2: On the Basic panel, move the Exposure slider to the right to create a lighter version.

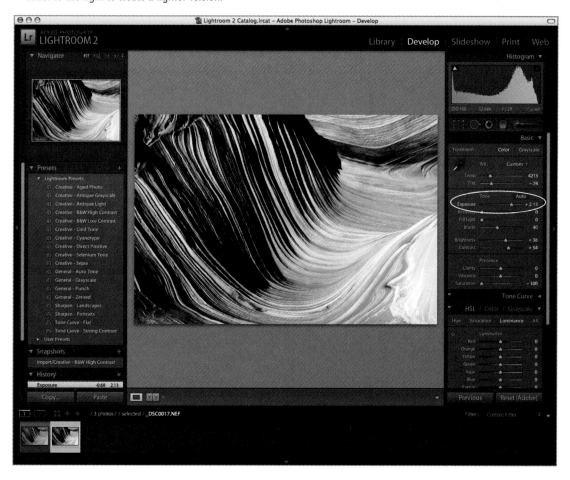

▶ Step 3: Make sure the lighter version you just created is selected in the Filmstrip. From the Lightroom Photo menu, choose Create Virtual Copy to create a copy of the lighter version. This copy appears selected in the Filmstrip at the bottom of the Lightroom window.

▶ Step 4: On the Basic panel, move the Black slider to the right. Then, move the Exposure slider to the left to create the darker version.

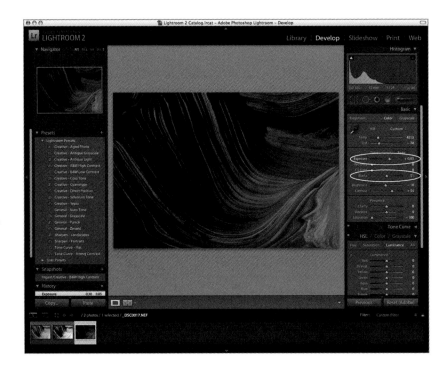

▼ Step 5: Hold down the Shift key and click each version in the Filmstrip to select the three versions.

▶ Step 6: From the Lightroom Photo menu, choose Edit In ▶ Open as Layers in Photoshop...

The three Lightroom versions appear in the Photoshop Layers palette.

▶ Step 7: The layers automatically appear in the Photoshop Layers palette as Background, Layer 0, and Layer 1. Rename Layer 0 as "Lighter" and Layer 1 as "Darker."

This is now the functional equivalent of multi-RAW processing using ACR and Photoshop as explained on pages 108–113.

▶ Step 8: Using layers and masking in Photoshop (as explained on pages 98–107), blend the three layers to make the left side lighter and the right side darker.

▼ Pages 96–97: The Wave is a spectacular geologic formation on the Utah-Arizona border. As a photographer, one of the things I like best is the way this landscape becomes an abstraction. It's very hard to know the scale of an image such as this one, which is part of its appeal for me. It could be a detail of tree bark, or pulled taffy—but in fact it is a rather vast valley of stone, frozen like a wave in time.

Speaking of time, it's good news for photographers that using the Lightroom-Photoshop combination black and white conversions such as this one can be created in just a few minutes.

52mm, 1/20 of a second at f/29 and ISO 100, tripod mounted

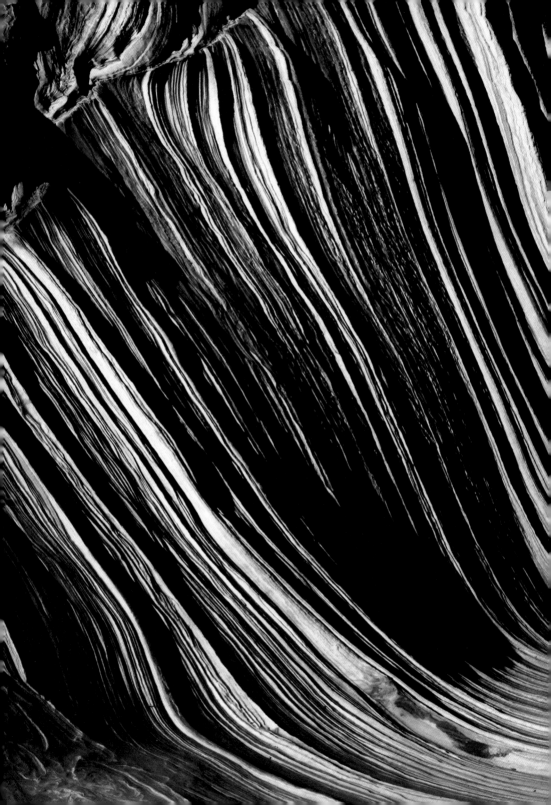

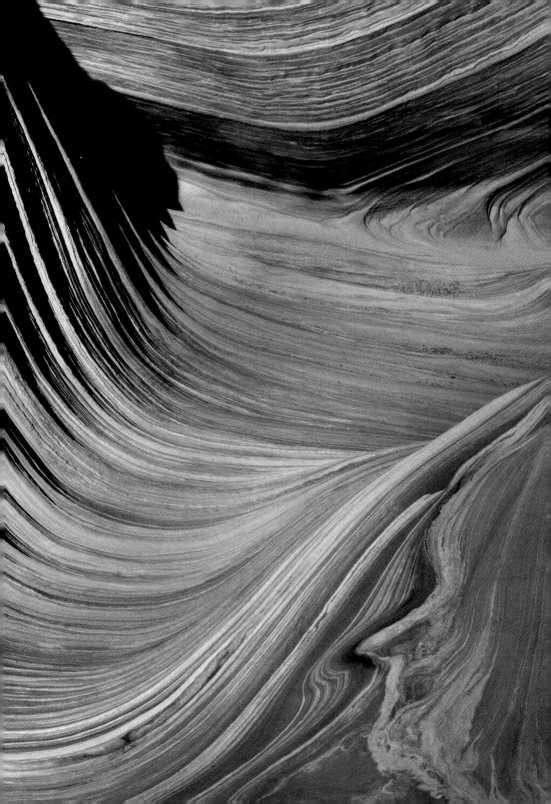

Multiple Layers and Masking in Photoshop

There's no such thing as a monochrome-only sensor on the marketplace, and I probably wouldn't want it if there were. In-camera JPEG black and white photos are inherently inferior to images processed from RAW files (see pages 74–75).

Therefore, since I start with a color RAW capture, my digital workflow for high quality black and white imagery involves the following steps:

1. Looking at the world around me with an eye towards subjects that will work well in black and white (see pages 10–65).

2. Coming up with a plan for exposure and conversion.

3. Capturing my images in RAW format.

4. Processing the image for color in Adobe Camera RAW (ACR).

5. Repeating the RAW conversion more than once at differing exposure values. This is called *multi-RAW processing*.

How Layers Work

If you understand how to use layers, then you know how to unleash the power of Photoshop. Almost everything in Photoshop is better with layers, and you can even control elements of your image with precision down to the pixel level. Fortunately, effective use of layers and layer masks is not very hard to understand and to learn to use.

Layers are placed on top of other layers to form a layer stack. You can control the opacity of each layer, as well as the formula for how pixels in the layers are combined, called the *blending mode*.

A layer mask is used to hide or reveal portions of the associated layer. Black conceals the associated layer, white reveals it, and gray shades in-between pure black and full white—partially revealing or partially concealing the associated layer (depending how you look on things). It's important to remember that we are talking about concealing or revealing the layer that the mask is on, *not* the layers below it in the stack.

You can start with a layer mask that is completely black (by choosing a Hide All layer mask) or completely white (by choosing Reveal All) and then modify the layer mask. The most common tools for layer mask modification are the Brush Tool and the Gradient Tool.

▶ Step 1: From Adobe Bridge, double-click a RAW file to process a version for the background of the photo in ACR. Bear in mind that when planning to convert to black and white, you generally want more dramatic contrast than you would have normally in color photos. When you are pleased with the settings, hold down the Alt key and click Open Copy to open the image in Photoshop.

6. Combining the different RAW conversions in Photoshop into a color version using layers and masking (pages 98–107).

7. Converting the images to black and white in Photoshop using multiple conversion techniques depending on the image (or portion of the image), layers, and masking.

Note that steps 3 and 4 are functionally equivalent to the Lightroom technique shown on pages 92–97 of creating virtual copies of an image, applying different exposures, and bringing the virtual copies into Photoshop as a layer stack.

Since layers and masking are vitally important to two parts of this process—the initial color conversion and the subsequent conversion to black and white in Photoshop—it's worth taking a look at the basics of using layers.

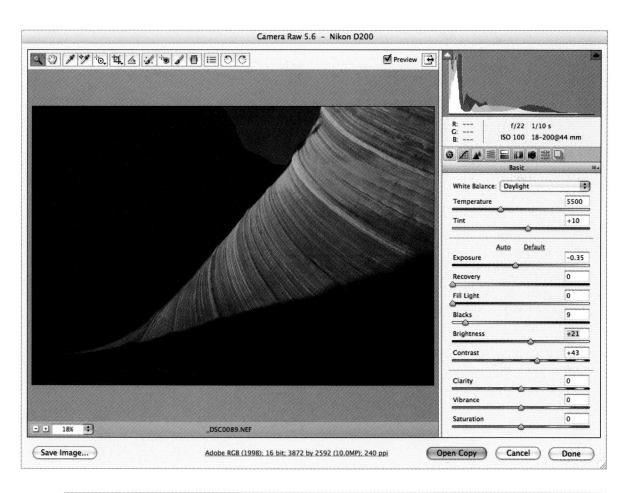

▶ Step 2: Go back to Bridge and double-click the *same* file again to open it a second time in ACR. Process this version of the image so that it is brighter, to lighten the deep shadow areas. When you are pleased with the settings, hold down the Alt key and click Open Copy to open the image in Photoshop.

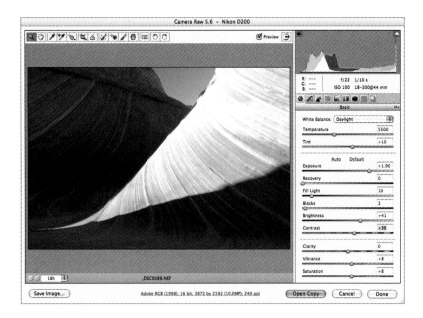

▶ Step 3: Third time pays for all! Go back to Bridge and double-click the same file again to open it a third time in ACR. Process this version of the image so it is darker. This version will be used to tone down highlights that are too bright. When you are pleased with the settings, hold down the Alt key and click Open Copy to open the image in Photoshop.

You now have three versions of the image open in Photoshop. You'll use the background and lighter versions right away. You'll use the darker version a bit later so just move it to one side of your monitor to get it out of the way for now.

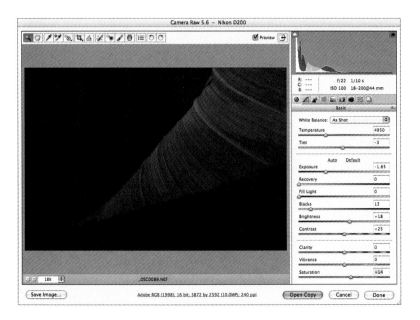

▶ Step 4: The next thing you want to do is align the lighter RAW conversion exactly on top of the background version in the same Photoshop window.

To do this, hold down the Shift key and use the Move tool to drag and drop the lighter version onto the original version (see pages 96–99). (Make sure you release the mouse button before you release the Shift key or the versions may not be perfectly aligned.) The lighter version will appear in the Layers palette. Rename this layer "Lighter – Upper Left Side."

▶ Step 5: With the "Lighter–Upper Left Side" layer selected in the Layers palette, choose Layer ▶ Layer Mask ▶ Hide All to add a layer mask to that layer.

The Hide All layer mask hides the layer it is associated with (in this case the "Lighter–Upper Left Side" layer). It appears as a black thumbnail in the Layers palette associated with the layer.

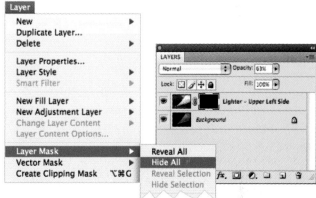

▶ Step 6: Make sure the layer mask on the "Lighter–Upper Left Side" layer is selected in the Layers palette. Choose the Gradient Tool from the Toolbox and drag a white-to-black gradient diagonally from the upper left corner of the image window to the brighter area in the middle of the image window.

This lightens the upper left side in a natural way.

▶ Step 7: The lower area of the image could use some lightening as well. To do this, make sure the "Lighter–Upper Left Side" layer is selected in the Layers palette, and then choose Layer ▶ Duplicate Layer to duplicate the layer. Name the new layer "Lighter–Bottom."

Notice that when you duplicated the layer, the layer mask was duplicated as well. In the next step, you'll remove this duplicate layer mask and then add a new, unused one.

▶ Step 8: Remove the duplicate layer mask by selecting Layer ▶ Layer Mask ▶ Delete.

Next, add a new, unused layer mask by choosing Layer ▶ Layer Mask ▶ Hide All like you did in Step 5 on page 101.

There are now three layers: "Background," "Lighter–Upper Left Side," and "Lighter–Bottom."

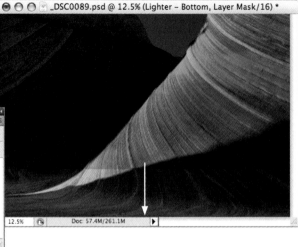

▶ Step 9: Make sure the layer mask on the "Lighter–Bottom" layer is selected in the Layers palette. Choose the Gradient Tool from the Toolbox and drag a black-to-white gradient from where the lower shadowed area of the image starts down to the bottom of the image window.

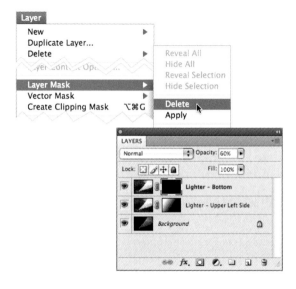

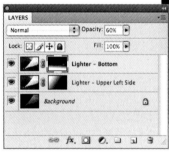

▶ Step 10: Go back to the darker RAW conversion that you parked on one side of your monitor back in Step 3. Hold down the Shift key and drag this darker RAW conversion on top of the "Lighter–Bottom" layer. Rename it "Darker."

There are now four layers: "Background," "Lighter–Upper Left Side," "Lighter–Bottom," and "Darker."

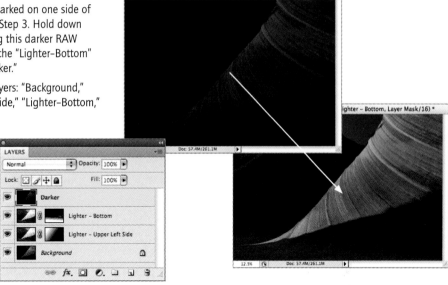

▶ Step 11: With the Darker layer selected, add a black layer mask to the layer by choosing Layer ► Layer Mask ► Hide All like you did in Step 5 on page 101.

▶ Step 12: In the Toolbox, set white as the Foreground color. Make sure the layer mask on the "Darker" layer is selected in the Layers palette. Use the Brush tool to paint in the areas where you want to selectively darken the overly-bright areas of the image. To start, set your brush to 50% Opacity and 50% Flow. Adjust the Brush settings as you paint.

Brush Tool

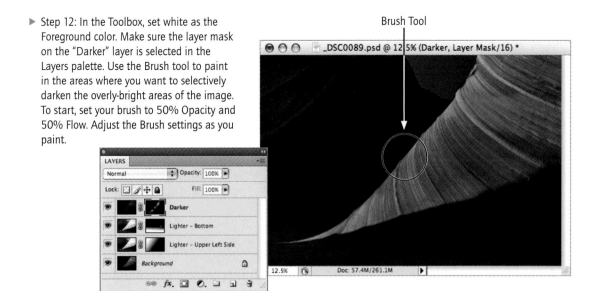

▶ Step 13: To convert the image to black and white, start by merging the four layers down into one layer by selecting Layer ▸ Flatten Image. The four layers will collapse into one "Background" layer.

▶ Step 14: Duplicate the Background layer by selecting Layer ▸ Duplicate Layer. Name the duplicate layer "B&W–Darker."

▶ Step 15: Make sure the "B&W–Darker" layer is selected in the Layers palette. On the Adjustments palette, click the Create Black & White adjustment layer button to apply a default black and white adjustment. (You could also access Black & White adjustment layers by selecting Layer ▸ New Adjustment Layer ▸ Black & White.)

Click to add a Black & White adjustment layer. Fore more about Black & White adjustment layers see pages 122–127.

Why I merge down adjustment layers

I often decide to merge down adjustment layers, even though there are some disadvantages to this step: a normal layer takes up more space on disk than an adjustment layer, and once an adjustment layer has been merged down you can't tweak its settings.

The reason I merge down adjustment layers despite these disadvantages is that I find it easier to see what I'm doing in a complex, multi-layered document. I also want to be able to reduce the opacity of the layer that an adjustment layer is connected to—not just the opacity of the adjustment layer.

But let's face it, the choice is yours. If you prefer adjustment layers to merged-down layers, that's fine!

Step 16: Use the drop-down list on the Adjustments palette to make the Black & White adjustment layer to Darker. This layer is now the base for the black and white version of this image.

The color "Background" layer has no impact on the final image because the "B&W–Darker" layer is set at 100% opacity.

Step 17: With the adjustment layer selected in the Layers palette, merge the Black & White adjustment layer down onto the "B&W–Darker" layer by choosing Layer ▶ Merge Down.

Step 18: Duplicate the color "Background" layer by selecting Layer ▶ Duplicate Layer. Name the duplicate layer "B&W Infrared."

Step 19: With the "B&W Infrared" layer selected in the Layers palette, use the Adjustments palette to apply a Black & White adjustment layer set to Infrared (this is one of the selections on the drop-down list shown in Step 16).

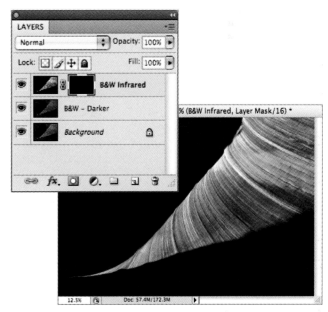

Step 20: With the adjustment layer selected in the Layers palette, merge the Black & White adjustment layer down onto the "B&W Infrared" layer by choosing Layer ▶ Merge Down.

Step 21: With the "B&W Infrared" layer selected in the Layers palette, choose Layer ▶ Layer Mask ▶ Hide All to add a layer mask to that layer.

Step 22: Selectively tone down areas of the image by painting with the Brush Tool in white on the black layer mask.

Step 23: Repeat steps 18–22 adding more black and white layers using different Black & White adjustment layer settings. As you can see in the Layers palette shown here, I ended up with five black and white layers that I used to subtly tone the image. The final image is shown on pages 106–107.

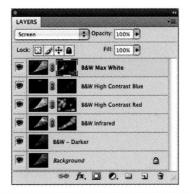

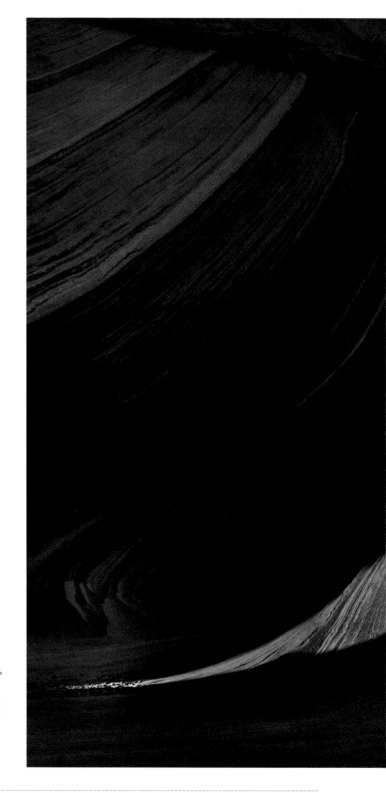

▶ As the sun sank towards the west, light began filtering through the canyons and rock formations, creating deep shadows along with occasional brightly lit areas. I saw this high contrast between the dark and light areas as a natural for a semi-abstract black and white composition. I captured the image as a RAW file, and back at my computer processed the image using multiple layers twice: once to fully capture the color information, and once to customize my translation to black and white.

44mm, 1/10 of a second at f/22 and ISO 100, tripod mounted

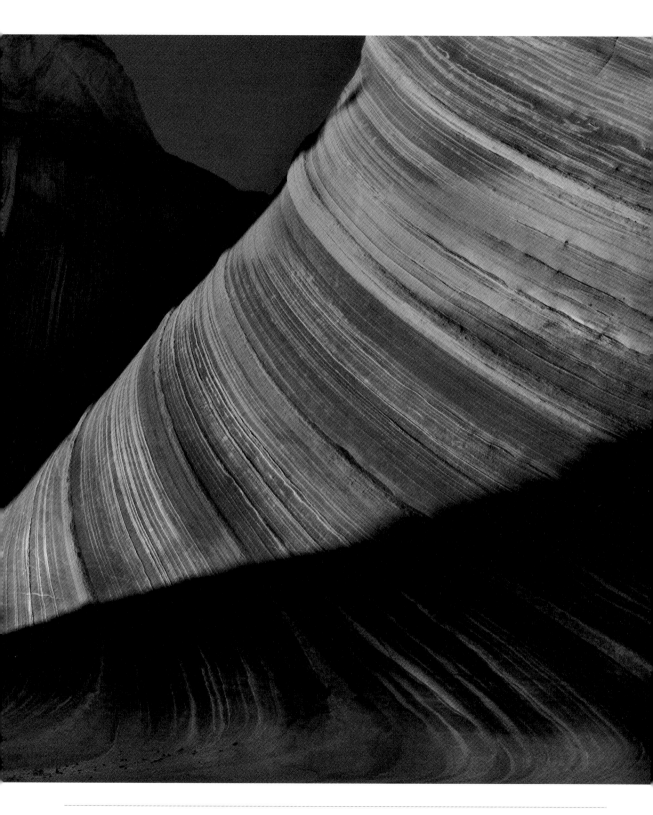

Multi-RAW Processing In Photoshop

Suppose you have a perfect subject for extending the dynamic range through multi-RAW processing (see pages 98–103 for an example). It's important to come up with a plan as to how you are going to post-process your RAW captures more than once to come up with an image that can be effectively converted to black and white.

The three strategies I most commonly use are:

- Dark to light: This means processing the darkest, most underexposed version first, and then blending-in successively lighter versions on top.

- Starting in the middle: If your capture is pretty close to where you want it, you could start by processing it fairly neutrally. Next, you could add lighter and darker versions on top as necessary.

- Light to dark: This means processing the lightest, most overexposed version first, and then blending-in successively darker versions on top.

Whichever strategy you choose, the mechanics of creating a layer stack with aligned layers from different versions of the RAW capture, and then combining the layers is the same.

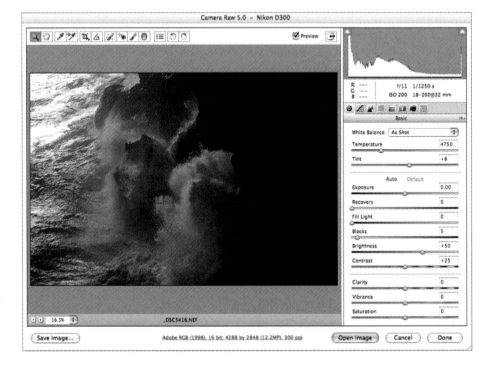

▶ With this image of waves crashing on the shore, I knew I would need to process a lighter version to get detail in the shoreline at the right of the image. I would also need a darker version to tone down the comparatively brighter waves on the upper left.

▶ Step 1: Open the RAW capture in ACR. Use the Exposure slider to darken the capture so the waves on the left side of the image are exposed correctly.

Hold down the Alt key and click Open Copy to open this darker version in Photoshop. It will appear in the Layers palette as a Background layer. (See Steps 1–3 on pages 99–100 to find out more about opening multiple versions of the same image in Photoshop using ACR.)

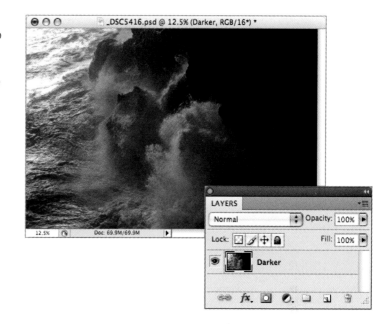

▶ Step 2: Choose Layer ▸ New ▸ Layer from Background and rename the layer "Darker."

▶ Step 3: Open the RAW capture *again* in ACR. Use the Exposure slider to lighten the capture so the shoreline on the right side of the image is exposed correctly.

Hold down the Alt key and click Open Copy to open this darker version in Photoshop. It will appear in the Layers palette as a Background layer.

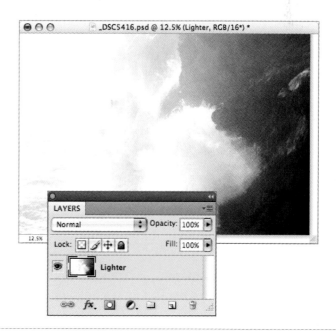

▶ Step 4: Choose Layer ▸ New ▸ Layer from Background and rename the layer "Lighter."

You now have two versions—a lighter version and a darker version—of the same image open in Photoshop.

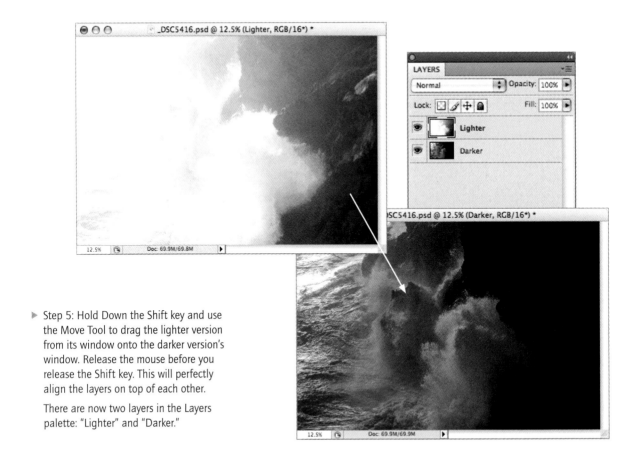

▶ Step 5: Hold Down the Shift key and use the Move Tool to drag the lighter version from its window onto the darker version's window. Release the mouse before you release the Shift key. This will perfectly align the layers on top of each other.

There are now two layers in the Layers palette: "Lighter" and "Darker."

▶ Step 6: With the "Lighter" layer selected in the Layers palette, choose Layer ▶ Layer Mask ▶ Hide All to add a layer mask to that layer.

The Hide All layer mask hides the layer it is associated with (in this case the "Lighter" layer). So all you will see in the image window right now is the "Darker" layer. The layer mask appears as a black thumbnail in the Layers palette.

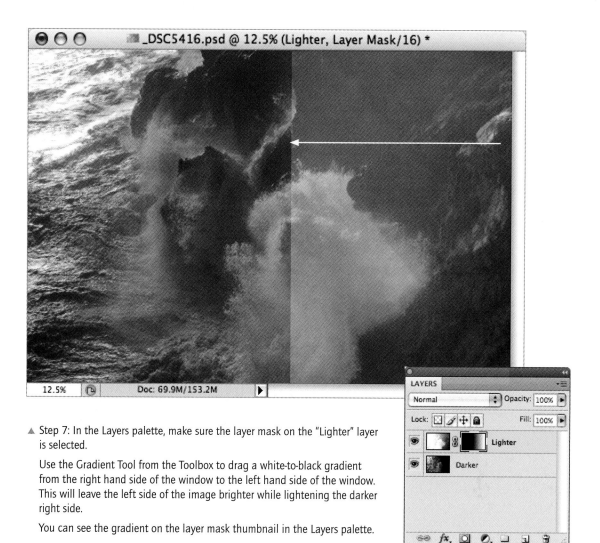

12.5% Doc: 69.9M/153.2M

LAYERS

Normal Opacity: 100%

Lock: Fill: 100%

Lighter

Darker

▲ Step 7: In the Layers palette, make sure the layer mask on the "Lighter" layer is selected.

Use the Gradient Tool from the Toolbox to drag a white-to-black gradient from the right hand side of the window to the left hand side of the window. This will leave the left side of the image brighter while lightening the darker right side.

You can see the gradient on the layer mask thumbnail in the Layers palette.

▼ Pages 112–113: Surf was dramatically crashing on the rocky shore by the light of the setting sun. In my mind's eye, I saw a black and white photo contrasting the bright waves with the dark shore. To achieve the photo I pre-visualized, I knew I would need to use a fast shutter speed, and underexpose so that I could stop the motion of the waves and not lose their detail because of blown-out highlights. My plan was to "rescue" the overly dark areas of the photo using multi-RAW processing.

After blending multiple RAW versions of the image in Photoshop, I converted this already essentially colorless image to black and white using Black & White adjustment layers (see pages 104–105 and 122–127).

32mm, 1/1250 of a second at f/11 and ISO 200, hand held

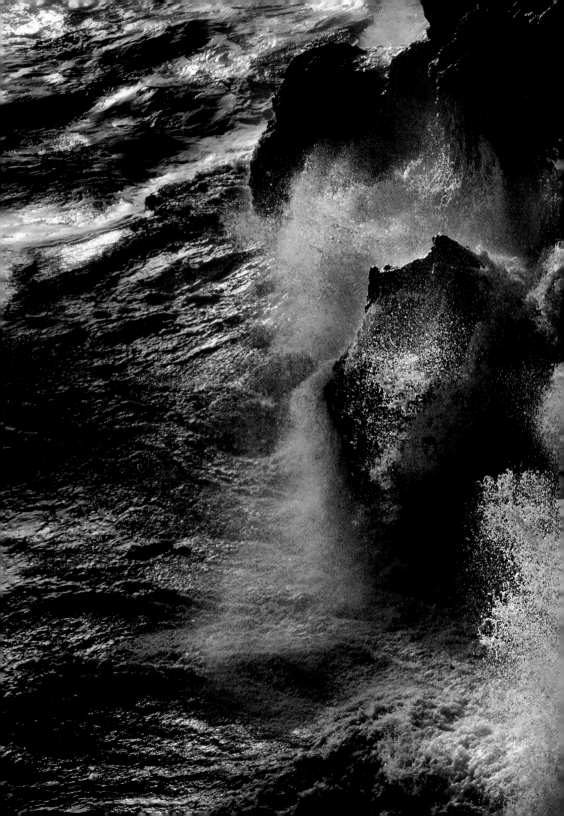

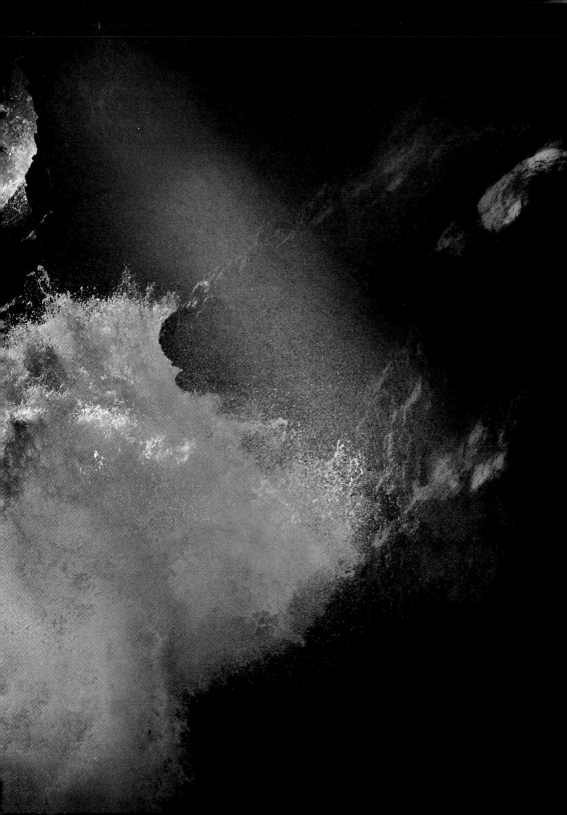

Black and White in Photoshop

One of the wonderful things about Photoshop is that there are always many ways to accomplish any task. This is good news—and bad news. The good news is that Photoshop is immensely powerful and flexible. The bad news is that one is never done learning Photoshop, and there are so many ways to accomplish anything that it's sometimes hard to know which one to use.

Black and white conversion in Photoshop is no exception. There are many ways to go about this task, ranging from very simple—which does not create very nuanced black and white imagery—to quite elaborate, powerful and flexible.

The simplest way to translate a color photo in Photoshop into black and white is to simply drop the color information. This can work reasonably well with images that are not high contrast, and where there isn't much color information available in any case.

To convert to black and white by dropping the color information, you can do one of the following (which all have more or less the same results):

- With an RGB image select Image ► Mode ► Grayscale (see the example of a conversion accomplished this way on the facing page).

- With an RGB image select Image ► Adjustments ► Desaturate.

- Convert your image to LAB color, and drop the A and B channels (for more about using LAB color to create black and white images, see pages 182–187).

Another pretty straightforward approach is to use the Color blending mode to combine the photo with a black layer (see pages 116–117). This can work well with photos that have strong blacks and whites in the color version.

More sophisticated black and white conversion methods in Photoshop include:

- Using the Channel Mixer, either as an adjustment layer or on a duplicate layer (pages 118–121).

- Using a Black & White adjustment layer (pages 122–127).

- Using a third-party black and white conversion filter, such as Silver Efex Pro (pages 128–135).

I often find that it takes more than one black and white conversion tech-nique—either applied to different parts of an image, or applied sequentially—to fully process photos to my satisfaction. For information about combining conversions in Photoshop, see pages 136–141.

▶ I shot this image of a large succulent plant outdoors with a camera that had been retrofitted to make captures on the infrared spectrum (see pages 224–231). Since the infrared capture was a low contrast image that contained very little color information, a simple grayscale conversion in Photoshop (Image ► Mode ► Grayscale) worked fine.

40mm, 1/100 of a second at f/11 and ISO 200, hand held

Blending with Black

In the color version of the tulip image shown to the left, the white tulips and highlights were very white, and the blacks were very dark.

When I decided to convert the image to black and white, it seemed to me that blending the photo with a black layer using the Color blending mode would work well. This is a quick and easy way to convert a high contrast color photo to black and white.

▶ Step 1: In the Layers palette, click the Create a new layer button at the bottom of the palette to add a transparent (empty) layer on top of the color image. Name the layer "Black."

Create a new layer

▶ Step 2: Select the Paint Bucket Tool in the Toolbox. Press D to make sure the Foreground Color is set to Black.

▶ Step 3: Make sure the "Black" layer is selected in the Layers palette. Click the Paint Bucket Tool in the image window to fill the layer with black. All you will see in the image window is solid black. Don't worry, that will change with the next step!

▶ Step 4: In the Layers palette, use the Blending Mode drop-down list to change the blending mode from Normal to Color.

Blending Mode drop-down list

The Color blending mode mixes the luminance (grayscale values) of the underlying color image with the hue and saturation values of the "Black" layer on top, creating a black and white image.

I used a Lensbaby to selectively focus on the white tulips in a cut crystal vase, with the idea of converting the image to black and white so that the colored background wouldn't compete with the white flowers.

Since I was only interested in the white whites and the black blacks, I didn't really need to use the color information in the photo for an effective black and white conversion. Using the Color blending mode to combine the photo with a black layer was quick and worked well.

Lensbaby Composer, 1/640 of a second using f/4 aperture ring at ISO 200, hand held

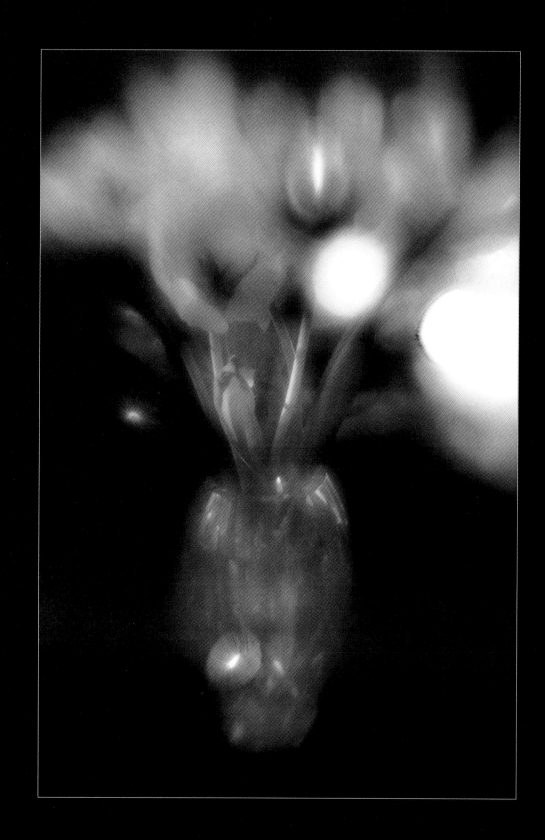

Using the Channel Mixer

The Channel Mixer provides a great mechanism for using color information to control the look and feel of your black and white photos when you convert them using Photoshop.

Before the introduction of Black & White adjustment layers with the CS3 version of Photoshop, the Channel Mixer was probably the premier way to control your black and white conversions. It remains an important tool—particularly in situations in which the precise mixture of information from each color channel that is used to form the black and white tones is an important aspect of the black and white conversion.

For example, hugely decreasing the contribution of the Blue channel while simultaneously boosting Red and Green channel contributions is known as the "Ansel Adams effect"—the look can be one of sumptuous, very black blacks in contrast to extreme whites. Using the Channel Mixer remains the best way to achieve this special effect.

The dramatic interplay between sky and mountains with Yosemite Valley as a backdrop made me think that this photo below was a good candidate for the Ansel Adams effect, applied using a Photoshop Channel Mixer adjustment layer.

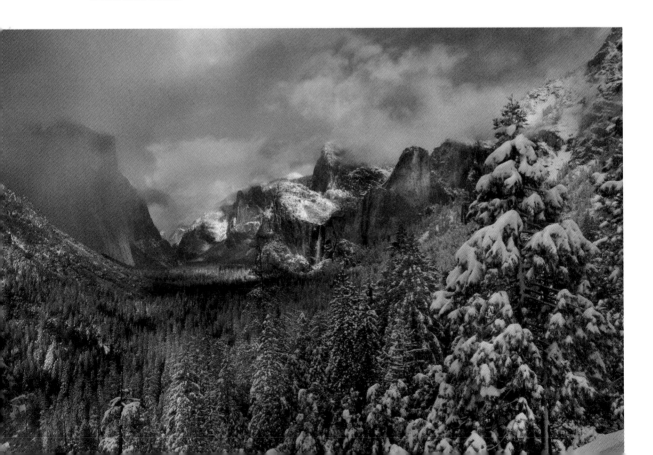

▶ Step 1: Choose Layer ► Layer via Copy to duplicate the color Background layer. Name this duplicate layer "Channel Mixer–Ansel Adams."

▶ Step 2: With the "Channel Mixer–Ansel Adams" layer selected in the Layers palette, click the Create new fill or adjustment layer button at the bottom of the palette. Next, choose Channel Mixer from the drop-down list.

(Alternatively, you can add a Channel Mixer adjustment layer using the Adjustments palette or by choosing Layer ► New Adjustment Layer ► Channel Mixer.)

The Channel Mixer adjustment layer appears above the "Channel Mixer–Ansel Adams" layer in the Layers palette and default Channel Mixer settings appear in the Adjustments palette.

▶ Step 3: In the Adjustments panel, make sure Monochrome is checked.

▶ Step 4: Use the sliders to set up the Ansel Adams effect: set Red to +150; set Green to +140; and set Blue to -190.

Notice that if you add these values up they equal 100%. When using the Channel Mixer sliders, the values for the three channels should total 100%.

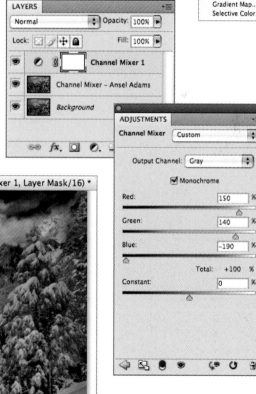

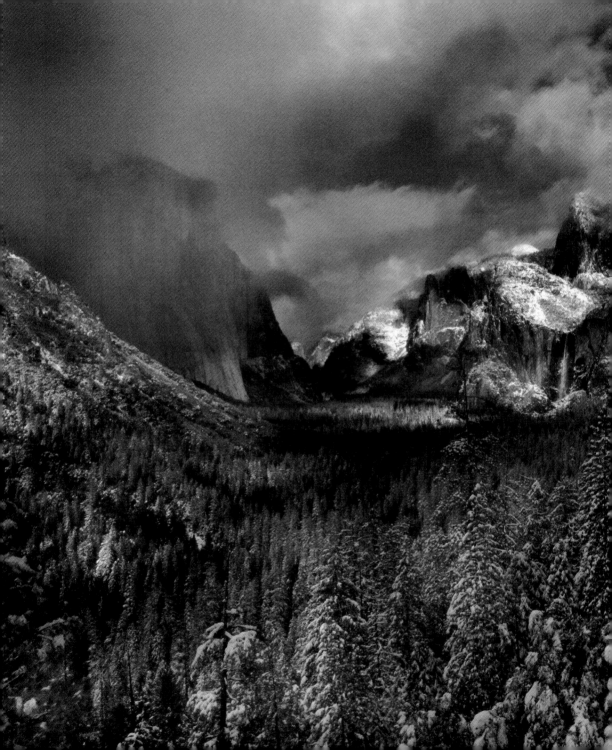

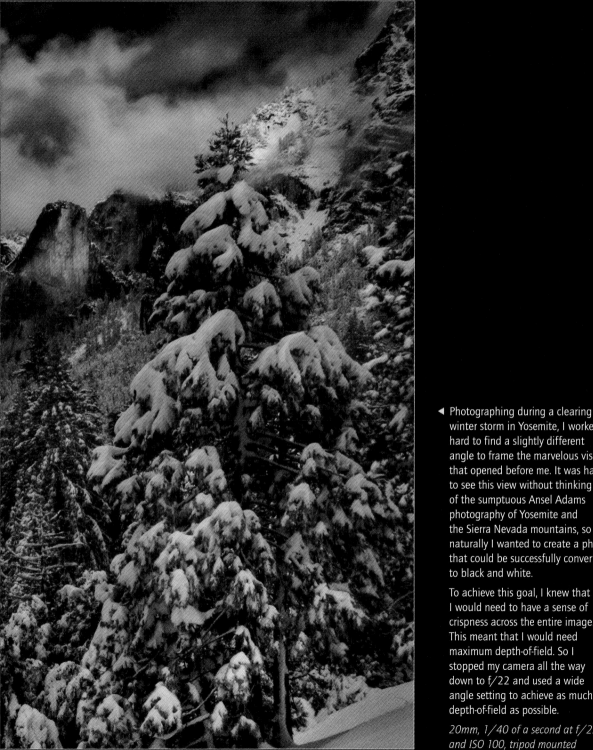

◀ Photographing during a clearing winter storm in Yosemite, I worked hard to find a slightly different angle to frame the marvelous vista that opened before me. It was hard to see this view without thinking of the sumptuous Ansel Adams photography of Yosemite and the Sierra Nevada mountains, so naturally I wanted to create a photo that could be successfully converted to black and white.

To achieve this goal, I knew that I would need to have a sense of crispness across the entire image. This meant that I would need maximum depth-of-field. So I stopped my camera all the way down to f/22 and used a wide angle setting to achieve as much depth-of-field as possible.

20mm, 1/40 of a second at f/22 and ISO 100, tripod mounted

Black & White Adjustment Layers

▲ I shot this photo of an ancient Bristlecone Pine, one of the oldest living things, with black and white in mind.

Black & White adjustment layers are probably the most effective and powerful way to create great creative monochromatic imagery in Photoshop. They're easy, flexible, and powerful—although in many cases a single Black & White adjustment layer isn't optimal for all areas in a photo. To resolve this problem, multiple adjustment layers can be used with different settings, each setting applied on a different layer, with the layers masked and blended to create the final results. (For more about layer masks and blending layers see pages 98–107.)

Even just one Black & White adjustment layer can be a powerful conversion tool. Part of what makes Black & White adjustment layers easy to use are the *Presets*—conversions to black and white using settings chosen from a list. These Presets mostly use the metaphor of applying filters in an old-fashioned darkroom, and are named after these filters. (Presets and how to use them are discussed on pages 123–125.)

Don't get too caught up in the metaphor to film that the presets provide. As with everything digital, the analogy to old-fashioned process doesn't always hold up. The best way to see what one of the black and white adjustment presets does is try it, and find out. If you don't like it, you can always go back and try again.

Note that I tend to merge down adjustment layers to form "just plain old regular" layers that can be masked normally. This process is explained further on pages 136–141.

▶ Step 1: In the Layers palette, select the layer to which you want to add the adjustment layer.

▶ Step 2: In the Adjustments palette, click the Create Black & White adjustment layer button to apply a default black and white adjustment.

You can also add a Black & White adjustment layer by selecting Layer ► New Adjustment Layer ► Black & White.

Click to add a Black & White adjustment layer

▶ After adding the Black & White adjustment layer, the Default preset becomes active in the Adjustments palette as shown, converting the layer to a neutral monochromatic image.

If you move the sliders, changing the color values represented by the sliders, you will immediately see the impact on the photo in the image window. The Default preset has neutral tonal values, so this is often a good starting place for conversions that require additional work.

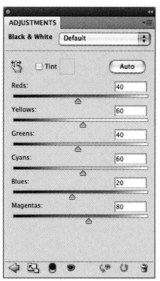

Default Black & White adjustment layer applied to the image shown to the left

▶ Step 3: Use the Black & White drop-down list to choose a preset. These presets are only a starting place—there's nothing to stop you from making further tweaks using the sliders.

▶ The slider settings created by the Green Filter preset are basically fairly neutral for this photo.

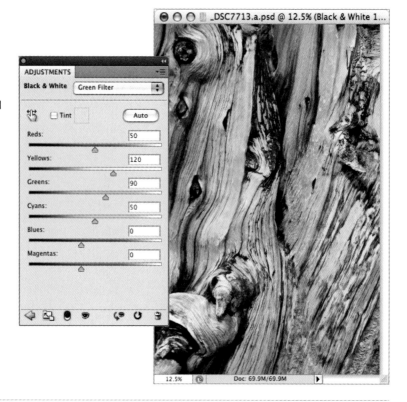

▶ The High Contrast Blue Filter preset darkens the image dramatically—particularly on the upper left. It's a striking effect, and one that I planned to partially incorporate in my finished image.

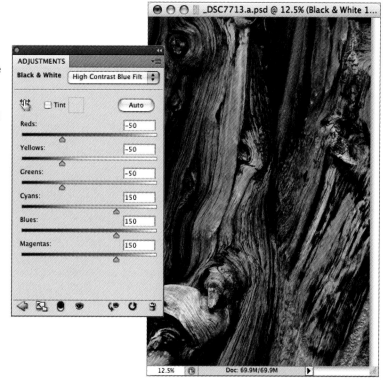

▶ The High Contrast Red Filter preset produces an image that is generally toned to the light side across the entire image.

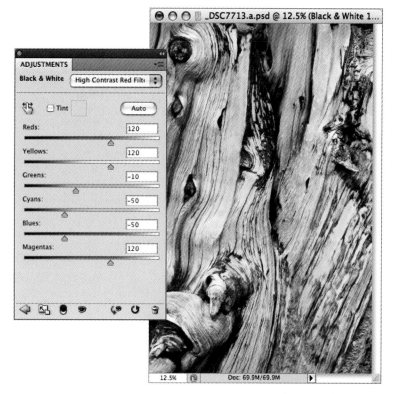

▶ To create a simple sepia tone for your black and white image, you can start with the Default preset, check the Tint box, and select a sepia color. When I want a tinted monochromatic effect, I almost always take the Sepia Tint layer down to about 20% opacity.

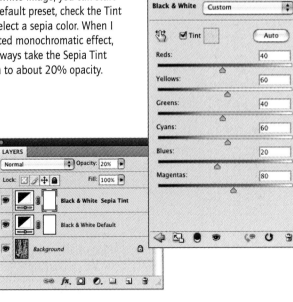

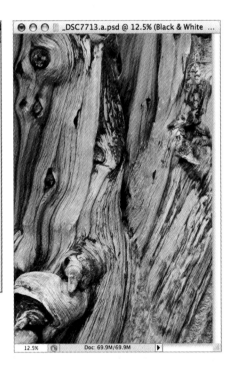

▶ The final conversion uses four Black & White adjustment layers in a layer stack. On top of the conversion achieved using the Default preset the following layers were used:

- A layer using the High Contrast Blue preset with a gradient on a layer mask to make the left side of the photo darker.

- A second layer using the High Contrast Blue preset with painting on a layer mask, making the image darker in specific areas.

- A layer using the Infrared preset with painting on a layer mask that adds a nice, light quality.

▶ This textural image of an ancient and weathered Bristlecone Pine high in the White Mountains on the California–Nevada border struck me as perfect for monochrome, but I wanted to make sure that monochrome didn't mean monotonous. The photo that I pre-visualized required considerable tonal gradations from dark to light. So I made sure to process the image using multiple Black & White adjustment layers.

200mm, 1/100 of a second at f/8 and ISO 100, tripod mounted

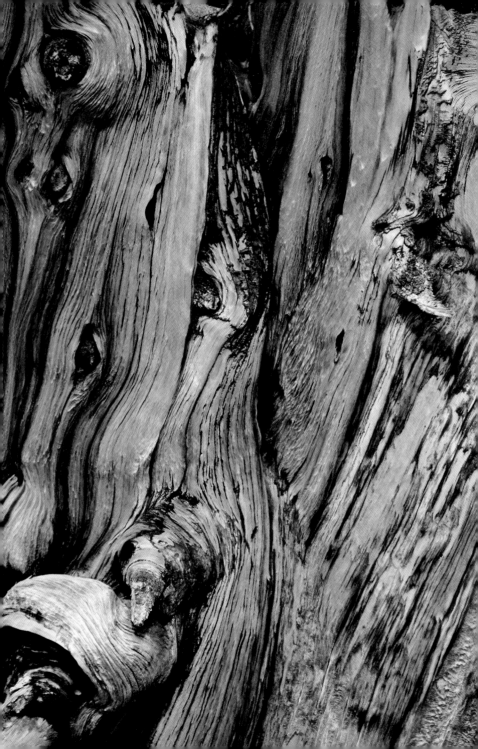

Silver Efex Pro

Silver Efex Pro works with both Lightroom and Photoshop. It is probably the best known third-party plug-in for these programs that provides extensive black and white conversion capabilities via the use of filters (see page 234 for some other options).

I'm not generally enthusiastic about recommending expensive third-party tools. After all, you've probably already laid out good money for Adobe's Lightroom or Photoshop. But Silver Efex Pro has some serious advantages, and I often find I use it as part of my black and white conversion workflow—either by itself or in conjunction with other Photoshop conversion tools such as the Channel Mixer and Black & White adjustment layers.

If you decide to live without Silver Efex Pro, I think you can still do awesome digital black and white work—it just might take a little longer. You can always find a way in Photoshop itself to create the effects that are easily available in Silver Efex Pro, but how to do so isn't necessarily obvious. In my opinion, why recreate the wheel? I prefer to spend my time in more creative pursuits.

Like Black & White adjustment layers themselves, the different black and white effects that Silver Efex Pro provides are largely named as if they were filters on the enlarger in a film darkroom. In addition, some of the options are named after antique film technologies—for example, Tin Type.

Obviously in both cases, what you are getting is a digital simulation of the effect that is referenced by its anachronistic name.

Once you've selected a particular filter, you can adjust its strength by changing the exposure and adding special effects such as toning and vignetting. Please refer to the product documentation for a detailed explanation of how these controls work.

As always, I strongly recommend working with Silver Efex Pro on a duplicate layer rather than on the background itself. This gives me added flexibility, particularly as most of my conversions seem to involve more than one filter.

Once Silver Efex Pro has been installed, it will appear towards the bottom of the Photoshop Filters menu as an item.

To open Silver Efex Pro:

1. Open the photo you want to convert to black and white in Photoshop.

2. Duplicate the layer you want to convert.

3. With the duplicate layer selected, choose Silver Efex from the Photoshop Filters menu. The Silver Efex Pro window will open with a Neutral conversion selected. I often use this neutral conversion as the starting place for my black and white work with Silver Efex Pro.

▲ Silver Efex Pro is shown here in split-screen mode, with the original color capture of an onion on top, and the Silver Efex Pro default conversion, called Neutral, on the bottom.

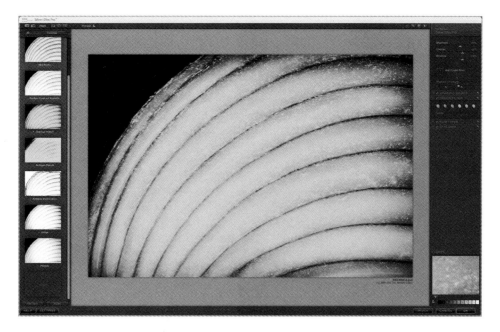

▲ The Silver Efex Antique Plate filter gives black and white photos an old-fashioned look.

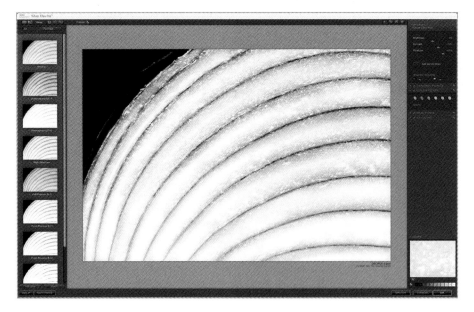

▲ The Silver Efex Pro High Structure filter increases contrast throughout an image.

▶ The final conversion uses six different Silver Efex Pro filters, shown here in the Layers palette. Most of the time I use more than one Silver Efex Pro conversion, with each different filter on its own layer. Note that I've retained the original color image as the bottom, Background layer.

▼ Pages 132–133: In creating this black and white conversion from a color photo of a red pepper, I wanted to achieve an intentionally old-fashioned effect. So I started with a Color Efex Antique Plate layer as the primary basis for my conversion. On top of the Antique Plate layer I added a Silver Efex Pro High Structure layer (to add definition) and an Overexposure layer (to brighten), with both layers selectively applied using layer masks and painting-in the areas I wanted.

85mm macro, five exposures combined in Photoshop at shutter speeds between 30 seconds and 3 minutes; each exposure at f/51 and ISO 100, tripod mounted

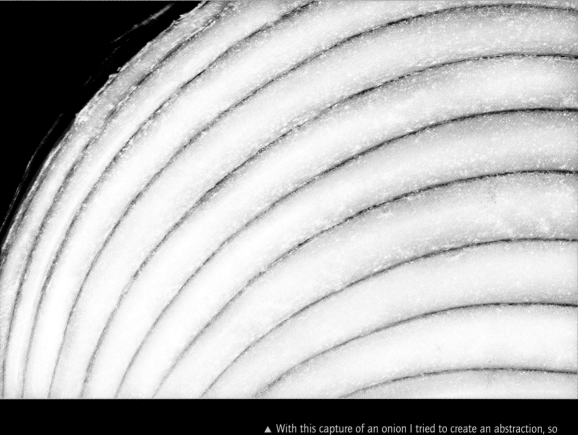

▲ With this capture of an onion I tried to create an abstraction, so that the layers of the onion appear something like the tracks in a race course.

200mm macro, three exposures combined in Photoshop at shutter speeds between 30 seconds and 90 seconds; each exposure at f/32 and ISO 100, tripod mounted

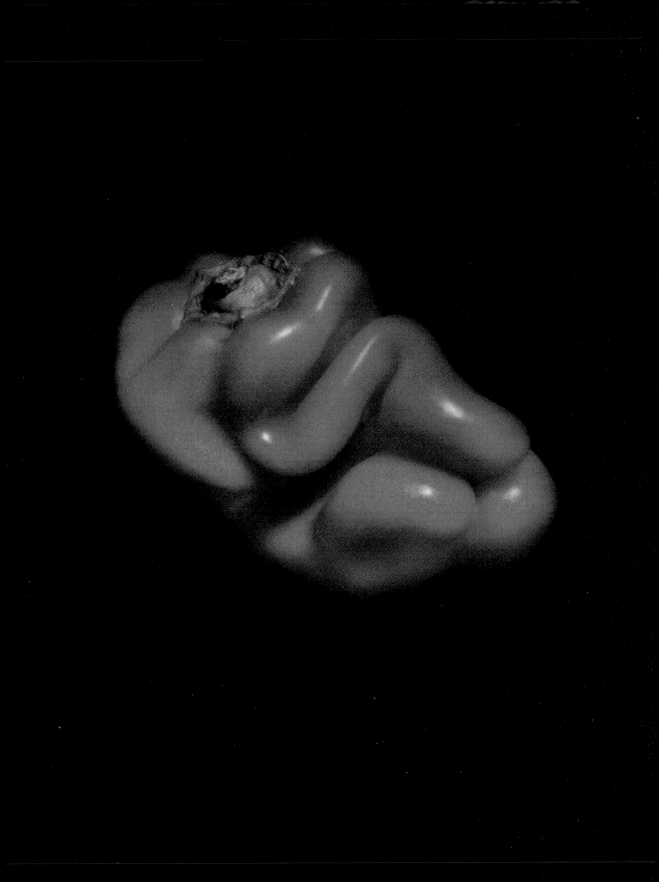

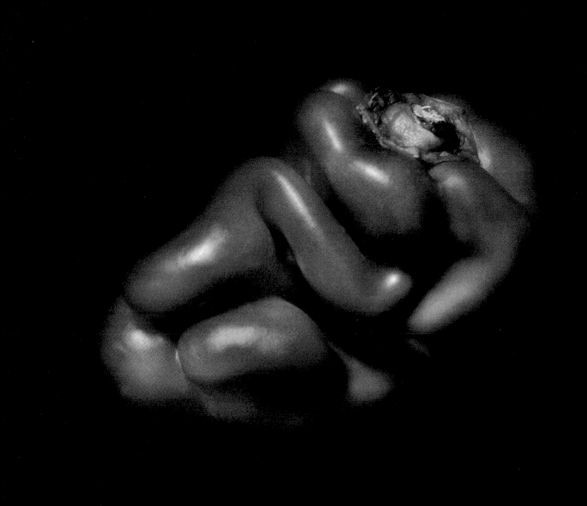

▲ I used an LED light positioned behind some marbles to create this still-life composition that makes strong use of shadows.

▶ Among the many Silver Efex Pro filters, there are quite a few that use the black and white conversion process to simulate the appearance of an image as if it had been shot with a specific film camera or film stock. In this black and white conversion, I used the Holga Silver Efex Pro simulation for a slightly antique effect with increased contrasting grain.

Both: 200mm macro, 8 seconds at f/36 and ISO 100, tripod mounted

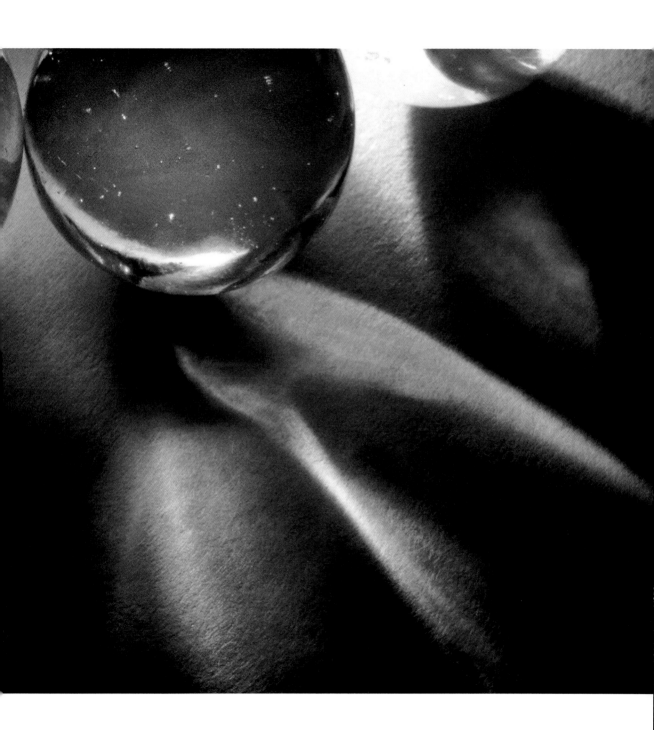

Combining Conversions in Photoshop

It's certainly true that no one black and white conversion technique works well for all photos. In addition, I usually find that a single black and white conversion technique doesn't work for all parts of a photo. My expectation is that my black and white conversions will require a number of different filters and effects—with each one on its own layer and with different effects applied to different parts of the image.

As I've mentioned, before I even get to the black and white conversion I like to process the color photo so it will convert into a dramatic black and white shot. This often means increasing the contrast and saturation, as well as using multiple RAW processing techniques to properly bring out the exposure for the different areas of the photo (see pages 108–113).

Here's an example of how I might go about using multiple conversion techniques in a single black and white conversion.

I started with a color version of a photo taken in the ancient Bristlecone Pine forest high in the desert mountains along the California-Nevada border. To live up to the drama inherent in the color version, I knew I would have to process the foreground portions of the image differently from the clouds and sky.

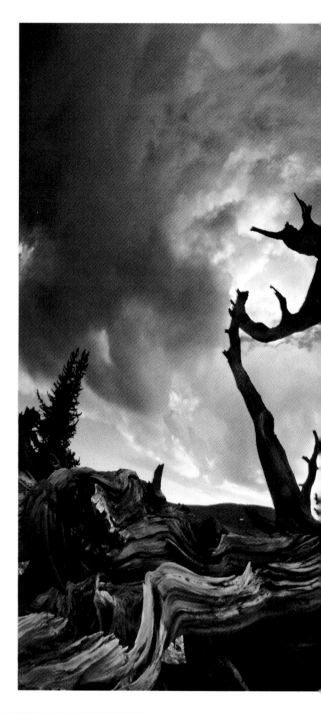

▶ I processed the RAW file to increase saturation and contrast in the color image.

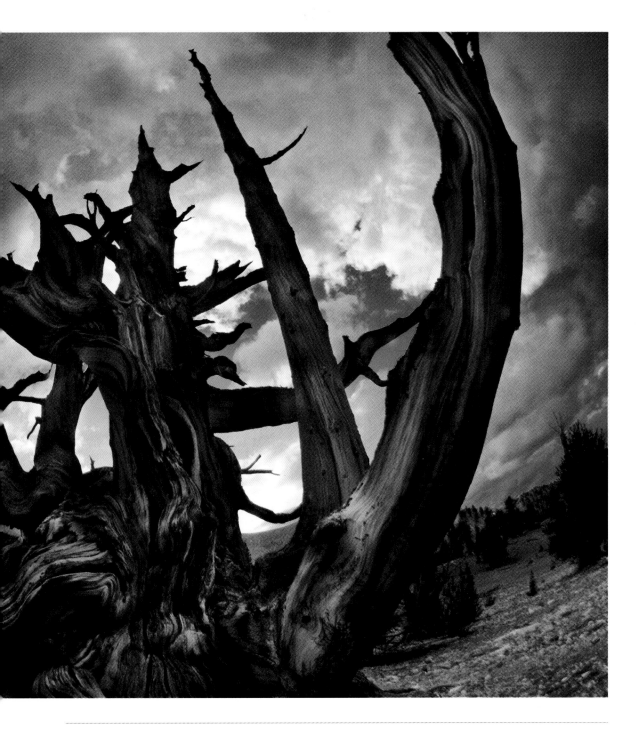

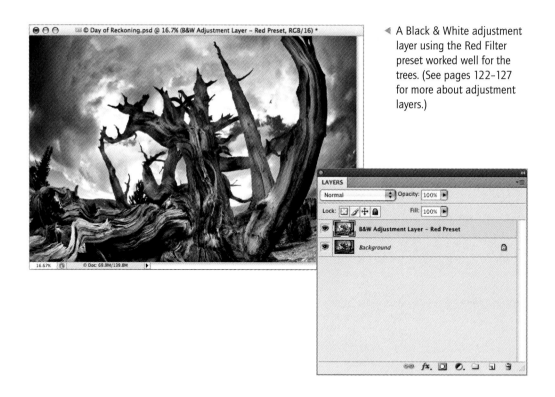

◁ A Black & White adjustment layer using the Red Filter preset worked well for the trees. (See pages 122–127 for more about adjustment layers.)

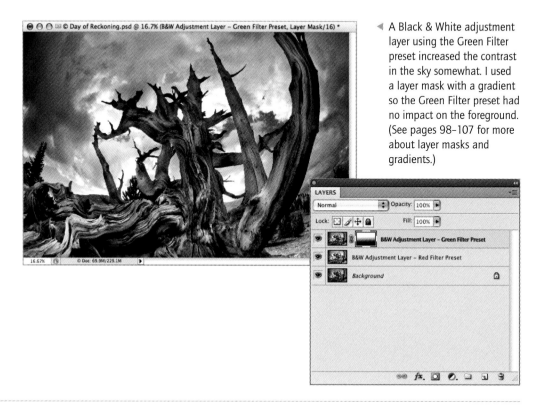

◁ A Black & White adjustment layer using the Green Filter preset increased the contrast in the sky somewhat. I used a layer mask with a gradient so the Green Filter preset had no impact on the foreground. (See pages 98–107 for more about layer masks and gradients.)

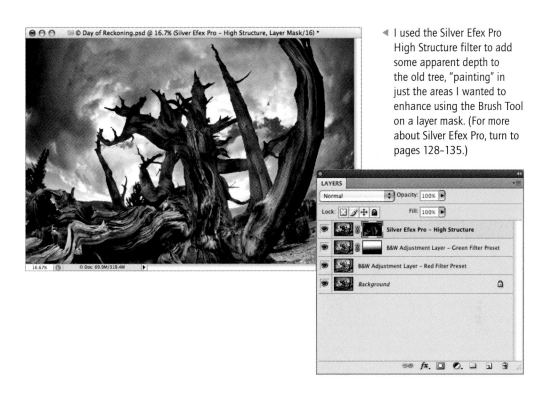

◀ I used the Silver Efex Pro High Structure filter to add some apparent depth to the old tree, "painting" in just the areas I wanted to enhance using the Brush Tool on a layer mask. (For more about Silver Efex Pro, turn to pages 128–135.)

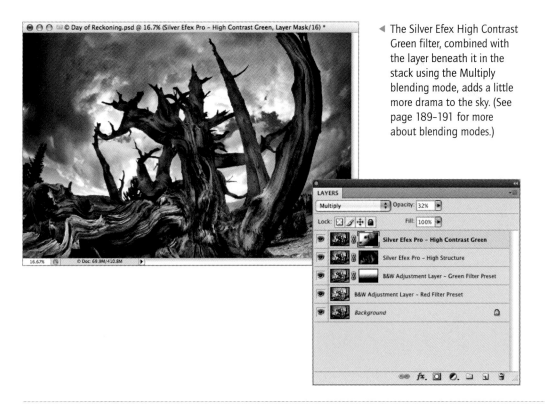

◀ The Silver Efex High Contrast Green filter, combined with the layer beneath it in the stack using the Multiply blending mode, adds a little more drama to the sky. (See page 189–191 for more about blending modes.)

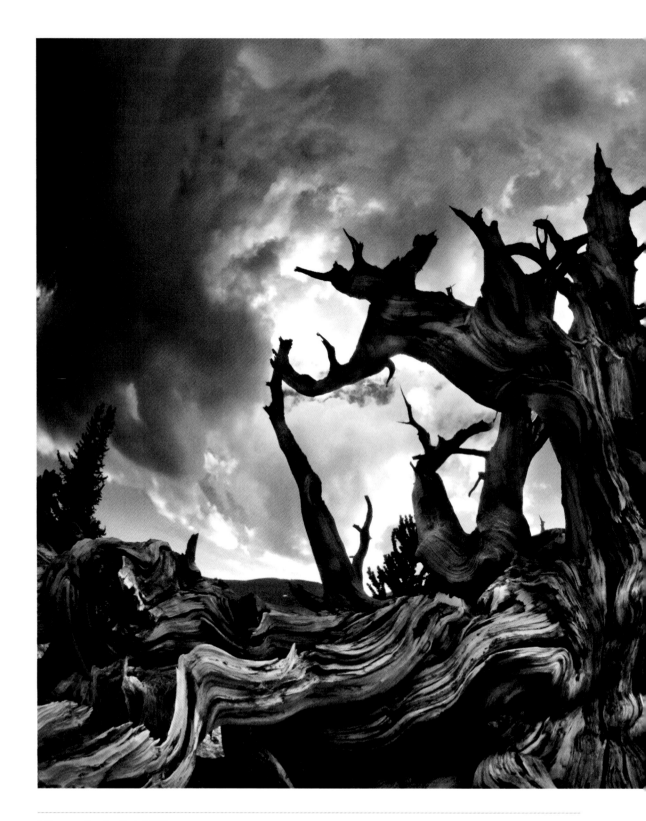

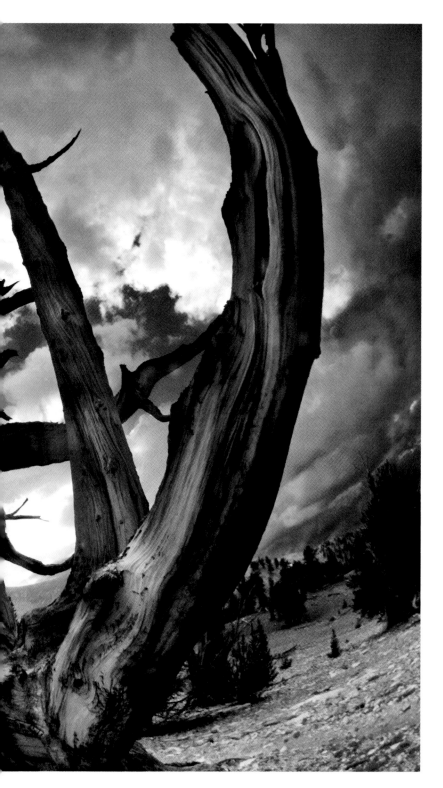

◄ On a day of turbulent, dramatic clouds and weather I wandered in the high, desolate groves of Bristlecone Pines. These oldest of living things are a photographer's dream—whether you work in color or black and white. I knew that to present the nuances and contrast in this subject I would need to use several conversion tools when I converted my capture to monochrome.

10.5mm digital fisheye, 1/60 of a second at f/22 and ISO 200, tripod mounted

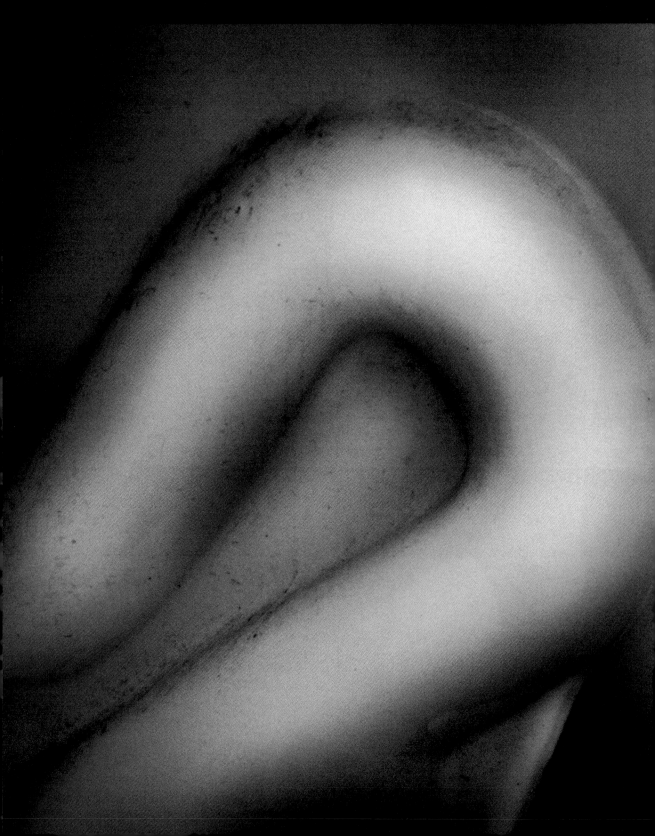

Lighting and Monochromatic Photos

If there's one thing almost all photographers agree on, it's that photographs are about capturing light. How your subject is lit—whether you arrange the lighting, or it is natural because the light was "just there"—is crucial to the success of any photo. The most important aspect of the art and craft of working with light is perceptual. It's necessary to learn to be able to pre-visualize the impact of lighting—and relatively small changes in lighting—on a final image.

The way light works in your photographic compositions is different depending on whether your photo is a monochromatic or color image. With color, there are more variables. Light with a given quality can interact and appear differently depending on what is being photographed. Two objects, right next to each other in the same photo, can reflect different color temperatures, even though they are lit the same way. The infinite gradations of light intensity, color temperature, and tone correspond to the normal way we see the world, and provide a rich and subtle palette for nuanced imagery.

The strengths of black and white tend to lie elsewhere. Light still plays a crucial role in monochromatic compositions. But its role is usually anything other than subtle. Monochrome favors bold boundaries and abrupt transitions from light to dark. When I see a subject that shows this kind of strong, abstract demarcation—particularly if color doesn't play a vital role in the composition—I start thinking, "black and white."

Since a digital monochromatic image is essentially a simulation that involves re-purposing a full color capture, working with light in black and white should take place in four stages:

- Recognizing, or setting up, a black and white composition (see Part I, *The Monochromatic Vision*, starting on page 10).

- Making an exposure (or more than one to extend dynamic range, see pages 156-165). Many of the photos I've used in this book, taken together with their captions that include camera settings information, are intended to help

▶ Watching the morning sun rise on the Yosemite Valley floor, I couldn't see much in the way of color. But the interaction of the rays of sunshine with the morning haze held the promise of an interesting monochromatic image. I intentionally underexposed my capture, then processed the photo by selectively lightening the bright areas using multi-RAW processing, layers, and masking.

32mm, 1/400 of a second at f/5 and ISO 100, hand held

▲ Pages 142-143: This photo presents an abstraction based on a composition made up of several toilets. The shapes reminded me of bodies, rather than plumbing. My idea was to make the photo look as old-fashioned as possible, so I extended the dynamic range of the image for blacker blacks and whiter whites, and "toned" the photo with an overall sepia tint.

85mm macro, 1/4 of a second at f/64 and ISO 100, tripod mounted

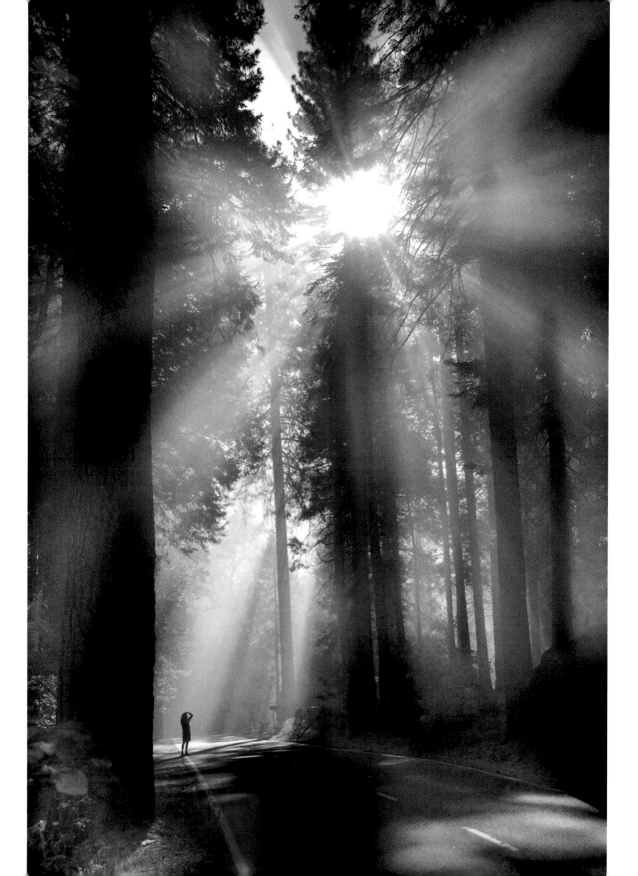

give you a starting place for your own creative black and white exposures.

- Processing an image captured in color—usually as a RAW file—into monochrome (see Part II, *Black and White in the Digital Era*, starting on page 66).

- Applying creative special effects to the way the lighting appears in your processed photos using the digital darkroom.

Part III, *Creative Black and White Opportunities*, shows you many of the special effects you can use as part of processing your monochromatic photo from the RAW file after it has been initially processed.

You can use these ideas as a reference, as possibilities to bear in mind when you conceptualize a black and white image or as recipes for enhancing your existing work.

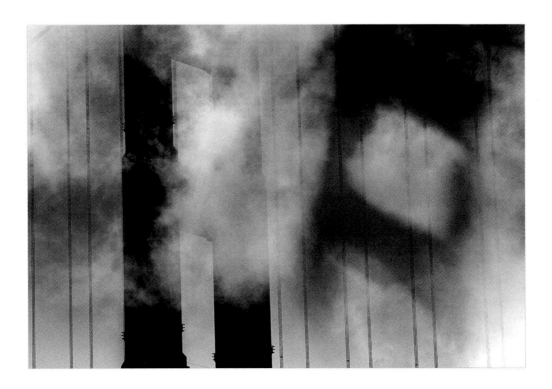

▲ From the vantage point of a sailboat under the Golden Gate Bridge, I noticed that sunlight passing through the bridge tower created a shadow of the tower projected on the fog. The unusual lighting conditions made a striking monochromatic composition possible. I overexposed the capture, then worked in post-processing to darken the tower and its shadow.

135mm, 1/1000 of a second at f/8 and ISO 200, hand held

▶ By using some carefully positioned lights in my studio I was able to create an interesting composition out of an egg, its refractions through the glass, and the shadows created by both the egg and glass.

85mm macro, 1/4 of a second at f/17 and ISO 100, tripod mounted

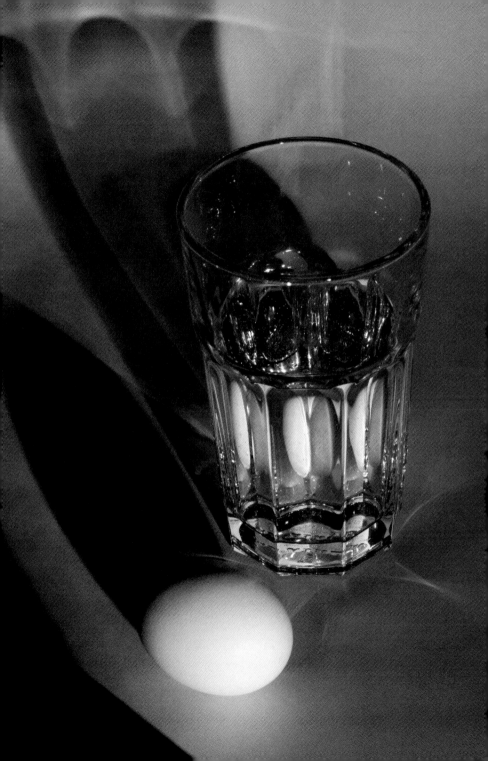

Creating High-Key Effects

When I explained high-key photography from the viewpoint of shooting the image on pages 40–43, I noted that not all subjects work well for high-key photos, and that when you find a good high-key subject you should plan to overexpose.

As I described more generally (pages 144–147), when you are looking at light in the context of a black and white composition you should consider appropriateness, exposure, RAW processing, and black and white conversion. It's best if you can learn to pre-visualize these steps as much as possible at the early stages of your creations.

With shooting with high-key in mind, look for bright, white, well-lit subjects which can be rendered in subtle shades of gray and do not require strong contrasts.

Overexpose by as much as a couple of f-stops. As you likely know, each successively smaller f-stop lets in 1/2 of the light of the previous f-stop—so a two f-stop overexposure means increasing the shutter speed by a factor of 4 if you keep the f-stop constant. For example, at f/32 if the exposure according to your camera's light meter is 1 second, then 4 seconds might be the right shutter speed for a successful high-key effect. If you bracket, you'll maximize the chances of getting the right exposure.

Process the RAW conversion in multiple layers to emphasize transparency (see pages 108–113 for more about RAW processing). This means using lighter layers for areas of the high-key image that you want to look transparent, with darker layers possibly providing information for the image's edges.

Convert to black and white using a method that tends to lighten your image; for example the Maximum White preset available as a Black & White adjustment layer, or the Overexposure filter that is part of Silver Efex Pro. You can always add a darker conversion for areas—such as edges—that you want to emphasize.

One technique that adds apparent transparency to a high-key image is to paint with white over areas you want to lighten. For the most accuracy, use a layer and layer mask as follows:

1. In the Layers palette, click the Create a new layer button at the bottom of the palette to add a transparent (empty) layer on top of the layer stack. (See pages 98–107 for more about layers).

2. Press D and then X to make sure the Foreground color is set to White.

3. Using the Paint Bucket Tool, fill the new layer with white. Your image will disappear, but don't be alarmed! It will be right back in the next step.

4. Choose Layer ► Layer Mask ► Hide All to add a black Hide All layer mask. This hides the all-white layer.

5. With the layer mask selected in the Layers palette, use the Brush Tool (set to roughly 10% opacity) to paint on the layer mask. This will make the areas you paint on more "transparent"—by adding white to them. (For more about painting on a layer mask, turn to page 103.)

▲ Page 149: I carefully placed these poppies from my garden on a white light box, and gently sprayed them with water to increase their transparency. I made a series of captures at different shutter speeds with the camera on a tripod, intentionally overexposing most of these captures.

Three of the captures were combined in Photoshop. I used the lightest captures for the flower petals, and darker captures for the edges of the flowers.

To convert to black and white, I used Black & White adjustment layers, with the Maximum White preset for the interior of the petals, and the Maximum Black preset for the edges.

As a final step, I used a layer and a layer mask to selectively paint in white in areas that I wanted to look more transparent (see page 148).

50mm macro, 3 exposures combined in Photoshop at shutter speeds from 1 second to 10 seconds, each exposure at f/32 and ISO 100, tripod mounted

▶ Looking up during a storm in Yosemite Valley, I saw the cliff briefly become visible through a break in the weather. My thought was to create a mysterious, high-key image that used the clouds to frame the cliff. So I exposed for the details of tree, rock, and snow letting the clouds overexpose.

I used a Black & White adjustment layer with the High Contrast Red filter for the background of the image, with the Silver Efex Pro High Structure filter to bring out the details on the cliff. Finally, to give the image an old-fashioned look, I tinted it with a 20% sepia layer (see pages 162–167).

200mm, 1/400 of a second at f/10 and ISO 200, hand held

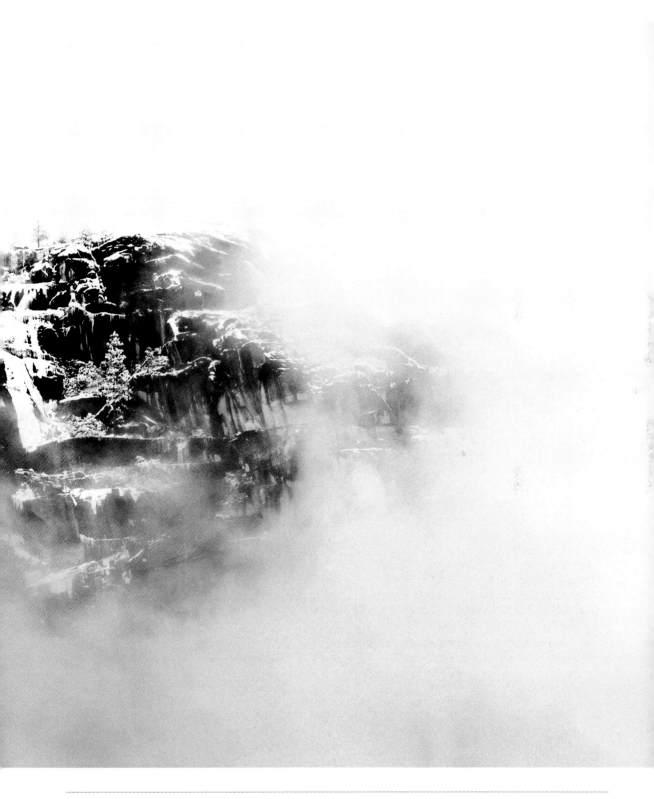

Creating Low-Key Effects

On pages 44–47 I explained that low-key images are predominantly very dark. The point of these compositions is to contrast the important areas that are lit with the blackness that surrounds them. It's human nature to vest the dark negative spaces with an aura of power and mystery—so low-key compositions can be very powerful. Another feature of low-key compositions is they are effective at isolating the key elements of a composition and removing extraneous details. You can hide many sins, not to mention a great deal of clutter, behind a curtain of dense black!

With shooting with low-key in mind, look for the exact opposite of what you'd try to find with high-key. In other words, good low-key subjects are dark and black. The best low-key subjects are intermittently lit. Lighting often shows a *chiaroscuro* effect, meaning that there is mottled lighting with an extreme contrast between light and dark areas.

Effective use of low-key lighting involves underexposing the overall scene. That way, the highlight areas, which is what you are really interested in, will be properly exposed. There's no substitute for trial and error, and for checking your captures using your camera's LCD. Since you are only interested in selective areas of your composition, with a willingness to let the rest go very dark, be sure to zoom in on the parts of the photo that matter rather than relying on an overall impression.

Process the RAW conversion using multiple layers to emphasize the darkness that you'd like to have surrounding the lit areas of your composition (see pages 108–113 for more about RAW processing). This often means creating a dark layer to use for background areas. You can layer in lighter areas using a mask and the Brush Tool.

Converting to black and white using a method that tends to darken your image—for example, using the Maximum Black preset available as a Black & White adjustment layer, or the Underexposure filter that is part of Silver Efex Pro—is a possible way to create a low-key image. Sometimes a High Contrast Red preset or filter works well with low-key images. You can always add a darker conversion for areas that need to be almost or entirely black.

One technique that adds darkness to a low-key image is painting with black over areas you want to darken. For the most accuracy, use a layer and layer mask as follows:

1. Choose Layer ▸ New ▸ Layer to add a transparent (empty) layer at the top of your layer stack (see pages 98–107 for

▶ I photographed my sleeping daughter by the light of a single low-wattage bulb. To recreate the chiaroscuro lighting of the scene once I converted the photo to monochrome, I added an all black layer and "painted in" the areas that I wanted using varying degrees of opacity.

105mm, 1/25 of a second at f/5.6, hand held

more about layers). Click OK in the New Layer window to add the new empty layer.

2. Press D to set the Foreground color to black.

3. Select the Paint Bucket Tool from the Toolbox. Click on the transparent layer with the Paint Bucket Tool. The layer will fill with black and your image will disappear. Don't be alarmed, the image will be back in the next step.

4. Choose Layer ▸ Layer Mask ▸ Hide All to add a black Hide All layer mask to the all-black layer. This hides the all-black layer and makes the image layer visible again.

5. Select the Brush Tool from the Toolbox. Set the Brush Tool's opacity to 50%. Make sure the Foreground color is set to white and then paint on the layer mask in the areas you want to make darker. You can vary the opacity setting of the Brush Tool as you work.

6. When you finish adding black, archive your layered document, and merge it down so the file can be used for reproduction or on the web.

◀ I photographed this Parks department volunteer working on restoring the wheel of an antique cannon using his work light for illumination. During the black and white conversion process I seized the opportunity to remove extraneous and distracting details from the composition by blending the photo with a black layer, and selectively painting out distractions.

135mm, 1/100 of a second at f/9 and ISO 500, tripod mounted

▶ I aimed for emotional mystery in this infrared capture of a model in the studio (see pages 222–231 for more about black and white infrared capture). In post-processing, I used the Silver Efex Pro Underexposure filter to keep the low-key effect that I had visualized.

Infrared capture, 1/50 of a second at f/4.5 and ISO 1600, hand held

HDR in Black and White

HDR—High Dynamic Range—photography means creating photos with a greater variation in tone from lightest to darker than is normally possible in a single digital capture (or a frame of film, for that matter).

The human eye is capable of perceiving a much greater tonal range than is normally captured in photography. To see this is true, try staring at the shadows in a dark room that is illuminated in one area by a shaft of strong sunlight. As your eyes adjust, you'll be able to see details in both the dark areas and in the bright sunshine. No conventional photo can do as much.

Digital photos with an extended tonal range can render an even greater gamut from light to dark of tonal values than even the human eye. This can sometimes cause these photos to look unnatural and almost unreal—which, depending on the context and the intention of the photographer is either good, or bad.

When it comes to digital black and white photography, there are a number of possible strategies for extending dynamic range:

- Multi-Raw processing (pages 108–113)
- Combining black and white conversions (pages 136–141)
- High Dynamic Range (HDR) photography

You'll find examples of photos that use these different strategies throughout this book; this is generally explained in the caption information for each image.

To create an HDR image, start by shooting multiple captures at different exposure settings. The multiple captures are combined in post-processing to create a single image.

Hand HDR involves putting the captures together in Photoshop using layers and masking (pages 98–107). Automated HDR uses automatic software to do this compositing. Photoshop provides an automated HDR feature, but the best software for the job is Photomatix, explained in this section.

Color images created with Photomatix HDR can look garish. In black and white, no colors no problem. I think you'll find that using an automated HDR program such as Photomatix can open a whole world of new possibilities in your creative black and white work.

Shooting for HDR

Whether you use Photoshop, Photomatix, or some other tool, here's what I've found to work best when shooting for HDR:

- The camera shouldn't move between captures; therefore, I almost always use a tripod.
- I keep my ISO fairly low, probably less than 400. Otherwise, my HDR composite is likely to get very noisy.
- It's better to vary the shutter speed than the aperture. If you change apertures between captures, you may change the depth-of-field between images—which could make the final HDR composite

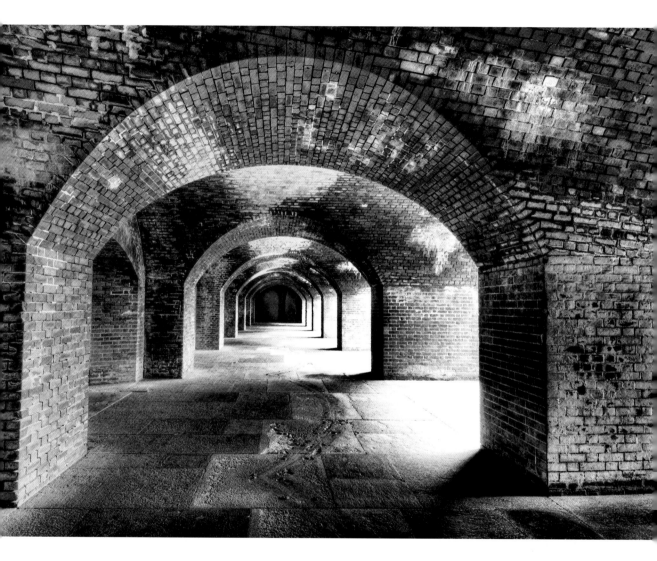

▲ I was impressed with the patterns of light and shadow on the brick work at the historic Fort Point beneath the Golden Gate Bridge in San Francisco, California. However, I realized that a single exposure could not possibly capture the dynamic range involved. So I made a series of bracketed exposures, and used HDR techniques to blend the captures to extend the dynamic range of the final image.

14mm, 6 exposures combined in Photomatix at exposure times from 0.6 of a second to 8 seconds, each exposure at f/22 and ISO 100, tripod mounted

look off-balance and simply weird—because the in-focus areas wouldn't be the same from image to image.

- Assuming you are bracketing the shutter speed, you should have no fewer than three captures. You may get better results with more captures; 5–10 is a good range.

I tend to bracket at about 100% shutter speed increments, calculating my exposures manually rather than using an in-camera bracket program. For example, I shot the three images of the ornate and unused Capitolio Nacional (below) using a digital

fisheye at 0.4 of a second, 0.6 of a second, and 1.3 seconds.

Using Photomatix

There are two parts to Photomatix: the initial HDR blend, and an adjustment step that is called "applying a tone curve."

Using the first part of Photomatix couldn't be simpler. You fire up the application, and the small window shown in Step 1 opens. Choose Generate HDR image, choose the images to blend in the window shown on the right, and click OK.

▶ These three images of the ornate and unused Capitolio Nacional were shot using a digital fisheye at 0.4 of a second, 0.6 of a second, and 1.3 seconds. Here the three RAW captures are shown in Adobe Bridge. I'm going to process them in Photomatix to show you how HDR blending works.

▶ Step 1: Launch Photomatix and click the Generate HDR image button in the Workflow Shortcuts window. Then, use the Generate HDR window to choose the images you want to blend and click OK.

The HDR blending process may take a while, even on powerful hardware.

▶ Step 2: When the blending is complete, a window like the one shown below will open. Don't pay too much attention to the way the image looks at this point.

Click the Tone Mapping button in the Workflow Shortcuts window, and then fiddle with the sliders until you get something you like.

You don't really begin to see what you get with Photomatix HDR until you perform this Tone Mapping step. It's well worth playing with the various sliders until you like the results.

Try to bear in mind that the final image will be in black and white. This means you can ignore unfortunate colors and concentrate on the tonal range as if the colors were not there.

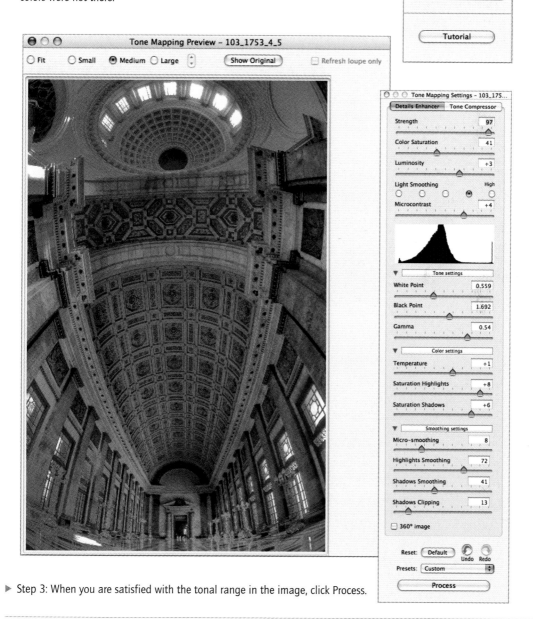

▶ Step 3: When you are satisfied with the tonal range in the image, click Process.

▶ **Step 4:** Here's a Photomatix trick: After you've processed your tone curve, you can press ⌘+T (Mac) or Ctrl+T (Windows) and re-process the image a second time. Depending on the image, you are likely to get an even greater HDR effect with this second processing.

Following a second tone mapping there's an even greater tonal range in the image to the right, although the image admittedly looks pretty garish in color. Fortunately, we don't care about the color.

▶ **Step 5:** When you've finished tone mapping your image, use the Photomatix File menu to save it as a TIFF file. Then open the file in Photoshop and convert it to black and white as you would any other color photo. (See pages 114–141 for Photoshop black and white conversion methods.)

▶ I bracketed exposures inside the Capitolio Nacional in Havana, Cuba—not so much with the plan of creating an auto-generated HDR image but in order to be sure to get the right exposure values. Back at my computer, the three captures I had made did seem in fact like a good candidate for processing with Photomatix. After running the sequence through Photomatix twice (see Step 4 above), I converted to black and white using the Nik Silver Efex Pro High Structure filter—which further enhanced the HDR effect.

10.5mm digital fisheye, 3 exposures combined in Photomatix at exposure times from 0.4 of a second to 1.3 seconds, each exposure at f/13 and ISO 100, tripod mounted

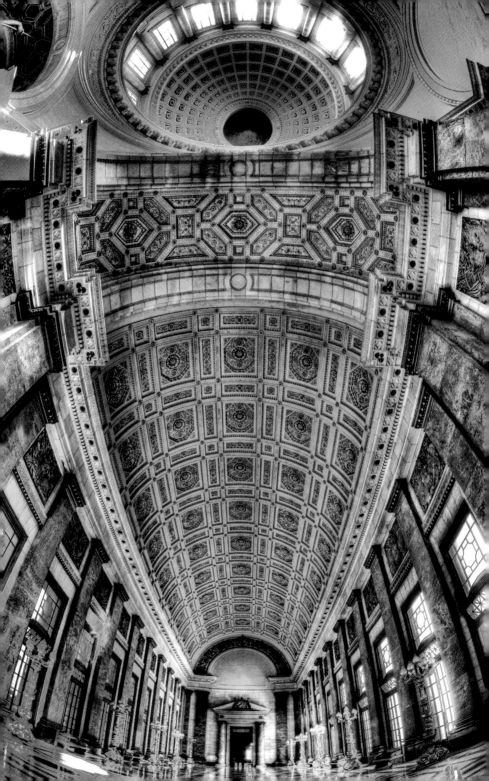

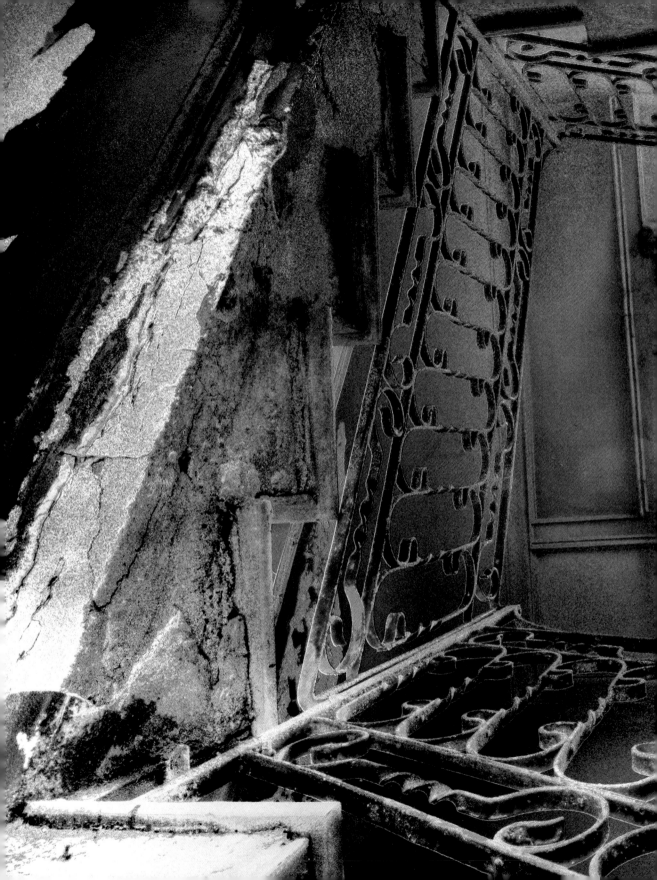

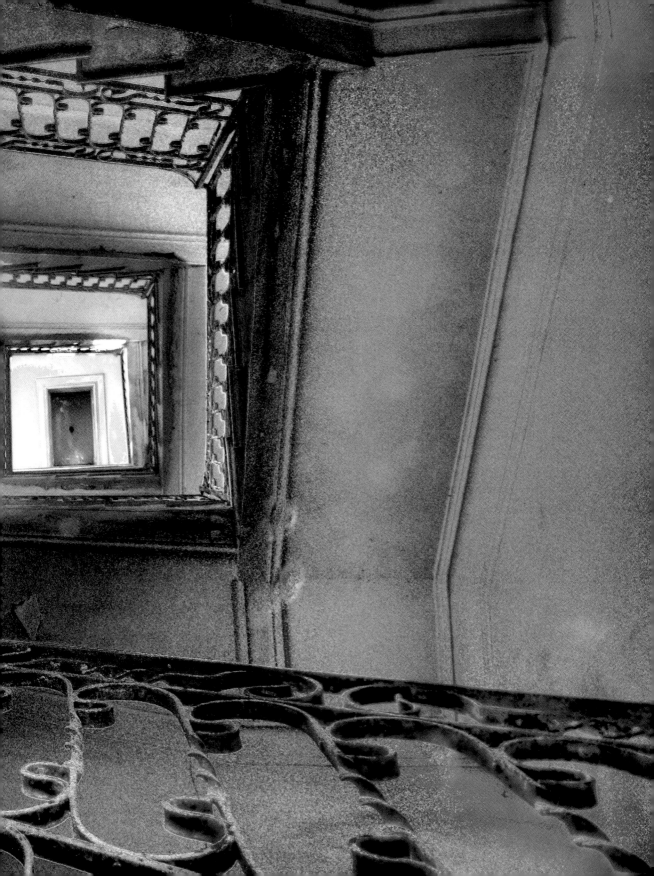

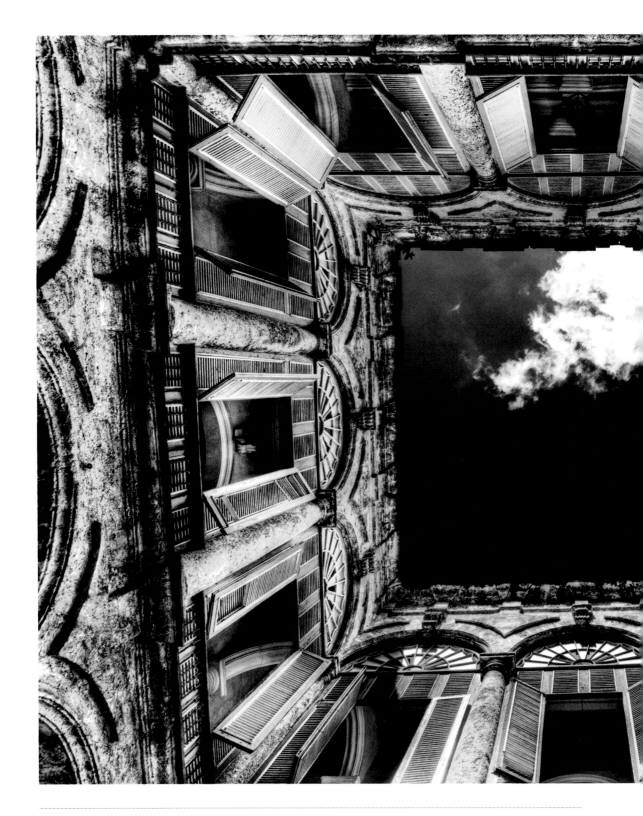

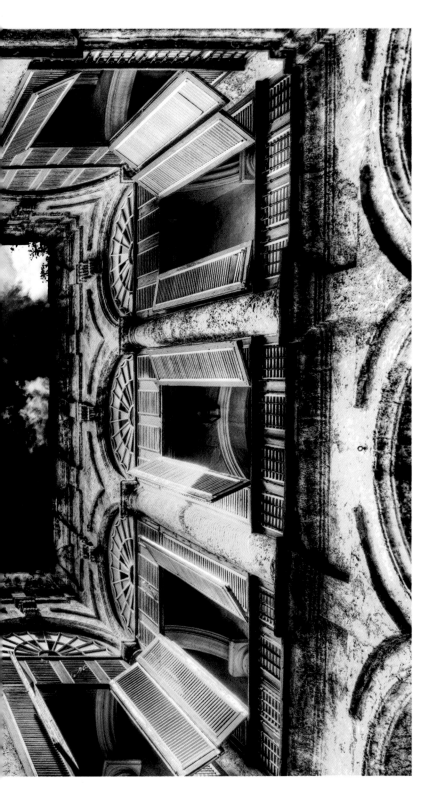

▲ Pages 162–163: I stood at the bottom of a stairwell in Cienfuegos, Cuba and looked up. I knew a single capture could never render the extreme dynamic range from the dark parts of the stair to the bright sunlight, so I exposed a series of bracketed exposures, with the plan of combining the exposures to extend the dynamic range in post-processing. Processing this image for HDR in Photomatix added considerable noise—some of which I converted to simulated film grain (see pages 218–219). But I didn't mind, as the apparent messiness of the image fits well with the tumble-down state of the stairs.

13mm, 6 exposures combined in Photomatix at exposure times from 1/2 of a second to 20 seconds, each exposure at f/22 and ISO 100, tripod mounted

◀ My idea with this black and white HDR image was to subvert the usual assumptions about framing an architectural photo. When you realize that the camera was positioned at the bottom of a courtyard, it's easy to see you are looking up at the sky. However, at a glance the nearly square patch of sky and cloud could be a framed work of art on the wall. Using HDR allowed me to lift the bottom of the courtyard out of shadow and expose the decorative details within the windows making this visual double take possible.

12mm, 6 exposures combined in Photomatix at exposure times from 1/250 of a second to 1/25 of a second, each exposure at f/14 and ISO 100, tripod mounted

Toning and Tinting

Black and white is black and white, right? Not so fast, pardner. From the very beginnings of photography, black and white has actually meant the light brown of sepia toning, the gray caused by the chemical selenium, the blue of the cyanotype process, and so on—the single, monochrome color on a scale with white. In other words, black and white means monochrome, but it doesn't literally imply that the image is actually and literally in the key of black.

Historically, toning was the result—or by-product—of the chemical process used to make a print, although aesthetic choice may also have been involved when a toned effect was actively sought after. Toning sometimes added archival qualities and extended the tonal range of a print; whereas, tinting simply added color.

With digital photography, all "toning" and "tinting" choices are virtual—applied digitally—and intended to add to the visual appeal of a black and white photo.

The decision to tone a digital photo means to add a color tint to some or all of a photo for aesthetic reasons. Thus, in the digital world, there is no difference between toning and tinting (in the chemical darkroom the two may have been achieved differently). However, if you want those who look at your monochromatic photos to associate the added color with the kind of tones they've seen in vintage photos, you should keep your color choices to those that might plausibly have been seen in toned, old prints.

Obviously, there are many ways to add a color overlay to a monochromatic image. These methods work with images that are in RGB or CMYK (if you've converted your images to Grayscale, you should convert it back to a color mode).

It's worth noting that most monochromatic digital images are archived as RGB color files, and only converted to grayscale if there is a specific reason for doing so.

Here are some of the simpler ways to add a tone or tint to your image:

- In Adobe Camera RAW (pages 76–81) choose the Split Toning tab. Enter the same values for highlights and shadows.

- In Adobe Lightroom (pages 82–97) use the Split Toning tab with the same values set for highlights and shadows.

- In Photoshop, place a layer filled with your color above a photo on the background layer, and then adjust opacity and blending mode until you achieve the desired effect.

- In Photoshop, add a Hue/Saturation adjustment layer to your photo, with the Colorize box checked.

- In Photoshop, add a tint to a Black & White adjustment layer (see "Tinting with a B&W Adjustment Layer" on page 167).

Note: You can also use programs like iPhoto and Picassa to add tints to your photos. In addition, many cameras will add tones to copies of your photos before you even download the images to your computer.

Tinting with a Black & White Adjustment Layer

▶ Step 1: Add a Black & White adjustment layer as shown in Steps 1 and 2 on page 123.

After adding the Black & White adjustment layer, the Default preset becomes active in the Adjustments palette, converting the layer to a neutral monochromatic image.

▶ Step 2: In the Adjustments panel, check Tint. This adds a virtual tone to the image.

▼ Step 3: Click the swatch to the right of the Tint check box to open the Color Picker window. Use this window to select the color of the tint that will be added to the image.

After selecting the tint, click OK to close the Color Picker.

I suggest cutting the opacity of a Black & White adjustment layer used for the purpose of adding a tint or tone down to the 20% to 25% range so that the effect doesn't seem overwhelming.

◄ I chose to add a slight sepia tint to this photo using a neutral Black & White adjustment layer with the Tint box checked to give the image a slightly antique look, and to recreate the "feel" of the original background.

85mm macro, 0.4 of a second at f/24 and ISO 100, tripod mounted

► I wanted to give this high-key portrait of Christianna an old fashioned look. I started with the Silver Efex Pro Tin Type filter, then used Silver Efex Pro to add sepia tone and a vignette effect (the darkened corners of the image).

32mm, 1/160 of a second at f/6.3 and ISO 3200, hand held

▲ I photographed the Rodin sculpture garden at Stanford University at night. My idea after converting the photos of Adam (above) and Eve (right) to monochrome was to show the dreams these figures might be having—their shadows—as warmer than Adam and Eve themselves, figures lost in the mists of time. So I used a simple layer mask and gradient to tint the sculpture side in each image a cool blue and the opposite side shadow in warmer sepia tones.

Both: 82mm, 4 seconds at f/11 and ISO 200, tripod mounted

Split Toning

Split toning means adding two different tones to an image. Classically, this was accomplished using chemical baths that impacted highlights and dark areas differently. Split toning is therefore often considered an effect that treats dark tones and highlights differently—but there is no reason to limit the effect to this traditional use.

You can use the Split Toning tools available in Adobe Camera RAW and Lightroom to easily add a classical split toning effect—where the highlights and shadows have different added tints.

In Photoshop, there are a number of different approaches to achieving a split toning effect. If you want the traditional split between highlights and shadows, you can use the Color Range window to make separate selections of highlight areas and shadow areas. With each selection, create a mask. Invert the mask to apply the desired tint only to highlights, and only to shadows using any of the techniques for applying color I've shown you.

Another alternative is to use layers and masking to paint in whatever tones you want for visual effect. To heck with tradition! It's good to know some photo history so the context of modern digital image making is clearer. However, why be limited by the chemical photo techniques of the past?

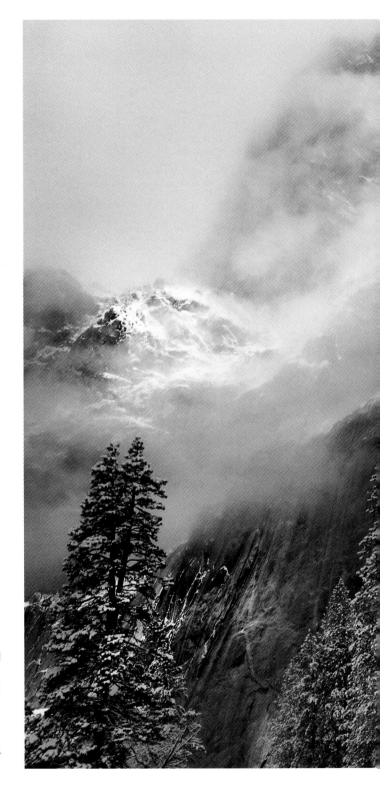

▶ The difference in feeling between the foreground trees and the mountains in the background made this winter Yosemite image seem a natural for split toning. I used a light, warm sepia tone for the highlights, and a darker sepia tone for the darker areas of the photo.

27mm, 1/350 of a second at f/10 and ISO 100, tripod mounted

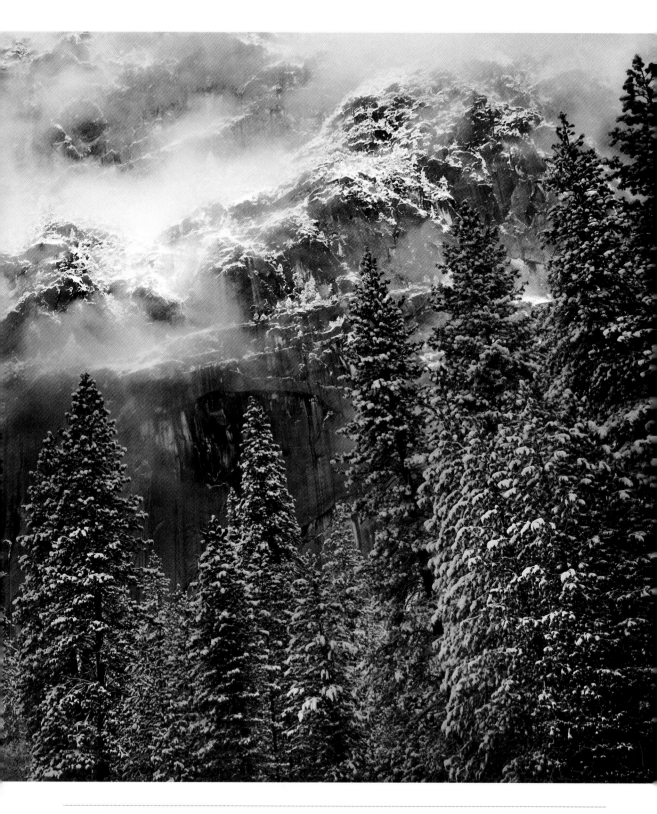

Selective Color

In Steven Spielberg's mostly monochromatic film *Schindler's List*, there's one small bit of color: a girl in a red coat. We later recognize the girl on a pile of corpses because of the color of the coat she's wearing.

This visual device using selective color works in *Schindler's List* because it is somewhat restrained. In other words, it's easy to create a selective color effect in an otherwise monochromatic image, but seldom an effective creative choice because it can often seem unnatural and over the top. When you do try it, don't overdo it!

If you have a color version of a monochromatic image, it's easy to sandwich the color

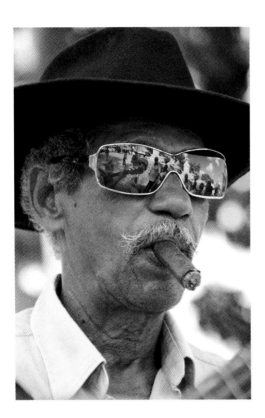

▲ Live music is a big part of everyday life in Cuba. I photographed this cigar-smoking guitar player in the central square of a provincial Cuban city.

▲ I converted the photo to black and white, but thought that something was missing. I decided to apply selective color via masking to the reflections in the sunglasses.

and monochromatic versions together. You can then add selective color by masking out the color and selectively painting small areas of it back in.

Depending on the situation, another approach is to literally paint-in the color you'd like. I always suggest doing this on a duplicate layer, in case you want to adjust the opacity at a later point.

Either way, it's easy to add spots of color to a monochromatic image. The hard part is making sure that the color adds cohesion to a black and white photo in a pleasing way and doesn't seem to be just a gimmick.

▶ Step 1: Make sure the black and white version is on the layer stack above the colored version in the Layers palette.

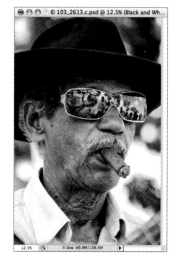

▶ Step 2: With the black and white layer selected in the Layers palette, choose Layer ▶ Layer Mask ▶ Reveal All to add a white layer mask to the black and white layer.

The white Reveal All layer mask makes the color layer beneath invisible.

▶ Step 3: Select the Brush Tool from the Toolbox and set it to 70% Opacity and 70% Hardness (this is just a starting place for these settings, you can vary them as you paint). Make sure the Foreground color is set to black.

▶ Step 4: With the layer mask selected in the Layers palette, paint on the image window in the sunglass area. As you paint, color will appear on the sunglass lenses. Make sure the edges of the glasses look crisp.

This is how the layer mask looks after painting

▶ There was no glow present at the end of the cigar in the color photo, but I thought I might as well add some burning embers to the mostly monochromatic version of the photo. I used the Brush Tool to paint in red at low opacity on a duplicate layer, suggesting a faint glow at the end of the cigar.

▶ The finished image is entirely in shades of gray except for the reflections in the sunglasses (taken from the color version) and a faint glow at the end of the cigar (painted in).

200mm, 1/125 of a second at f/5.6 and ISO 200, hand held

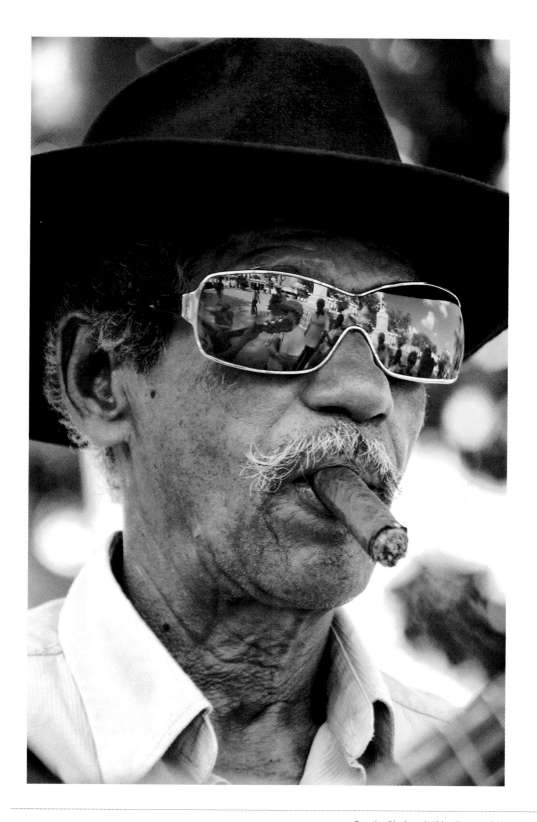

Hand Coloring

Ever since the earliest days of photography people have been painting by hand in color on black and white photos. Originally this was a laborious process that started with a finished black and white print and added color with the idea of adding realism to the image. When color photography came along, some photographers continued hand painting their monochromatic prints for the value of the aesthetic statement they could make by applying a paint brush to their finished prints.

With digital monochrome, it's easily possible to add a hand color effect without having to be particularly good at painting.

As I've mentioned, a black and white digital photo is a kind of virtual mono-chromatic image that dispenses with colors for aesthetic purposes. Imagine:

creating a hand color effect on top of a monochromatic image is doubling the simulated nature of the ensemble. First, the monochromatic image is abstracted from a color file. Next, digital tricks are used to add back in some color, but this digital color looks intentionally applied—a digital artifice added to an already artificial construct. What fun!

That said, the best monochromatic images for hand coloring are those that will exhibit internal visual cohesion and logic when the color is applied. Hand colored black and white photos may be intentionally "retro" but they needn't be gauche. Look for imagery that has an antique look before hand coloring is applied, be selective about the application of color, and try to extend the anachronistic appeal of your hand-colored photo.

◀ I created the hand-colored effect by dragging the color version of the image back over the monochromatic version, adding a Hide All layer mask, and painting-in the model at reduced opacity. I did this twice, once with the layer blending mode set to Overlay and the second time with the blending mode set to Screen.

▶ Adding selective color back into the "tintype" photo of Christianna shown on page 169 creates an interesting effect that works well with the idea of a tintype, since tintypes historically were often painted on.

32mm, 1/160 of a second at f/6.3 and ISO 3200, hand held

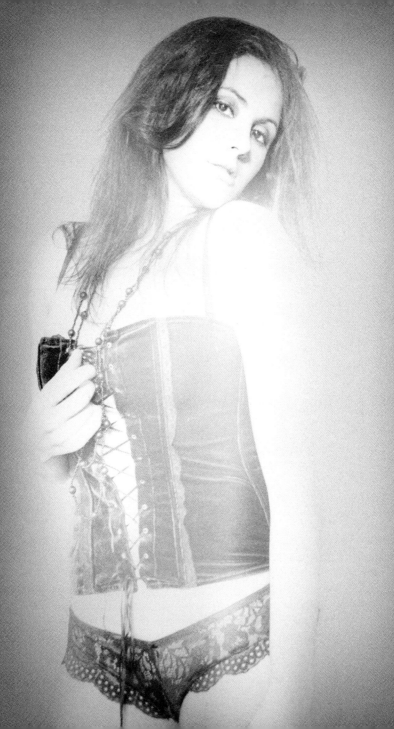

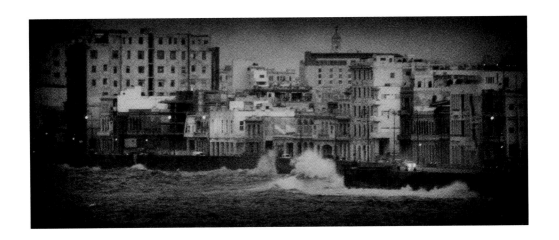

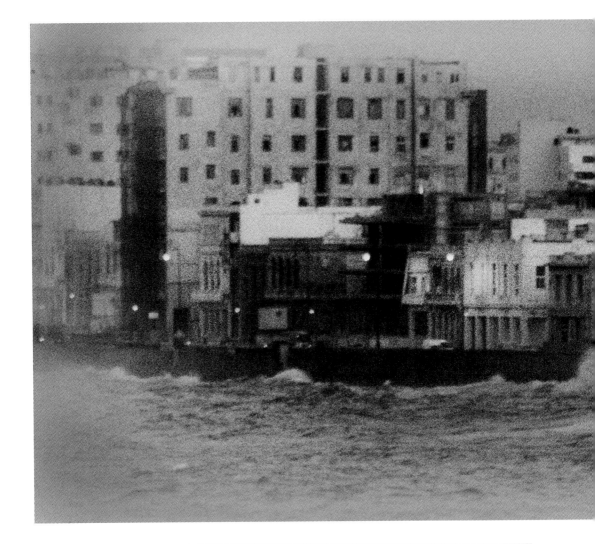

◄ Along the Malecón, the boulevard that runs beside the ocean in Havana, Cuba, waves often crash across the road. Building maintenance has been deferred, and a number of structures fall down every year. During a storm, I snapped this telephoto view of the architecture of Old Havana behind the Malecón at a high ISO. I wanted to convey the decayed aspect of this architecture, so I converted the image to monochrome.

▼ The monochromatic view was interesting, but I wanted to add emphasis and a sense of how things had faded in the years since the Cuban revolution. What better metaphor than fading color? I lightened the image and applied a selective layer of color to the photo, helping to make the image look antique.

Both: 200mm, 1/60 of a second at f/5.6 and ISO 400, hand held

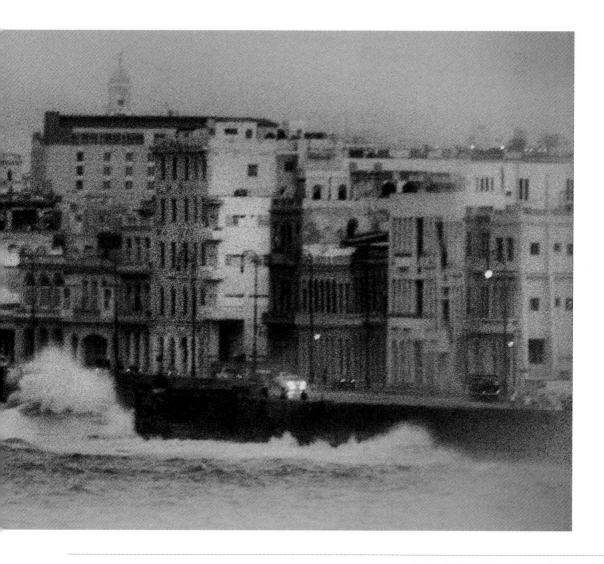

Using LAB Color

I've mentioned using color information in a capture to create interesting effects in black and white. This may seem paradoxical—but it's not because color information can be really valuable when it comes to making interesting black and white images.

Color information is used as part of the more flexible black and white conversion processes—for example, the color sliders in the Channel Mixer are used to determine the composition of a monochromatic conversion. The suggestion here is a little different: radically manipulate the image in color before conversion to get spectacular black and white following conversion.

The LAB color space is particularly useful for this kind of work because LAB separates black and white from color information. This means that you can do downright radical things to the monochromatic information in your color image, recombine the color and black and white, then convert to color—ending up with a work product that is inarguably different from your starting place, and in some cases markedly superior.

Let me back up for a little and explain what you need to know about the LAB color space. Then I'll show you some examples of how techniques that use LAB color can improve your black and white results.

Understanding LAB

A color model—sometimes called a *color space*—is the mechanism used to display the colors we see in the world. You are probably familiar with two of the most common color spaces, RGB and CMYK. The RGB—Red, Green, and Blue—color space is used to display photos on a monitor. The CMYK—Cyan, Magenta, Yellow, and Black—color space is primarily used for printing books, magazines, and other materials.

You may not know as much about the LAB color space, which is structured in three channels:

- The L channel contains *luminance* information. Luminance is another way of referring to the black and white data in a photo. In the Photoshop Channels palette, the L channel is called the *Lightness* channel.

- The A channel provides information about greens and magentas.

- The B channel provides information about yellows and blues.

I'm not going to go into the details of the theory of LAB, or many of the aspects of how best to work with LAB. You could write a book on these topics (and, in fact, books have been written).

What you need to understand is that the black and white information is completely separate from the color information. This means that you can operate on the black and white data without having any impact on the color in an image. Specifically, if you want to swap blown-out highlights for shadows—and, in some cases, you might—LAB is the way to go about it.

By the way, it is worth mentioning that you can't actually do anything with an image in LAB. Printers aren't calibrated for LAB, and there's no such thing as a LAB JPEG that you can display on a photo sharing site. Before you can use an image that you've worked in LAB, you'll need to convert it back to RGB or CMYK.

Converting a photo into the LAB color space only takes a second in Photoshop. There are two ways to go about it as shown below.

▶ To convert to LAB color:

Choose Image ► Mode ► Lab Color

or

Choose Edit ► Convert to Profile. The Convert to Profile dialog will open. Select Lab Color from the Profile drop-down list in the Destination Space area. Make sure Relative Colormetric is selected from the Intent drop-down list and that Use Black Point Compensation is checked.

It's probably better to use the Edit ► Convert to Profile method because that way you can be sure the right options are used.

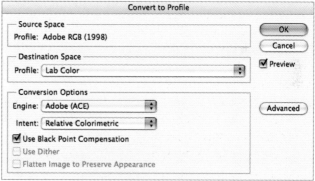

▶ Once you've converted an image to LAB mode, take a look at the Channels palette. There you'll see the three channels: Lightness, or L, containing the black and white data; and the A and B channels for the color information.

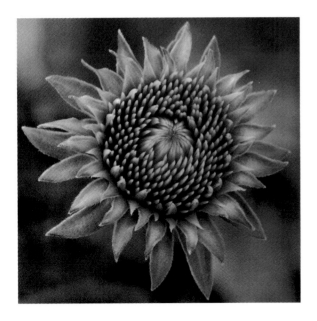

Flower Effects

The small, green flower bud to the left is a young Echinacea, sometimes called a Cone Flower. I knew I had to photograph it—and I realized that the image was essentially only one color: green. To me, this meant that I would end up creating a black and white photo. However, a standard conversion to black and white (below left) using Black & White adjustment layers yielded unexciting results.

Looking at the black and white photo, I thought it was acceptable, but I longed for an image with more punch and pizzazz. So I decided to go back to the color photo in Photoshop to increase the contrast in LAB before converting to black and white. The increased contrast would make for a more interesting monochromatic image.

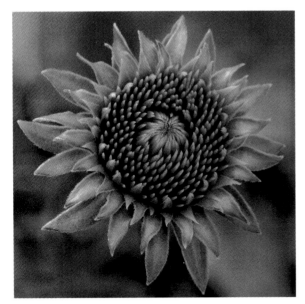

▲ Top: Since this capture of a green Echinacea bud was essentially one color, it was a good candidate for black and white conversion.

▲ Below: I used Black & White adjustment layers in Photoshop for a "normal" conversion of the image to black and white. However, I wanted more from this conversion.

Both images: 85mm macro, 1/2 of a second at f/16, tripod mounted

Inverting the L Channel

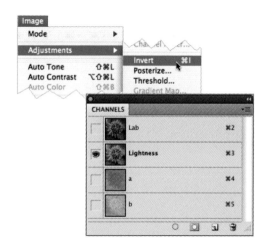

▶ Step 1: Convert the image to the LAB color space by choosing Image ▸ Mode ▸ LAB Color from the Image menu (see Step 1 on page 183).

▶ Step 2: In the Channels Palette, select the Lightness (L) channel. This channel holds all the luminance, or black and white, information in a photo.

▶ Step 3: With only the L channel selected, invert the black and white information in the photo by choosing Adjustments ▸ Invert from the Image menu.

The color image appears with whites and blacks "inverted"—a sometimes odd look that can be quite striking.

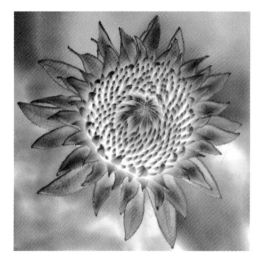

▶ Step 4: Convert the image back to RGB by selecting Image ▸ Mode ▸ RGB.

▶ Step 5: Convert the image to black and white using Black & White adjustment layers. (For more about converting using adjustment layers, turn to pages 122–127.)

The effect here is pretty cool and a bit like solarization (see pages 200–203 for more about solarization). But looking at the result made me somewhat dizzy. I wanted a black and white effect that was striking, but maybe not quite so opposite in luminance levels to the original photo.

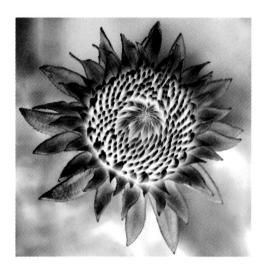

Equalizing LAB Channels

▶ Step 1: Starting with the original color photo, convert the image to the LAB Color space by choosing Image ▸ Mode ▸ LAB Color from the Image menu (see Step 1 on page 183).

▶ Step 2: With all the channels selected, choose Image ▸ Adjustment ▸ Equalize.

Equalization adjustments push tonal values towards the maximum so blacks become blacker and whites become whiter. The color image of the Echinacea (below right) now has more contrast.

(As a different technique, you could select just one channel and equalize it. Try it and see what effects you get.)

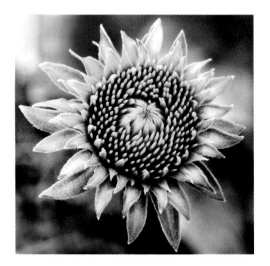

▶ Step 3: Convert the image back to RGB by selecting Image ▸ Mode ▸ RGB.

▶ Step 4: Convert the image to black and white using Black & White adjustment layers. (For more about converting using adjustment layers, turn to page 122.)

The two LAB adjustments shown on pages 185 and 186—inverting and equalizing—are very simple moves. A small amount of tweaking in LAB color can give you many options when you convert your photos to monochrome.

▶ Here is the resulting image after equalizing the LAB channels and converting the image to black and white using a straightforward Black & White default adjustment layer for the conversion. This is the best of the three black and white versions of this photo.

85mm macro, 1/2 of a second at f/16, tripod mounted

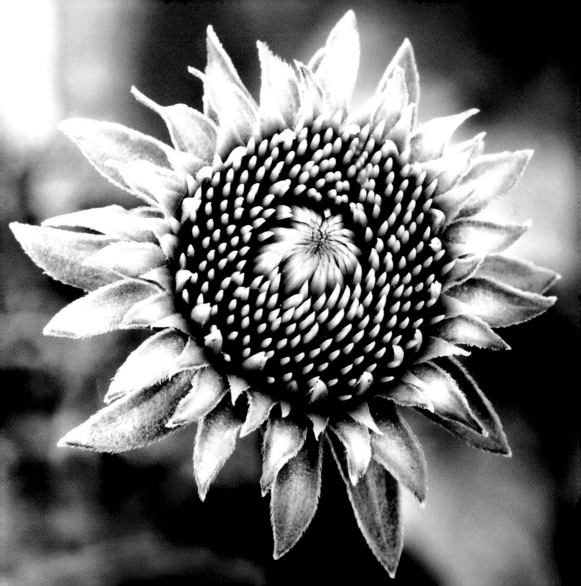

Swapping Tonalities

Whites not white enough? Blacks not black enough? You can use LAB color moves and blending modes to adjust your way out of these problems and avoid monochromatic blandness.

▶ For example, take the shot of lace underwear on a model shown here. I intentionally overexposed the image in the hope of getting an interesting abstraction, but wasn't very excited with the immediate results.

▶ Converting the photo to LAB color and inverting it produced something interesting, but I really wasn't interested in an image on a black background. (To find out how to invert LAB channels, turn to page 185.)

What I wanted to do was increase the graphic quality of the initial image, not transform it beyond recognition.

▶ Next, I equalized the image in LAB color to get an expanded tonal range. (For more about equalizing LAB channels, turn to page 186.)

This is better because it exaggerates the tonal range of the image, but I still wanted more contrast and tonal range before converting to black and white.

Using Blending Modes

After working on the color image, I had three versions of the lace underwear photo:

- The original, overexposed version (top left)
- The LAB color inversion on a black background (middle left)
- The LAB equalization with the expanded tonal range (bottom left)

In Photoshop, a *blending mode* controls the way the pixels from one layer blend with the pixels on the layers beneath them. I decided to put the three versions together as layers in one image and then use blending modes to mix the tonalities of the three layers.

▶ Step 1: Convert the three versions of the image back to RGB, if necessary, by selecting Image ► Mode ► RGB.

▶ Step 2: Use the inversion on the black background as the bottom layer for a layer stack. Rename the layer "Inverted."

▶ Step 3: Hold down the Shift key and drag the equalized version from its image window on top of the "Inversion" layer. Name this layer "Equalized." (For more about dragging images from one window to another, turn to page 101.)

▶ Step 4: With the "Equalized" layer selected in the Layers palette, select Difference from the blending mode drop-down list on the Layers palette. This blends the two layers, adds more contrast to the image, and puts the lace underwear back on a white background.

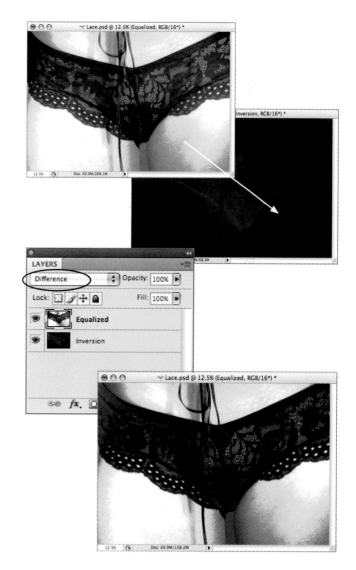

▶ Step 5: Drag the original overexposed version on top of the "Equalized" layer. Name this new layer "Original."

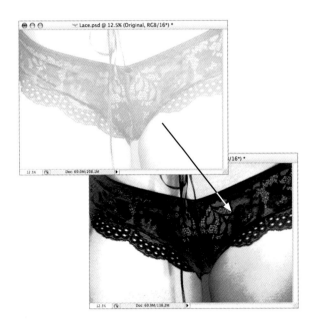

▶ Step 6: With the "Original" layer selected in the Layers palette, select Multiply from the blending mode drop-down list on the Layers palette. This blends the "Original" layer with the layers underneath adding more subtle toning.

▶ Step 7: Choose Layers ▸ Flatten to merge the three layers down into one layer.

▶ Step 8: Use a default Black & White adjustment layer to convert the image to monochrome. (For more about this, turn to page 122.) The resulting monochromatic image is shown on page 191.

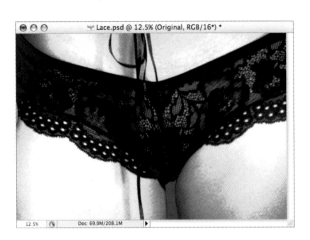

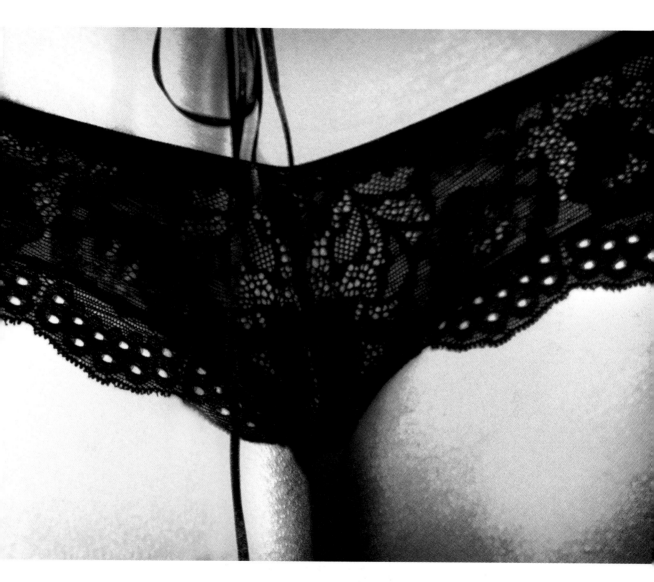

▲ I started with the inverted image and combined it with the equalized image. I then blended the original capture over the adjusted versions to come up with this stylized monochromatic version.

200mm, 1/160 of a second at f/6.3 and ISO 3200, hand held

Soft Focus

While some schools of photography preach that everything in a photograph from end-to-end should be razor sharp, other photographers have always intentionally created images where the focus is soft, either in whole or part.

A great thing about the world is that it is big enough to have room for many schools of visual thought—and many different kinds of photos have aesthetic validity.

Personally, I try not to prejudge photos based on whether or not I like—or use—a given technique in my own work. Seeing a technique that I don't use often but that's put to good use is always inspiring for my own work. That said, I prefer soft focus photos where the absence of hard edges is integral to the composition and makes visual sense, rather than photos that use soft focus to hide flaws in the underlying subject. The choice, however, is yours: when soft focus is in your toolbox you can use it to hide wrinkles, or to create novel compositions—or both.

There are many ways to create soft focus effects with your camera.

Some of these involve no special equipment, but can be tricky to get just right; for example, throwing your lens slightly out of focus, or moving the camera slightly.

Another approach is to add a filter to the end of your normal lens that will soften the photo (a clear filter coated with a soapy solution, vaseline, or other "schmutz" works for this), or to use a special "soft focus" lens—essentially, as I've joked, turning an expensive interchangeable lens DSLR into a cheap plastic camera.

An interesting variation is selective soft focus. This means that everything in an image is soft except a relatively small area—often the center. A crisply focused lens set to a wide open aperture (so there is low depth-of-field) can achieve this effect, as can some filters. A great tool for controlled and selective focus in-camera is the Lensbaby, a lens that can be moved to alter the point of focus and the degree to which the surrounding areas are out of focus.

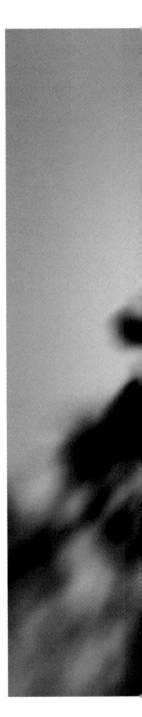

▶ I used the *sweet spot*—the area that is in focus when creating an otherwise soft focus Lensbaby image—to highlight a single apple blossom in this selective focus image.

Lensbaby Composer, standard optic, 1/8000 of a second using f/8 aperture ring at ISO 400, hand held

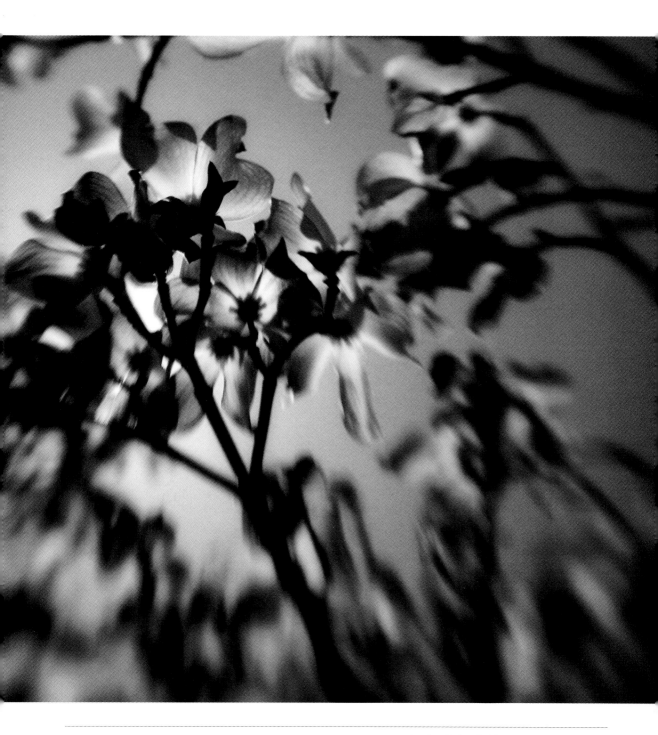

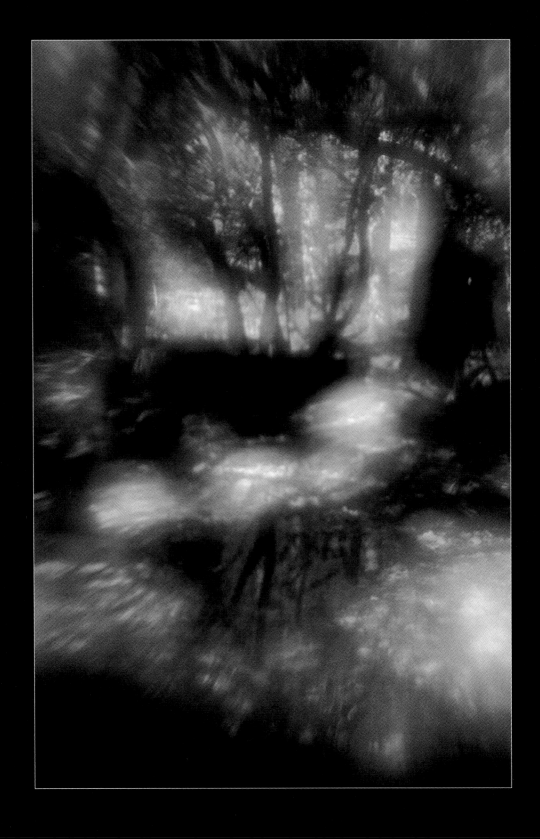

Adding Soft Focus

Didn't think to create a soft focus capture when you took the photo? Don't worry, no problem. It's pretty easy to create soft focus effects after the fact in the Photoshop darkroom, including selective soft focus.

Of course, you can do just about anything in Photoshop—and there are usually many ways to do those many things. But you need to know where you are headed. That's why I've started this section with some examples of soft focus effects created in the camera—these provide an idea for what kind of effects you can create in post-processing that will have visual credibility.

Probably the easiest way to add a soft focus effect to a photo is to use the Gaussian Blur filter. For example, I took a number of fairly standard photos of a model holding her hands above her head, and wanted to add some interest to the portrait.

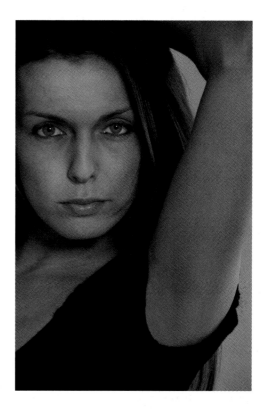

▲ The head shot of this model with her arms above her head needs a way to draw viewer interest into the photo and focus attention on her face.

▶ Step 1: Choose Layer ► Duplicate Layer to create a copy of the Background layer. Name this new layer "Blur."

I recommend always adding blur on a duplicate layer in Photoshop. That way, you can always go back to the original Background layer if you don't like the effect or want to start over.

▶ Step 2: Choose Filter ► Blur ► Gaussian Blur. The Gaussian Blur dialog opens.

◀ This intentionally soft focus effect of sunlight in a forest glade was created in-camera using a plastic lens.

Lensbaby Composer, Plastic Optic, 1/800 of a second using f/4 aperture ring at ISO 400, hand held

▶ Step 3: Use the Radius slider to set the blur. The higher the Radius setting, the more blur—and blur translates to a soft focus effect. I suggest trying 24 pixels. If this proves to be too much, you can always take down the strength of the soft focus effect by reducing the opacity of the layer that is blurred using the Opacity slider in the Layers palette.

Click OK when you are satisfied with the amount of blurring.

▶ Step 4: With the "Blur" layer selected in the Layers palette, choose Layer ▸ Layer Mask ▸ Reveal All to add a white layer mask to the "Blur" layer. (For more about layer masks, turn to page 98.)

▶ Step 5: Select the Brush Tool from the Toolbox and make it soft so the edges feather as you paint. Set the Hardness to 0% and the Opacity to 50%. You can adjust these settings as you paint.

▶ Step 6: Paint on the face to hide the "Blur" layer and reveal the sharp Background layer underneath.

▶ Page 197: The finished image really focuses the viewer on the model's face.

200mm, 1/125 of a second at f/7.1 and ISO 100, hand held

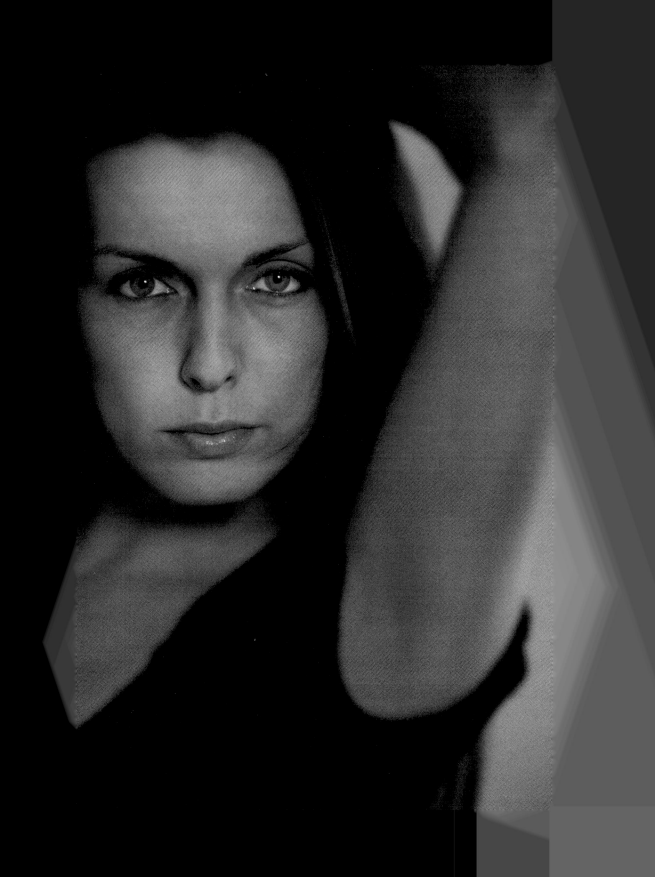

Pinhole Effect

In "real life" pinhole photography is photography without a lens. Instead of a lens, light passes through a tiny hole; the light passing through this hole forms the image in the camera.

The optics of the pinhole effect were understood as early as the fifteenth century Renaissance, and were described by Leonardo da Vinci and others. The optical effect was used to invent the *camera obscura*—a dark room that projects an image of the surroundings on the wall using a pinhole. The camera obscura is one of the key discoveries leading up to the invention of photography; if you get the chance, don't miss the opportunity to visit one.

Today, it is possible to purchase pinhole cameras, or to make them from a kit. Working pinhole cameras have been constructed from shoe boxes, tin cans, and even odder materials.

If you are interested in retrofitting a DSLR to work like a pinhole camera, a great choice is the Pinhole/Zone Plate optic associated with the Lensbaby Composer.

The general characteristics of a pinhole photo are great depth-of-field, overall softness, darkened edges, and brightness in the center of the image. To start with the simulation of this effect, I chose an image entirely in focus so depth-of-field wasn't an issue.

▶ Step 1: With the "Background" layer selected, choose Layer ▶ Duplicate to make a copy of the layer. Name this duplicate layer "Soft Focus."

For each step in creating the pinhole effect, work on a duplicate layer. That way, you can go back to the original image if you make an adjustment you don't like.

▶ Step 2: With the "Soft Focus" layer selected in the Layers palette, choose Filter ▶ Blur ▶ Gaussian Blur to open the Gaussian Blur dialog. Set the Radius to 3 to add an overall soft focus effect, and then click OK to apply the blur to the layer. (For more about soft focus, turn to page 192.)

▶ Step 3: With the "Soft Focus" layer selected in the Layers palette, choose Layer ▸ Duplicate to make a copy of the layer. Name this duplicate layer "Vignette."

▶ Step 4: Choose Filter ▸ Distort ▸ Lens Correction to open the Lens Correction dialog. Move the Amount slider towards darken in the Vignette area. This darkens the edges of the layer to make the edges look like an old-time pinhole photo. Click OK when you are pleased with the results.

▶ Step 5: With the "Vignette" layer selected in the Layers palette, choose Layer ▸ Duplicate to make a copy of the layer. Name this duplicate layer "Brighten Center."

▶ Step 6: With the "Brighten Center" layer selected, choose Layer ▸ Layer Mask ▸ Hide All to add a black layer mask to that layer. In the Layers palette select Screen from the blending mode drop-down list.

▶ Step 7: Use the Brush Tool to paint in the central area of the image window. (For more about layer masks and painting, turn to page 98.)

This will lighten the central area of the image, just like a pinhole photo.

▶ Step 8: Convert the image to monochrome using a Black & White adjustment layer set to the Max Black preset, and then add a dark sepia tint to make the image seem antique (see page 166).

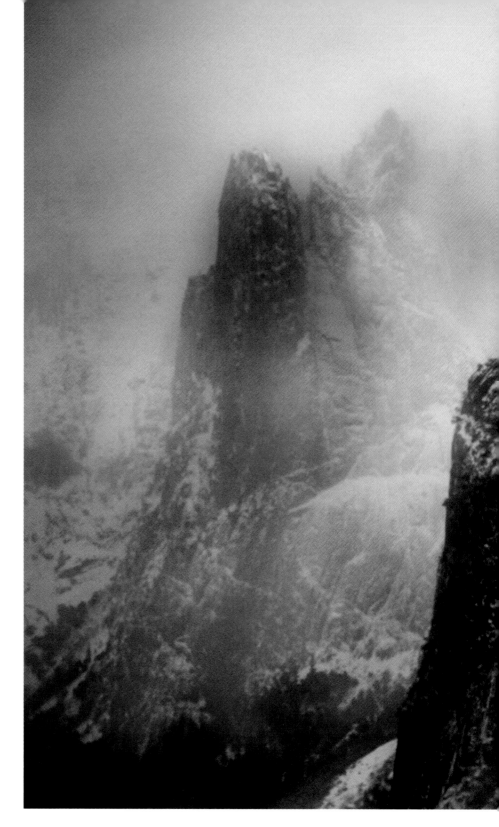

▶ The soft, dreamy
look of this vista of
the Cathedral Spires
behind Bridalveil Falls
in Yosemite Valley
struck me as perfect
for the pinhole effect.

*112mm, 1/500 of a
second at f/10 and
ISO 200, hand held*

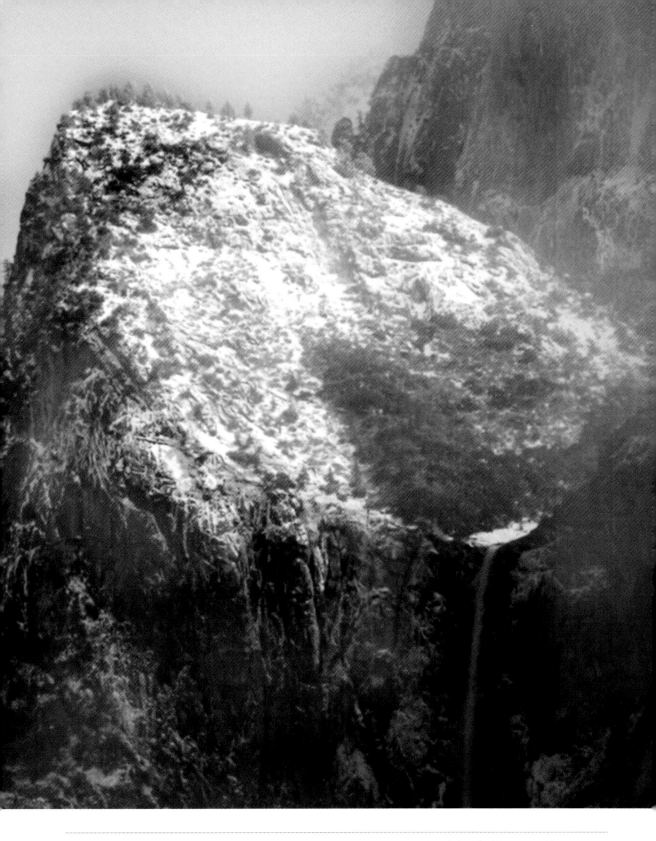

Solarization

Solarization in photography reverses blacks and whites. It is also called the Sabattier effect after French photographer and scientist Armand Sabattier, who described the effect in 1862. In the chemical darkroom, solarization was achieved by re-exposing an already exposed negative or print to light before development was finalized.

Since solarization reverses—or partially reverses—dark and light tones, this effect will work well for images in which the contrasts between blacks and whites are an important part of the overall composition.

In the Photoshop darkroom, there are a number of ways to achieve a simulated solarization effect. One of my favorites is to convert the image to LAB, followed by an inversion of the L channel. (See pages 182–193 for more about inverting LAB channels.) This step should be taken prior to the monochromatic conversion.

▶ Step 1: Starting with the original color image, choose Layer ▸ Duplicate to make a copy of the layer. Name this duplicate layer "Inversion."

▶ Step 2: Convert the image to the LAB Color space by choosing Image ▸ Mode ▸ LAB Color from the Image menu (see Step 1 on page 183).

▶ Step 3: With the "Inversion" layer selected in the Layers palette, click the Lightness channel in the Channels palette to select it.

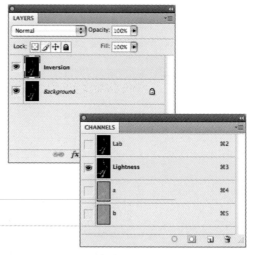

▶ Step 4: Choose Image ► Adjustments ► Invert to invert the Lightness channel. This creates a fairly conventional solarization effect.

▶ Step 5: Click Lab at the top of the Channels palette to select all the channels.

▶ Step 6: Choose Image ► Adjustments ► Invert to invert all the channels.

This double inversion can be used as the basis for a partially solarized monochromatic image.

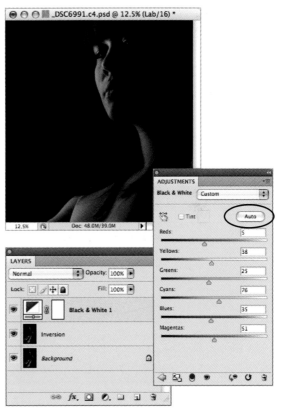

▶ Step 7: Convert the image back to RGB by selecting Image ► Mode ► RGB.

▶ Step 8: With the "Inversion" layer selected in the Layers palette, convert the layer to monochrome using a Black & White adjustment layer. Click the Auto button in the Adjustments palette to set the conversion values. (Turn to page 124 for details on how to do this.)

▼ Page 204: Using studio lighting, I slightly underexposed the image to create a black background and extend the sense of abstraction surrounding the model. I created a partial solarization effect by inverting first the L channel in LAB color, and then inverting the entire image. Following the second inversion, I converted back to RGB and then converted to monochrome.

95mm, 1/200 of a second at f/9 at ISO 100

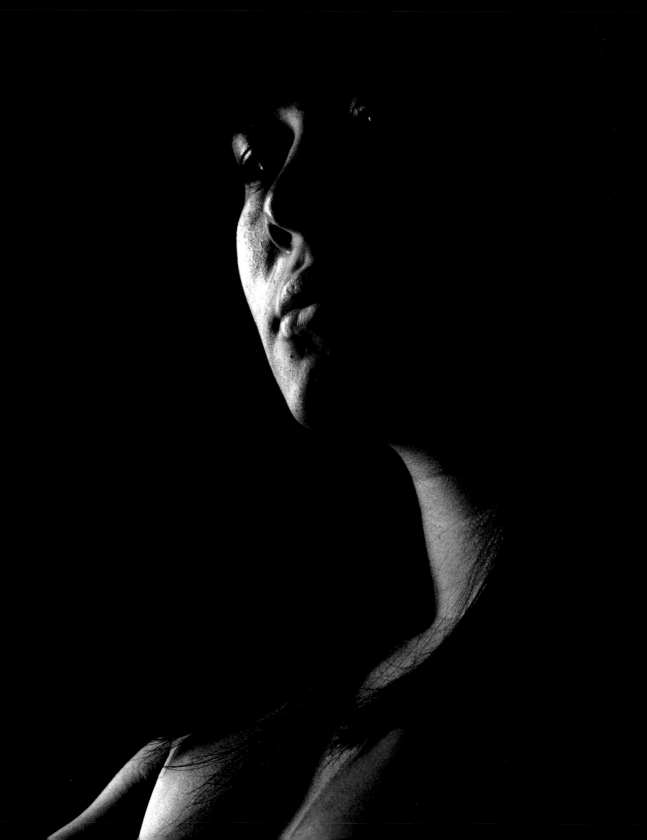

Using Curves to Solarize an Image

There are a number of other approaches to a post-processing solarization effect that you can experiment with besides LAB inversions. I do suggest you keep your image in color mode until after you have applied your solarization effect.

One of the easiest ways to solarize an image is to use the Photoshop Solarize filter by choosing Filter ► Stylize ► Solarize.

While this filter gives you a perfectly decent Solarize effect it doesn't provide any options. A more flexible approach that is fun to play with is to use a Curves adjustment layer.

▶ Step 1: Starting with the original color image, choose Layer ► Duplicate to make a copy of the layer. Name this duplicate layer "Solarize."

▶ Step 2: With the "Solarize" layer selected in the Layers palette, select Layer ► New Adjustment Layer ► Curves or click the Curves button on the Adjustments palette.

▶ Step 3: Using the curves window in the Adjustments palette, drag the handle at the upper right corner down to the baseline. This is the end of the curve that adjusts the white point in the image. Make sure the middle of the curve hits the center of the window, so that a triangle along the bottom baseline is formed.

Curve —

Drag this handle down

▶ Step 4: Use a Black & White adjustment layer to convert the image to monochrome. (To find out how to use Black & White adjustment layers, turn to page 122.)

The monochrome result is shown on page 206.

▶ The solarization effect emphasizes the contrast between the water drops on this spider's web and the background. Note the thin white line around the central water drop—this is one of the characteristics of solarization.

200mm macro, 24mm extension tube, 1/5 of a second at f/16 and ISO 200, tripod mounted

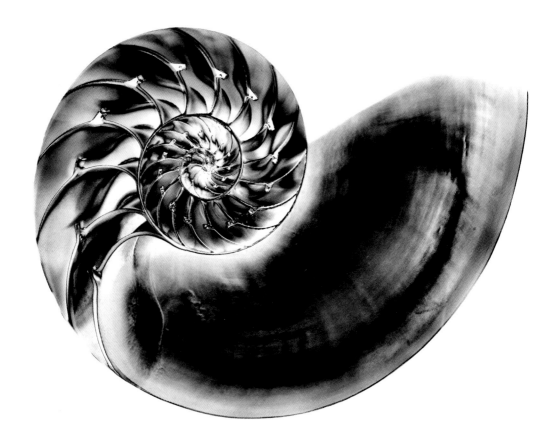

▲ To solarize the photo of the chambered Nautilus shell shown on page 13, I used the Solarization filter that is included in Nik Software's Color Efex Pro filter pack. As you can see, the black background became white and the internal elements of the shell are rendered almost as chrome.

50mm macro, 8 seconds at f/32 and ISO 100, tripod mounted

▶ The complex and sensuous curves in this image of a small Hellebore struck me as good candidates for solarization because the primary interest in the composition centered on the distinction between light and dark shapes.

100mm macro, 1.6 seconds at f/22 and ISO 100, tripod mounted

Duotone and Tritone Effects

Duotone was a printing process that created rich monochromatic imagery using two colors or inks—with black being one of the colors. Each color was used to ink a separate plate. The plates were pressed in sequence in perfect register to create the printed monochromatic image on the paper.

As you probably imagine, *tritone* printing involves creating monochromatic imagery with black ink and two other colors. Why stop with three? It's perfectly possible—although expensive and anachronistic—to create monochromatic imagery with four inked plates (called a *quadtone*). How about that? You can use four colors, and still end up with something that is "seen" as black and white. Note that—in the case of a quadtone—these are not process colors, they are spot colors. In other words, the four colors are not used in combination to create a complete spectrum of colors.

The inks are used one at a time on four different plates.

Today, you won't find any authentic duotone, tritone, or quadtone printing—except perhaps in one or two fine art print making ateliers. But you will find a mechanism for simulating this process from grayscale images in Photoshop.

Converting your RGB images to grayscale and then converting the grayscale images to duotone or tritone can be a way to produce rich monochromatic prints using a modern inkjet printer. However, making fine art prints is beyond the scope of this book. But I do use the Photoshop duotone functionality for another reason: to add an effect to my monochromatic imagery where it is appropriate. Using the duotone effect this way is essentially a digital simulation of the old printing process. Probably the effect that is closest to this is split toning (see pages 170–173).

▶ Step 1: Start by converting your photo to grayscale (if it is not already in grayscale mode) by choosing Image ▸ Mode ▸ Grayscale from the Photoshop menu. A Photoshop dialog may appear, asking whether you want to discard color information. This is okay because your monochromatic image should not have any color information, so click Discard.

If your image is in 16-bit mode, you will need to convert it to 8-bit mode by choosing Image ▸ Mode ▸ 8 Bits/Channel. Otherwise, the Duotone option on the Image ▸ Mode menu will be grayed out and unavailable.

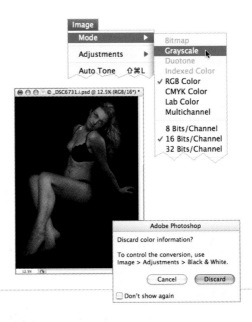

▶ Step 2: Choose Image ▶ Mode ▶ Duotone. The Duotone Options dialog will open.

The Duotone Options dialog appears deceptively simple, but it is actually a powerhouse that hides a wide range of creative options.

If you check out the Preset drop-down list, you'll find a large list of possible duotone, tritone, and quadtone combinations that you can use as a starting place for your effect. Though, my preference is to create my own color combinations. A few preset combinations are shown below.

Note that once you come up with an "ink" combination that works for you it can be saved and retrieved as a custom preset.

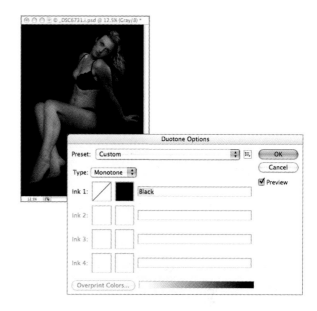

▶ This is a duotone preset using black and purple inks.

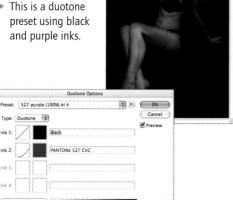

▶ This is a tritone preset using black, orange, and brown inks.

▶ This is a quadtone preset using black, cyan, magenta, and yellow inks.

Don't be confused by the CMYK inks. They are used here as spot colors, not as the process colors that make up the CMYK color space.

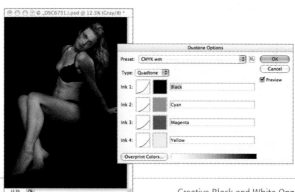

▶ Step 3: For this example, create a tritone by selecting Tritone from the Type drop-down list. This will let you use three color inks for the effect.

The default setting in the Duotone Options dialog is Monotone with black as the ink choice. You can change this default color, if you wish, though of course your image will also change color.

▶ Step 4: Leave the first ink choice as the default black. Notice that a color swatch of the black appears to the left of the color name.

Click here to open Color Libraries dialog and select the second ink

▶ Step 5: Click the color swatch for Ink 2 (which looks like a white square) to access the Color Libraries dialog.

Use the Book drop-down list to select different color libraries

▶ There are many color libraries to choose from. It's fun to look through the extensive list of colors available, but I'll confess to a weakness for the Pantone metallic coated "book"—perhaps because I rarely get the chance to specify such an expensive option in "real life."

▶ Step 6: The colors you pick should all be pretty different from one another for the most impact. For this example, choose Pantone 871 C from the Pantone metallic coated book. The ink is a metallic gold.

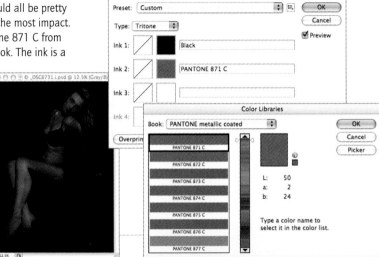

▶ Step 7: Click OK to close the Color Libraries dialog and return to the Duotone Options dialog.

▶ Step 8: Click the color swatch for Ink 3 to access the Color Libraries dialog.

▶ Step 9: For the third ink in this example, choose Pantone 877 C from the Pantone metallic coated book. The ink is a metallic silver.

Now that the three inks have been selected, it's time to control how the inks are applied by adjusting the curve setting for each ink.

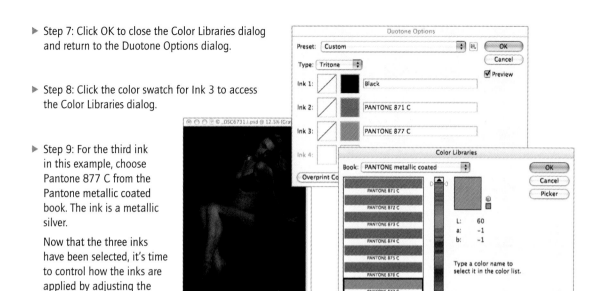

Click here to adjust the Black ink curve

▶ Step 10: To adjust the curve for the Black ink, click the curve box to the left of the Ink 1 color swatch. The Duotone Curve dialog opens.

Drag the curve line to adjust how the ink is used in the image. Moving the curve down and to the left decreases coverage of the ink in the tonal areas indicated by the bar at the bottom of the graph. Moving the curve up and right increases coverage.

There's no substitute for experimenting, so play with the curve and see how it affects your image.

Drag the curve to adjust ink coverage. You can click on the curve to add handles.

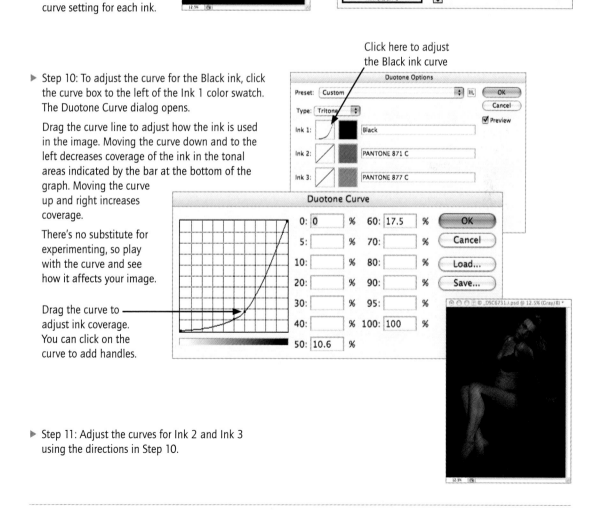

▶ Step 11: Adjust the curves for Ink 2 and Ink 3 using the directions in Step 10.

▶ After you adjust the curve for each ink and close the Duotone Curve dialog, a thumbnail of the curve appears in the curve box associated with each ink.

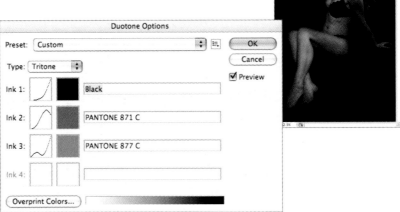

Color mode

▶ Step 12: When you are satisfied with the results, click OK to close the Duotone Options dialog. The color mode is shown in the title bar of the image.

Depending on what you plan to do with the photo, you may need to reconvert the image back to RGB or CMYK from the Duotone, Tritone, or Quadtone color mode. Once this reconversion has happened, the image can no longer be used for duotone printing with the "inks" you specified. Instead, the color model simulates the colors of the combined inks you specified for regular printing or display on the Web.

▶ This studio portrait of a model struck me as reminiscent of an old-fashioned pin-up, so I decided to increase the antique effect by adding the simulation of tritone reproduction using gold and silver Pantone metallic inks. This makes the model's skin glow and adds a hint of silver to the highlights in the photo.

31mm, 1/100 of a second at f/5.6 and ISO 100, hand held

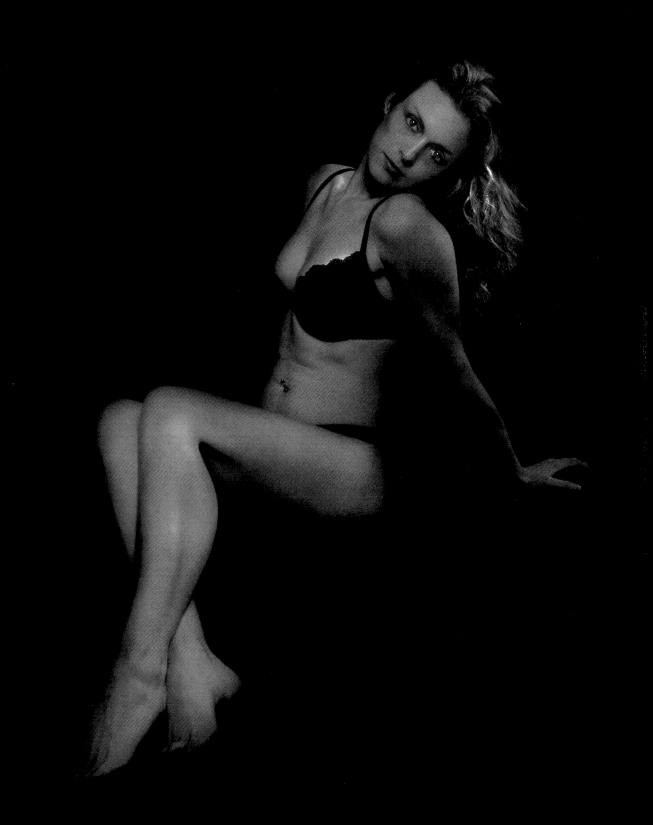

Adding and Reducing Noise

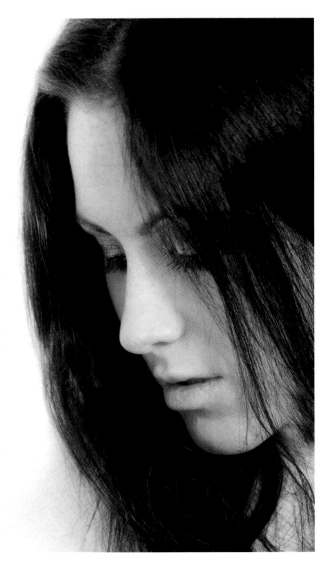

Just as grain was always present in film, *noise*—digital static in a photo—is always part of every digital image, although there may be so little noise that depending upon the magnification you may not really be able to see it.

Your attitude towards noise should depend upon the aesthetics of a photo and the effect you are trying to create. Reducing noise inherently reduces sharpness, and some images need the "bite" that only noise can provide—but too much noise can be inherently unpleasant looking.

Photoshop provides noise addition and reduction tools, found by selecting Filter ► Noise. In addition, a number of third-party plugins and filters provide sophisticated noise processing options. You'll need to refer to a book such as my *Photoshop Darkroom* for detailed instructions about how to use this kind of software.

◄ With this studio shot, I used selective noise reduction in post-processing to add apparent smoothness to portions of the model's face. It is not often understood that noise reduction inherently softens and smooths. I used selective noise reduction to take advantage of this effect where it was needed without also softening hair and eyelashes.

200mm, 1/200 of a second at f/6.3 and ISO 200, hand held

► To add more of a tactile sense to this abstract composition of a shadow within the frames of the lines of a building, I chose to up the noise levels in the lower left rectangle of the image.

26mm, 1/250 of a second at f/16 and ISO 200, hand held

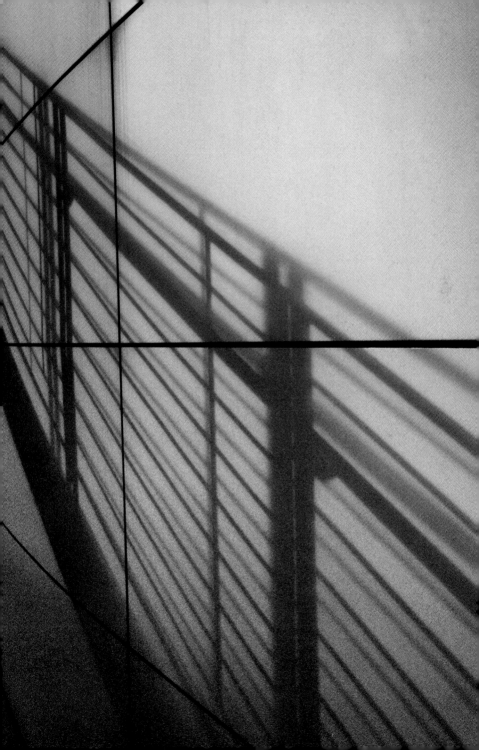

Film Effects

Because digital camera sensors capture color information, creating a digital black and white photo is to some extent an act of creative anachronism—some would even say nostalgia. It's therefore not surprising that digital mono-chromatic imagery is often made after study of film imagery. Also creative choices are sometimes presented in the context of the film comparison.

For example, do vintage grainy photographs taken on the streets or in coffee houses using high speed black and white film during the 1960s appeal to you? Then why not see if you can replicate this very distinctive look using digital tools.

Using Photoshop, the goal of reproducing the intentionally retro look of almost any old-time film stock can clearly be achieved. Some film effects are not hard to create, others take quite a bit of effort and planning. In any case, the Photoshop steps involved are beyond the scope of this book.

Fortunately, there are a number of third-party Photoshop filters that offer an array of film effects out of the box. One of the best of these, Silver Efex Pro, lets you choose from an extensive menu of film types for your simulation after you've first selected a basic monochromatic conversion strategy. Film effects are grouped depending upon their sensitivity (ISO) and you can choose whichever effect you think works best with your photo.

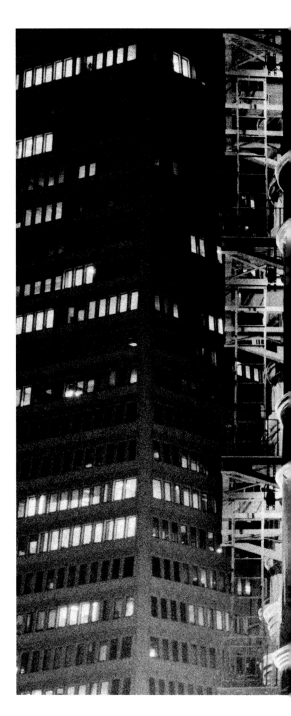

▶ I wanted to give this "noir" image of the streets of San Francisco a gritty look. I converted the color photo to monochrome with Nik's Silver Efex Pro using a neutral conversion filter. Next, I chose a high ISO film effect to add grain and contrast to the photo. I finished the image off with a split toning effect (see pages 170–173).

60mm, 3 seconds at f/10 and ISO 100, tripod mounted

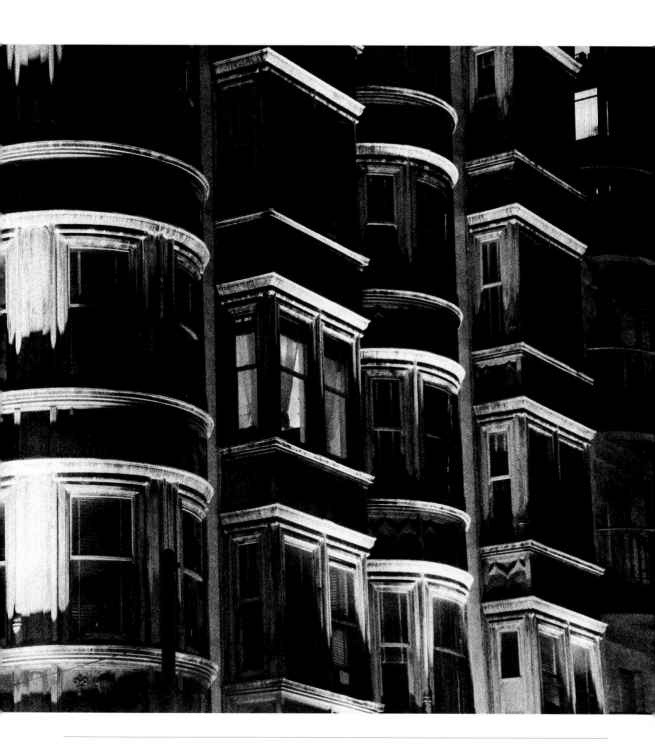

Infrared Camera Conversions

Infrared radiation (IR) is electromagnetic radiation with a wavelength that is longer and a frequency that is shorter than that which produces visible light. Capturing imagery using IR has forensic and scientific applications; however, there are currently no production IR cameras available.

The alternatives are to use a filter, or to retrofit a digital camera (you can also simulate IR in post-processing, as explained on pages 222–223). An IR filter appears either black or very dark red, letting IR pass through it while blocking visible light. One problem with this kind of filter is that since it blocks visible light it can be very hard to see and compose through if you are using a DSLR. For superior results, I'd recommend converting an existing camera (see page 235 for information about doing this). An older model DSLR or a compact camera with a manual exposure mode that is capable of RAW captures is probably best for IR retrofitting.

Most digital sensors, particularly older ones, have considerable inherent sensitivity to IR (as well as UV, the radiation at the opposite end of the visible spectrum). Retrofitting in part involves removing any filters that blocked IR. This may change the distance from the back of a lens to the sensor, and therefore its focusing. So it's a good idea to have the lens you will use with your IR camera calibrated for the retrofitted camera at the same time it is modified.

There's nothing inherently monochromatic about an IR capture, although IR captures will typically not exhibit a great dynamic range. RAW captures often have a kind of pinkish hue at default settings.

Personally, I prefer to present my IR captures in black and white, with the expectation that I'll be converting not-very-colorful RAW captures to monochrome using the techniques shown in this book.

If you don't want to go to the trouble of converting your infrared images to monochrome each time, it is possible to get your camera equipped with a black and white IR filter at the time it is retrofitted. However, I feel that this limits rather than expands your options.

What does an IR capture look like? This can be hard to know until you experiment in a given situation—one of the great things about digital IR capture is that you get immediate feedback on the LCD screen. Foliage appears white rather than green. The more plants are growing, the whiter they appear. Skies are dark, although clouds can be quite dramatic. Depending on the lighting you use, portraits can be very unusual with pale, milky skin and dark, dark eyes.

Infrared and monochrome go very well together. If you've never tried to make a photo using a light spectrum not visible to the naked eye, this may be just the time for you to experiment with one of the most creative effects available to black and white photography.

▲ A RAW infrared image in color is shown next to the in-camera almost monochromatic JPEG version in Adobe Bridge (see page 226 for the final version of this photo following black and white conversion).

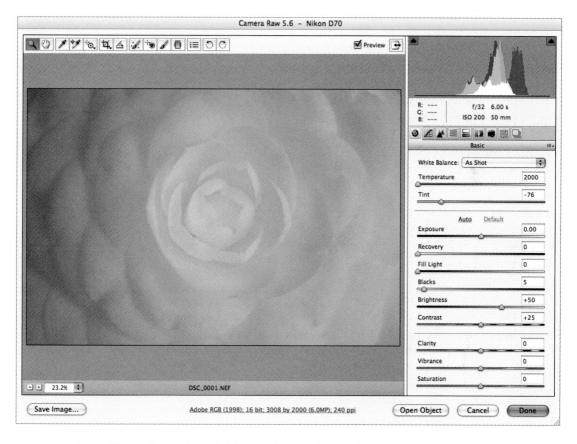

▲ Here is the infrared image shown with default "As Shot" settings in ACR. The white balance of this image is 2000 degrees Kelvin, the lowest possible temperature on the ACR scale.

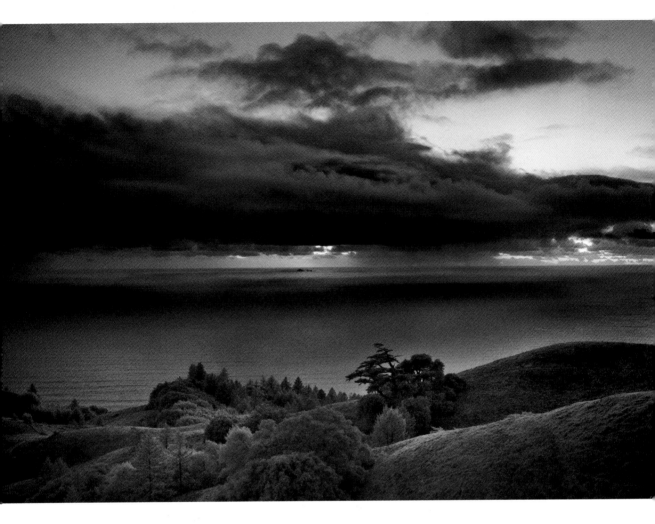

▲ On the slopes of Mount Tamalpais, California, my decision to use infrared capture added drama to this end-of-the-day image of sunset and rain squall over the distant Farallon Islands.

34mm, 1/6 of a second at f/4.5 and ISO 200, tripod mounted

▶ Lush, growing foliage shows up as brightly white in an infrared capture, like the lichen and background forest in this shot.

65mm, 1/13 of a second at f/9 and ISO 200, tripod mounted

▲ Infrared macro captures of flowers can produce surprisingly nuanced imagery, with areas that appear to be sharp and in focus contrasting to soft areas. Whatever the original color of the flower—this Camellia was vibrant red—it is likely to appear mostly white in the infrared capture.

50mm macro, 6 seconds at f/32 and ISO 200, tripod mounted

▶ I used a high-powered studio strobe to make this infrared portrait of a model. Compared to the actual tones of her skin, the infrared rendering when lit by direct flash made her skin look pale and almost ghost-like. The infrared rendering of the model's skin was quite different when I didn't use flash (see pages 228 and 229).

70mm, 1/160 of a second at f/8 and ISO 200, hand held

◄ This hand held infrared capture made using available ambient light and a high ISO has a dream-like effect.

IR captures look different depending upon the light source and it is hard to know how an image will come out in advance. So with IR, as with many other kinds of photography, the best thing you can do is experiment, play, and try lots of different lighting.

1/50 of a second at f/6.3 and ISO 1600, hand held

▶ The visual impact of infrared can sometimes be quite a surprise. With this high-ISO capture the model's face appeared far brighter than the rest of her body.

1/60 of a second at f/5.6 and ISO 1600, hand held

◀ This is a photograph of the abandoned naval shipyard at Mare Island, California. During World War II, more than 40,000 workers built the battleships here that waged the war in the Pacific theater. An infrared capture helped me convey the eeriness and desolation of the scene.

18mm, 1/160 of a second at f/6.3 and ISO 200, hand held

Infrared Conversion without an IR Camera

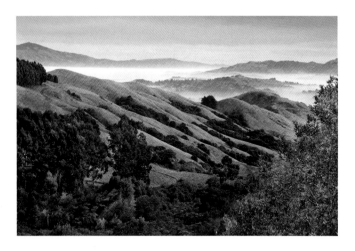

▲ Consider this image of Mount Diablo and the California coastal range in the spring. Infrared conversion renders foliage as white—and the more green and growing the foliage the whiter it becomes under infrared.

▼ Here's the image after applying a Black & White adjustment layer using the Infrared preset. Bear in mind that the Infrared preset gives you a pretty good starting place for creating a digital image that looks like it was an IR capture—but it is only a starting place. You'll almost certainly need to tweak the image further to come up with a realistic and plausible IR rendition.

Want to make digital infrared photos but don't have an extra camera lying around to convert to IR (or the extra couple of hundred bucks to pay for the conversion)? No problem!

Many effects can be fairly easy to simulate in post-processing, and monochromatic IR is one of them. Of course, first you have to know what a "real" infrared capture looks like—so you know what you are aiming for. So if you want to create your own simulated IR captures without a camera converted to infrared, start taking a look at as many IR photos as you can find (and check out pages 220–229).

A good starting place for converting a photo into an IR look-alike is to use a Black & White adjustment layer with the Infrared preset in the Adjustments palette. (See pages 122–129 for more about using Black & White adjustment layers for monochromatic conversions.)

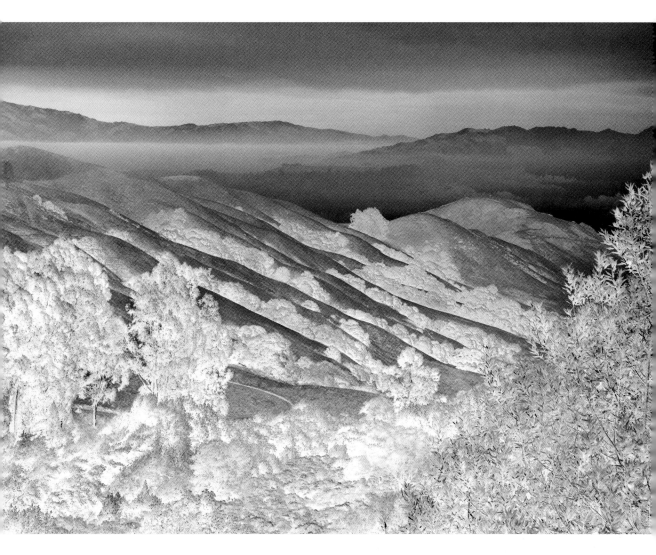

▲ To create the finished simulation of an IR image, I started with a Black & White adjustment layer using the Infrared preset shown to the left. However, this preset did not convert the foliage to white as it would have been in a "real" IR capture. So I added a LAB color inversion (see pages 185–188) to turn the dark trees white, and then painted in this effect using a layer and layer mask (see pages 98–107).

As you can see, it's not that hard to simulate a reasonably plausible infrared capture, starting with a Photoshop Black & White adjustment layer using the Infrared preset.

46mm, 1/250 of a second at f/8 and ISO 100, hand held

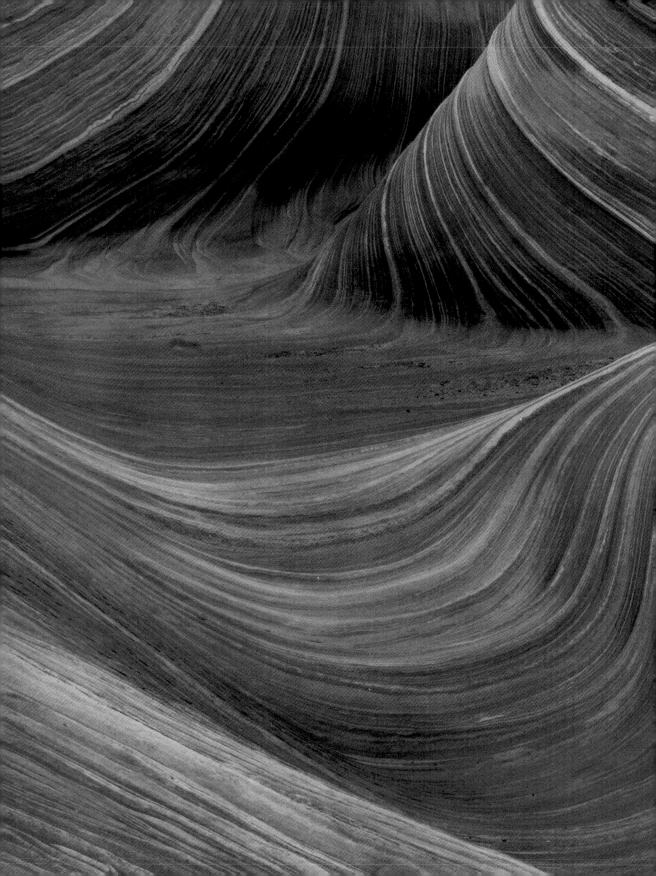

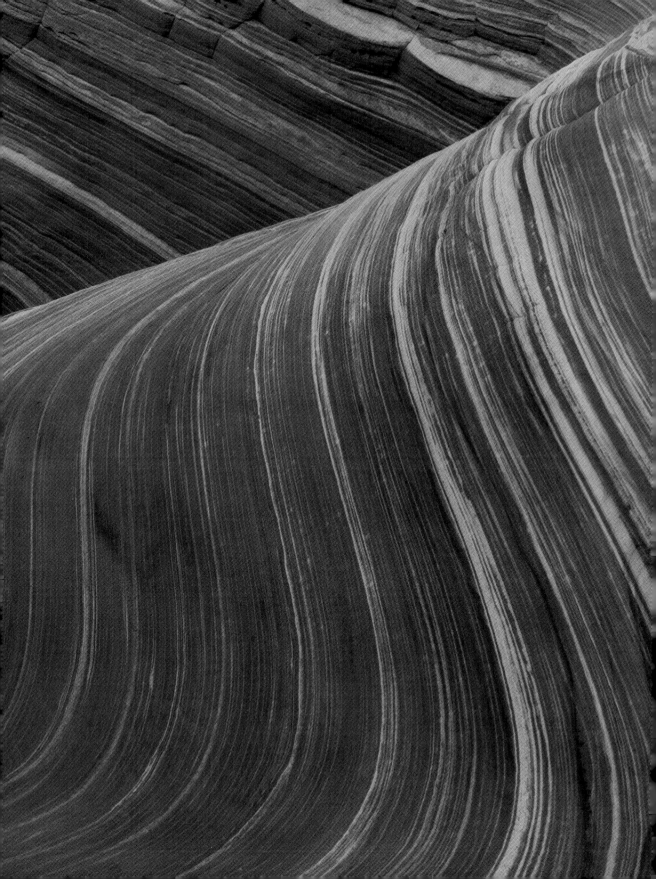

Notes and Resources

Simple B&W Conversion Programs

A number of programs that are either free or very inexpensive let you do straightforward black and white conversions from color captures. Check out *Digital Black & White Roadmap* on pages 68–69 to understand where this kind of software fits in the scheme of creative digital black and white photography.

For example, iPhoto, Picasa, and Photoshop Elements each provide black and white conversion for JPEG photographs that's easy to use—although not as powerful, subtle, or capable of tonal gradations as the methods that are the focus of this book. This kind of software is perfectly adequate for some kinds of black and white photography, depending upon your goals and what you want to do with the photos.

You won't find it very hard to convert your files using this kind of tool, although the results may fall short in terms of high quality creative expressiveness. You can easily find directions online. For example, to find out more about black and white conversions using Picasa, simply search Google for *Picasa black white conversion*.

Learning Photoshop

Creative Black & White: Digital Tips & Techniques is not a book about Photoshop—it's a book about learning to see the world in monochrome. That said, some of the book is concerned with finding the best strategy in Photoshop to convert specific images to black and white in a way that lives up to your expectations when the image was pre-visualized.

I've tried to include enough Photoshop information so that you can use the techniques with your own photos.

At the same time, I haven't included information on basic Photoshop techniques. If you need to brush up on Photoshop concepts and techniques, I think you might find one of my other books helpful. Please check out *The Photoshop Darkroom: Creative Digital Post-Processing* (Focal Press).

Sensor Size and Focal Length

Not all sensors are the same size. The smaller the sensor, the closer a given focal length lens brings you to your subject. For example, if a sensor has half the area of another sensor, then a specific focal length lens will bring you twice as close on a camera with the smaller sensor.

Since different cameras have different sized sensors it is not possible to have a uniform vocabulary of lens focal lengths. So people compare focal lengths to their 35mm film equivalent by adjusting for the sensor size.

To make the comparison with 35mm film focal lengths, you need to know the ratio of your sensor to a frame of 35mm film, which is called the *focal-length equivalency*. The photos in this book were created using Nikon DSLRs with a 1.5 times 35mm focal-length equivalency. To find out how the focal lengths I used compare with 35mm focal lengths, multiply my focal lengths by 1.5.

To compute the comparable focal lengths on your own camera if your sensor has a different size than mine, you need to know the focal-length equivalency factor of your

sensor. Check your camera manual for this information.

For example, I took the photo of the Wave shown on page 232–233 using a 28mm focal length. The 35mm equivalence is 42mm.

Black & White Filters

Silver Efex Pro is published by Nik Software, www.niksoftware.com. A free trial version is available. Nik also publishes Color Efex Pro, which includes a black and white conversion filter along with many interesting color filters.

Other filters and plugins specifically intended for black and white conversion in Photoshop and Lightroom are available from publishers including:

Auto FX Software: www.autofx.com

Fred Miranda Software: www.fredmiranda.com/software

Power Retouche: www.powerretouche.com

Silver Oxide: www.silveroxide.com.

Most of these publishers have free trial versions available.

Infrared Camera Conversion

Converting a camera to capture the infrared (IR) spectrum (see pages 220–229) is not for the faint of heart. The conversion is expensive, voids the camera manufacturer's warranty, cannot be undone, and usually makes the camera useless for captures by normal light.

Considering the negatives, why would one send one's camera off for this conversion process? IR captures can be spectacular, particularly in monochrome. Simulation in Photoshop (an example is shown on pages 230–231) really isn't the same.

If you search for *infrared conversion* on the web you'll find a number of companies that provide this service, including Life Pixel, www.lifepixel.com.

The process involves shipping your camera for IR conversion, usually takes a few weeks and costs several hundred dollars (the precise amount depending upon your camera model and the options you choose).

With most digital cameras, sensors are naturally very sensitive to IR radiation, and are protected with a special filter. The retrofitting replaces this filter with one that allows IR to pass through to the sensor. Focusing can be slightly different under IR, so if possible you should have a lens calibrated at the same time as the filter over the sensor is modified. This makes IR modification ideal for an older generation DSRL that was purchased with a "kit" lens.

Usually, you can choose to have the modification produce "normal" color IR, or only do black & white captures. I recommend choosing the color IR option. If you control the monochromatic conversion yourself, you can achieve greater flexibility and better results—all the information you need about conversion techniques is found on pages 66–141 of this book.

▲ Pages 232–233: The vast but surprisingly gentle undulations of this geologic formation reminded me of fabric. I waited for even light in the late afternoon when the vista was in shadow and used a small aperture setting to get maximum depth-of-field so the foreground would be in focus along with the rest of the rock formation. The drama of the image derives at least in part from the lack of contrast from white to black in the scene.

28mm, 4 seconds at F/22 and ISO 200, tripod mounted

Glossary

Ambient light: The available, or existing, light that naturally surrounds a scene.

Aperture: The size of the opening in the iris of a lens. Apertures are designated by f-numbers. The smaller the f-number, the larger the aperture and the more light that hits the sensor.

Bracket: To shoot more than one exposure at different exposure settings.

Chiaroscuro: Moody lighting that shows contrasts between shadows and brightness.

Color space: A color space—sometimes called a *color model*—is the mechanism used to display the colors we see in the world in print or on a monitor. CMYK, LAB, and RGB are examples of color spaces.

Composite: Multiple images that are combined to create a new composition.

CMYK: Cyan, Magenta, Yellow, and Black; the four-color color model used for most offset printing.

Depth-of-field: The field in front of and behind a subject that is in focus.

Diffraction: Bending of light rays; unwanted diffraction can cause loss of optical sharpness at small apertures.

DSLR: Digital Single Lens Reflex, a camera in which photos are composed through the lens that will be used to take the actual image.

Duotone: A historic printing process that created rich monochromatic imagery using two colors or inks—with black being one of the colors. Each color was used to ink a separate plate that were combined in register.

Dynamic range: The difference between the lightest tonal values and the darkest tonal values in a photo.

Exposure: The amount of light hitting the camera sensor. Also the camera settings used to capture this incoming light.

Exposure histogram: A bar graph displayed on a camera or computer that shows the distribution of lights and darks in a photo.

Extension tube: A hollow ring that fits between a lens and the DSLR, used to achieve closer focusing.

f-number, f-stop: The size of the aperture, written f/n, where n is the f-number. The smaller the f-number, the larger the opening in the lens; the larger the f-number, the smaller the opening in the lens.

Focal length: Roughly, the distance from the end of the lens to the sensor. (The relationship of focal length to sensor size is explained on page 234.)

Framing: In a photographic composition, positioning the image in relationship to its edges.

Grain: Texture found in photographic film and prints due to the residue of small grains of metallic silver left over from chemical developing.

Grayscale: Used to render images in a single color from white to black; in Photoshop a grayscale image has only one channel.

Hand HDR: The process of creating a HDR (High Dynamic Range) image from multiple photos at different exposures without using automatic software to combine the photos.

High Dynamic Range (HDR) image: Extending an image's dynamic range by combining more than one capture either using automated software or by hand.

High key: Brightly lit photos that are predominantly white, often with an intentionally "over exposed" effect.

Hyperfocal distance: The closest distance at which a lens at a given aperture can be focused while keeping objects at infinity in focus.

Image stabilization: Also called vibration reduction, this is a high-tech system in a lens or camera that attempts to compensate for, and reduce, camera motion.

Infinity: The distance from the camera that is far enough away so that any object at that distance or beyond will be in focus when the lens is set to infinity.

Infrared (IR) photography: Captures made using infrared rather than normal, visible light.

ISO: The linear scale used to set sensitivity of a digital sensor.

JPEG: A compressed file format for photos that have been processed from an original RAW image.

LAB: Color model that separates luminance from color information.

Lensbaby: A special purpose lens with a flexible barrel that allows you to adjust the "sweet spot" (area in focus).

Low key: Dimly lit photos that are predominantly black, often with an intentionally "under exposed" effect.

Macro lens: A lens that is specially designed for close focusing; often a macro lens focuses close enough to enable a 1:1 magnification ratio.

Monochrome, monochromatic: A monochrome image is presented as nominally consisting of tones from white to black; however, "black and white" images can be tinted or toned, and so may vary from straight grayscale.

Multi-RAW processing: Combining two or more different versions of the same RAW file.

Noise: Static in a digital image that appears as unexpected, and usually unwanted, pixels.

Open up, open wide: To open up a lens, or to set the lens wide open, means to set the aperture to a large opening, denoted with a small f-number.

Photo composite: *See composite.*

Pre-visualization: Seeing how an image will come out after capture and processing before making an exposure.

Process color: A technique for reproducing a broad spectrum of colors by blending a few inks or colors that represent the entire color spectrum; for example, CMYK.

Quadtone: Process that uses four inked plates to create monochromatic imagery; *see also Duotone.*

RAW: A digital RAW file is a complete record of the data captured by the sensor. The details of RAW file formats vary among camera manufacturers.

RGB: Red, Green, and Blue; the three-color color model used for displaying photos on the web and on computer monitors.

Sabattier effect: *See Solarization.*

Sensitivity: Set using an ISO number; determines the sensitivity of the sensor to light.

Shutter speed: The interval of time that the shutter is open.

Solarization: Reverses, or partially reverses, blacks and whites; in film photography using re-exposure to make partially developed material lighter, and in digital photography via simulation.

Split toning: Toning with two colors; often one toning color is applied to highlights and the other to shadows.

Spot color: In the printing process, color applied via a single plate; not process color.

Stop down: To stop down a lens means to set the aperture to a small opening; denoted with a large f-number.

Sweet spot: The area that is in focus when using a Lensbaby.

Tinting: Adding color to a monochromatic image.

Toning: In the chemical darkroom, toner such as sepia or selenium was added for visual effect; in the digital darkroom, toning simulates the impact of chemical toning.

Tritone: Process that uses three inked plates to create monochromatic imagery; *see also Duotone.*

Index

▼ Page 240: I took this photo on the slopes of Mount Tamalpais, California on a foggy morning. I liked the composition with the path heading through the forest floor in the color version, but when I converted the image to black and white the photo had a great deal more subtlety and impact.

19mm, 15 seconds at f/22 and ISO 100, tripod mounted

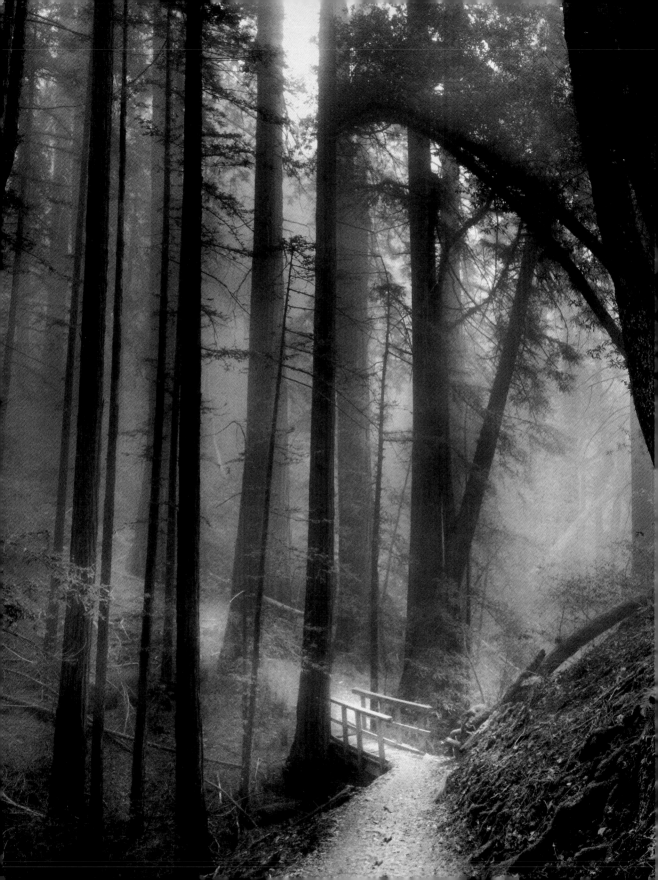